W9-CEF-539

Pittura e Misericordia

The Oratory of
S. Giovanni Decollato in Rome

Studies in the Fine Arts:
Art Patronage, No. 2

Linda Seidel, Series Editor

Associate Professor of Art History
University of Chicago

Other Titles in This Series

Pittura e Misericordia

The Oratory of
S. Giovanni Decollato in Rome

by
Jean S. Weisz

UMI RESEARCH PRESS
Ann Arbor, Michigan

UNIVERSITY OF TOLEDO LIBRARIES

Copyright © 1984, 1982
Jean Shepard Weisz
All rights reserved

Produced and distributed by
UMI Research Press
an imprint of
University Microfilms International
A Xerox Information Resources Company
Ann Arbor, Michigan 48106

Library of Congress Cataloging in Publication Data

Weisz, Jean S. (Jean Shepard)
Pittura e misericordia.

(Studies in the fine arts. Art patronage ; no. 2)
Revision of thesis—Harvard University, 1982.
Bibliography: p.
Includes index.
1. Mural painting and decoration, Italian—Italy—
Rome—Themes, motives. 2. Mannerism (Art)—Italy—
Rome. 3. Oratories—Italy—Rome. 4. San Giovanni
Decolatto (Church : Rome, Italy) I. Title. II. Series.

ND2757.R6W45 1984 751.7'3'0945632 84-151
ISBN 0-8357-1461-6

ND
2757
.R6 W45
1984

For Sydney J. Freedberg

Contents

List of Illustrations

Preface

The present work has grown out of a longstanding interest in the decorations of the Oratory of S. Giovanni Decollato in Rome and their role in the development of Maniera painting and out of a more recent desire to investigate the significance of the paintings within their historical context. In every way I am indebted to my thesis advisor Sydney J. Freedberg, with whom I first studied Italian Renaissance painting, in whose seminar I first became acquainted with the decorations of the oratory, and whose encouragement and guidance made this study possible. James S. Ackerman also provided many helpful comments on the draft of this work.

I am grateful to Samuel Y. Edgerton, Jr. and to the late Milton Lewine for their interest in the meaning of the oratory decorations, which stimulated my own, and for their encouragement of my project.

I should like to thank the members of the Archconfraternity of S. Giovanni Decollato in Rome for facilitating my research, especially Generale Goffredo Puccetti for allowing me access to the Archive and the late Ing. Gaetano Lumachi for spending many hours with me while I studied and photographed the paintings. Thanks are due also to the authorities of the Vatican Library, the Bibliotheca Herziana, and the Archivio di Stato in Rome for access to material, without which this study would not have been possible.

I am very grateful to the UCLA Art Council for a Faculty Research Grant to defray expenses of preparing the manuscript for publication and to Loren Partridge for assistance in acquiring photographs. Finally, I could not have completed this project without the encouragement and assistance of the staff of the UCLA Art Library, all of my colleagues, students, and friends in the art department, and my patient husband.

Introduction

The Confraternity of S. Giovanni Decollato, founded in the late fifteenth century, was a brotherhood of Florentine residents of Rome whose mandate was to give comfort and assistance to condemned prisoners in their final hours. Their expressed aim was to save the souls of the condemned by ensuring that they died in a state of grace — penitent and confident of salvation, redeemed by the sacrifice of Christ.

The construction and decoration of the Oratory of S. Giovanni Decollato was accomplished between the mid-1530s and mid-1550s. This period encompasses the 1540s, the decade which saw the foundation of the Jesuit Order, the establishment of the Roman Inquisition, and the opening of the Council of Trent — in short, the initiation of the Counter-Reformation.

The decorations of the Oratory of S. Giovanni Decollato can be fully understood only when considered in the immediate context of the activities of the patrons and within the larger context of midsixteenth-century Rome. To this end, in addition to the material in the archive of S. Giovanni Decollato, I have examined records of the confraternity now in the Archivio di Stato of Rome. These records were transferred from S. Giovanni Decollato to the state in 1891, making available to scholars much information about the actions of the inquisition against heretics which had been previously suppressed by the Church.[1] Examination of this material, which chronicled the day-to-day activities of the brotherhood and provided detailed accounts of the assistance to the condemned prisoners, made it possible to reconstruct a fuller context within which to study the decorative program of the oratory.

As a review of the literature indicates, the paintings in the Oratory of S. Giovanni Decollato can serve as a paradigm of Mannerist painting in Rome between the 1530s and the 1550s. The most incisive stylistic analysis of the role of each individual painting in the evolution of Maniera appears in Sydney J. Freedberg's *Painting in Italy: 1500–1600*.[2] Like earlier writers,[3] Freedberg discusses the paintings in separate chapters devoted to

the various participating artists, but without considering the program as a whole or its historical context. The individual paintings and artists have been discussed in the many books devoted to Mannerism which have appeared in recent years, particularly during the 1960s, as well as in several scholarly articles.[4]

No one, with the exception of Vittorio Moschini,[5] had attempted a study of the whole program in its context prior to Rolf Keller's *Das Oratorium von San Giovanni Decollato in Rom* of 1976.[6] This is a thorough and comprehensive study, valuable in that Keller pulled together the results of all previous scholarship, including all of the previously discovered documents regarding the construction and decoration of the oratory,[7] and measured all of the frescoes for the first time. However, he again discussed the paintings artist by artist, in what he considered to be their order of importance and quality. Therefore, he began not with the first fresco to be painted, the *Annunciation to Zaccariah* of ca. 1536/7 by Jacopino del Conte (also the first episode in the biblical narrative), but with the *Visitation* of 1538 by Francesco Salviati, which is the work most frequently reproduced and used as the exemplar of Roman Maniera in the literature. Keller did include a chapter on the history and activities of the confraternity but did not relate his discussion of the paintings to this context. In fact, he explicitly stated that, "Das Oratorium wird im Zusammenhang mit den Aufgaben der Bruderschaft nicht erwähnt. Mit ihren vornehmsten Aufgaben—den zum Tode Verurteilten beizustehen wie mit der Befreiung eines Verurteilten—hat es nichts zu tun."[8] Loren Partridge[9] in his review of Keller's book took exception to this approach and has criticized Keller's almost exclusive concern with style and his failure to consider the iconographical significance of the frescoes in the historical context of midsixteenth-century Rome. Previously, in 1970, Samuel Y. Edgerton, Jr.[10] had suggested that the paintings should be discussed in terms of their relevance to the purpose of the confraternity. However, to date the emphasis in the literature has been on style.

Freedberg is one of the few scholars to have recognized that the appearance of the paintings is at least to some extent due to the patrons' wishes: "Despite its morbid purpose," he writes, "the Confraternity chose to make their oratory a show-piece of modern decoration."[11] But, in fact, morbid as it may seem from today's viewpoint, the importation of Florentine charitable institutions to Rome must have been viewed then as an aspect of the "modernization" of Rome, along with the importation of Florentine banking and mercantile institutions and of Florentine culture in general. In the view of the Florentines of Rome, this would also have included the artistic modernization of the city. Thus, the style of the oratory paintings, based on Florentine tradition, was made contemporary and

Roman, serving to emphasize the modernity and timeliness of the confraternity and its charitable mission. Further, the innovations in style are linked with departures from traditional Florentine iconography for the representation of the various subjects.

The fundamental premise of this study is that there is indeed a relationship between the style of the decorations and their meaning which can only be understood when examined within the context of the concerns of the patrons and the effect upon the intended audience. Since there are no contemporary accounts of the program nor written instructions by the patrons, the interpretations suggested here must remain tentative. However, I have attempted to demonstrate a methodology for studies in patronage in which style and iconography can be used as tools for interpreting the meaning and function of such a program.

My method has been as follows:

1. To examine the paintings in relation to earlier examples of the same subjects and look for departures from either the traditional (particularly Florentine) or currently popular iconography, or both, which may have significance
2. To look for the possible significance of unusual motifs appearing throughout the program
3. To examine borrowed motifs in the paintings (as has been discussed in the literature and will be noted here, the paintings are full of obvious borrowings from other artists, particularly quotations of Michelangelo and Raphael) in the context of the meanings of their sources, considering the probability that borrowed figures and motifs express meaning through association with their sources[12]
4. To refer to the biblical text, primarily the Gospel of St. Luke, and occasionally to the *Golden Legend* rather than search the exegetical literature for texts to support the interpretations suggested (the premise is that the program was not abstruse, and the ideas expressed would have been accessible to the members of the confraternity who commissioned the paintings)
5. To consider all of the above elements in the context of the patrons' activities, with reference to the written records, and within the context of the religious climate of midsixteenth-century Rome

Part 1

History and Context

1

The Confraternity of
S. Giovanni Decollato

The Confraternity of S. Giovanni Decollato was established on 23 August 1490 when Pope Innocent VIII issued a bull mandating the brotherhood to comfort prisoners condemned to death during their final hours. This included taking their confessions, administering the Sacrament, accompanying them to their executions, and burying them.[1] Actually, these practices had originated slightly earlier; Gaspare Pontani, a late fifteenth-century Roman diarist, noted on 24 April 1488, "Cominciarono quelli della Compagnia de'Battuti ad accompagnare quelli che si andavano a giustiziare."[2] The Compagnia de'Battuti referred to by Pontani was the Compagnia della Pietà, which had been founded by the Florentine residents of Rome in 1448 to help victims of the plague and provide burial for those deceased.[3] This was in line with Florentine custom dating from the thirteenth century.[4] The Compagnia della Pietà later became the Confraternity of S. Giovanni dei Fiorentini, while those who began accompanying condemned prisoners to execution formed a separate confraternity—S. Giovanni Decollato.[5] It is interesting that this mission, which also had a precedent in Florentine tradition, was begun shortly after a member of the Altoviti family was hanged in front of the Tor di Nona.[6] The Altoviti were a prominent family of Florentine bankers and merchants living in Rome, and at that time Palazzo Altoviti was on the Piazza di S. Celso, almost opposite Ponte Sant'Angelo, which was adjacent to the Tor di Nona and the location of most executions.[7] Perhaps it was the hanging of one of their own, in addition to the fact that the Florentine colony was concentrated in that neighborhood, that stimulated the initiation of this pious and charitable activity. There was in any case a Florentine precedent in the Confraternity of Sta. Maria della Croce al Tempio, known also as the Compagnia dei Neri because of the black robes and hoods worn by the brothers, which was founded in 1343 for the purpose of comforting condemned prisoners and accompanying them to execution. There is no evidence that the Con-

fraternity of S. Giovanni Decollato was ever associated with its Florentine counterpart, but the Compagnia dei Neri provided the model for the practices of the Roman brotherhood.[8]

These practices are documented in detailed instruction books written for the members[9] and in the records of the confraternity preserved in the Archivio di Stato of Rome.[10] These records consist of lists of the *giustiziati* with name, date, place and method of execution, and occasionally the crime. In addition there are the *Libri di Testamenti,* which contain the testaments of the prisoners with name, date, place and method of execution, occasionally the crime, and sometimes comments about the attitude of the prisoner. Often the disposition of the remains is mentioned. The testament is always followed by the names of the members of the confraternity who attended the prisoner. Finally, the records include the *Giornali del Provveditore* which contain reports of the executions and also other activities: meetings, elections of new members, elections of officers, processions on feast days, visits to sick members, masses for deceased members, and various charitable works.[11] In the *Giornali* lists of the expenses incurred in all of these activities were recorded. These expenses included those of the executions where, in addition to the expenses involved in the burials and services, there were expenditures for candles and torches used in the processions, refreshments for the prisoners, and, when necessary, clothing provided for the condemned. All of these records provide a vivid picture of the activities of the brotherhood in comforting the *giustiziati.*

On the eve of an execution the confraternity was notified, whereupon a group consisting of the *provveditore* (a kind of administrative secretary), the chaplain, and four to six *confortatori* went to the prison wearing black robes and hoods. In a chamber reserved for the purpose, called the *conforteria,* they set up a portable altar, and the condemned prisoner was brought to them. They spent the night assisting the prisoner to confess, administering the Sacrament, taking down his testament if he so desired, and most of all exhorting him to repent his sins and accept his fate as divine will, believing that his sins would be forgiven and his soul received in paradise, "ricoperata col pretiosissimo sangue del Sig. N. Giesù Christo."[12] The records indicate that the condemned person was even encouraged to feel grateful that he was being given the opportunity to die penitent, fully prepared, and thus assured of salvation. This state was contrasted to that of one who died in an accident or from illness, having hoped to recover and thus not having prepared for death.[13] The prisoner was reminded that his fate, even if he professed innocence, was no more unjust than that of St. John the Baptist, the Christian martyrs, or even Christ himself.[14] Or, if he was an admitted malefactor, he was encouraged to identify with the repentant thief, who died with Christ and went straight to paradise.[15]

Small painted panels, *tavolette* with handles, depicting scenes from the Passion, usually the *Crucifixion* on one side, with other Passion scenes or the *Decollation of St. John the Baptist* on the reverse side, were held constantly before the eyes of the prisoner who was urged to kiss them (figs. 1–3).[16]

At dawn additional members of the confraternity assembled in the oratory.[17] They donned black robes and hoods and in procession, singing litanies and carrying torches and a large crucifix (fig. 4), went to the prison where they joined the officials, the prisoner, and the *confortatori*. From there they went in procession to the place of execution. The crucifix was placed facing the scaffold, and the prisoner was urged to kneel and kiss the feet of the Christ figure. One of the *confortatori* mounted the scaffold with the prisoner, holding one of the *tavole* before him, remaining with him to the end, and reminding him that God had pardoned him (fig. 5). The prisoner was asked to repeat the words, "In manus tuas Domine commendo spiritum meum," the last words of Christ; then, in Italian, "Giesù e Maria di nuovo ve dono il Cuore e l'anima mia," then three times, "Giesù Giesù Giesù."[18]

That night the brothers would return to take the corpse and carry it on a bier in a torchlight procession to the Church of S. Giovanni Decollato where Mass would be said and the body interred in the cloister, if that had been the victim's wish.[19] In the case of hangings, by far the most frequent method of execution,[20] the ropes were saved and, yearly on the Feast of the Decollation of St. John the Baptist, they were ceremonially burned.[21]

From 1540 on, the Feast of the Decollation was also celebrated by the liberation of a prisoner, selected by the members of the confraternity.[22] This was the occasion of a procession from the prison to the oratory where a ceremony was held. The confraternity also gave assistance, including financial if necessary, to the liberated prisoner.[23]

This was all done at the expense of the confraternity which had various ways of acquiring funds. The members paid dues and other fees; for example, brothers wishing to be excused from participation in the processions and the burials paid a fine.[24] Over the years the confraternity acquired property, mostly legacies from deceased members, some of which provided income from rent. It should be mentioned that not all of the members were wealthy. The membership, which was limited to Florentines, included not only bankers and merchants but also tailors and barbers, artists and jewelers, as well as a few ordained priests who lived on the premises. It is apparent that Florentines living in Rome continued the Florentine tradition of membership in religious confraternities.[25]

The bull of Innocent VIII had granted the confraternity the privilege of inheriting from the condemned; the bulls of subsequent Popes increased

the amount that could be inherited.[26] Though it has been suggested that this was the source of funds for the construction and decoration of the oratory,[27] in fact, the legacies of the executed criminals do not seem to have proved very lucrative. Testaments from this period indicate that most of the condemned were not wealthy; they were petty thieves, counterfeiters, occasionally assasins, committers of *vizii nefando* — including sodomy, and especially after the 1540s, heresy. The testaments mention such items as shirts and caps as frequently as cash.[28] Often the legacy was to the family of the condemned, or the confraternity was instructed to use the money to pay the debts of the deceased, or even to ship the remains back to the native city or village.[29] And even when money was left outright to S. Giovanni Decollato, it was usually stipulated that it be used for masses on behalf of the soul of the condemned prisoner.[30]

Most likely the funds for the oratory and its decorations came principally from individual members. Records of payments made to artists are very few. Those that have been found in the archives of S. Giovanni Decollato are cited in chapter 3. Only in the case of the altarpieces, for both the oratory and the church, is there mention in the *Giornale del Provveditore* of negotiations with the artists.[31] The entry states that three *fratelli* were empowered to negotiate in the name of the whole company and thus indicates that the commissioning of the altarpieces had been discussed in a meeting of the confraternity. This is the only such record of a group action in the decision-making process and is very likely an isolated instance.

Vasari[32] tells us that Battista da San Gallo, brother of Antonio da San Gallo the Younger, and the banker Giovanni da Cepperello commissioned the *Annunciation to Zaccariah* of 1536-37 and the *Visitation* of 1538 and that Bartolommeo Bussotti, a prominent banker and principal papal banker at the time, commissioned Salviati's Apostles of 1550-51. The information provided in the *Libri di Testamenti* shows that Battista da San Gallo and Giovanni da Cepperello, from the early 1530s, were among the most tireless and devoted in their services as *confortatori* to the condemned.[33] Battista da San Gallo also served as provveditore in 1532.[34] Therefore, it appears that the same members who participated most actively in the pious and charitable mission of the confraternity were also those most concerned with the decoration of the oratory in which the members held their meetings and religious services. It was just at the time when Bartolommeo Bussotti commissioned the paintings of the Apostles that his name appears among the *confortatori* — on 1 February 1550 and again on 29 March 1550.[35] Furthermore, the final phase of decoration of the oratory was initiated just when three of the most important Florentine bankers in Rome joined the confraternity: Bussotti and Ruberto Ubaldini

in 1549, and Bindo Altoviti in 1551.[36] In addition to being bankers involved with papal finances, these men served as consuls of Florence: Altoviti in 1531 and again in 1550, Ubaldini in 1551, and Bussotti in 1552.[37]

No evidence has been found connecting Bindo Altoviti or Ruberto Ubaldini to any of the oratory commissions, but Bindo was a well-known Maecenas,[38] and Ruberto Ubaldini was later involved in the efforts to complete the construction of S. Giovanni dei Fiorentini.[39] It would not be surprising to find that they also had been involved in the completion of the oratory decorations. In fact, the lack of records of payments to artists in the account books of the confraternity may be due to the fact that contracts were drawn up between individual patrons and artists. It is possible that such contracts were recorded by Bartolommeo Cappelli, another very active member of the confraternity,[40] who served as notary of the Florentine Consulate from 1531 to 1562.[41] Unfortunately, his notarial papers, previously preserved in the Archivio di Stato and the Archivio Capitolino, are missing from both archives. However, a record does exist in the Archive of S. Giovanni dei Fiorentini of a document drawn up by Cappelli annulling the contract between Michelangelo and the Duke of Urbino for the Tomb of Julius II.[42] Cappelli also recorded contracts between Bindo Altoviti and Benvenuto Cellini.[43] It is likely, therefore, that contracts for the decorations of the oratory once existed among Cappelli's notarial papers.

Ubaldini's name appears among the *confortatori* in 1550.[44] Bindo Altoviti's name does not appear in any of the extant *Libri di Testamenti,* but his son Giovanni Battista, who joined the confraternity in 1553, served as *confortatore* that same year.[45] One can only speculate about the motives that led these prominent men to become active at midcentury in the confraternity's affairs.[46] Papal indulgences were granted for services as *confortatore* and also for donations of funds for the fabric of the church.[47] The granting of indulgences may have been extended to donations of funds for the oratory as well. In any case, whether they were moved by Counter-Reformation piety, nationalistic pride, or by political expediency and economic self-interest,[48] it cannot be mere coincidence that the final effort to complete the oratory's decorations occurred during the period that these men joined the Confraternity of S. Giovanni Decollato.

2

The Church and Oratory of
S. Giovanni Decollato

The Church and Oratory of S. Giovanni Decollato are located below the
Campidoglio on the corner of Via di S. Giovanni Decollato and Via della
Misericordia (figs. 6–8). The structures are at right angles to each other and
are raised above the level of the street, presumably because of the frequent
flooding of low-lying areas near the Tiber, on a site which is roughly forty-
eight meters square. In addition to the church and oratory, there is an
arcaded cloister beyond which are two-story wings containing residences
for priests and the confraternity's quarters. The latter now include offices,
a large meeting room (Camera del Consiglio) with framed portraits of
members and old membership lists, the Archive, and a museum (Camera
Storica) in which are displayed objects used in comforting the prisoners —
tavolette, the altar from the Cappella della Conforteria at the Tor di Nona;
lanterns, torches, and the crucifix carried in the processions; and the bier
upon which the corpses of the prisoners were carried.

The exteriors of both church and oratory are very plain. The oratory is
a simple rectangle of dark, reddish-brown stucco with a tile roof. There are
three windows on the wall facing the street but no other articulation nor
decoration. The oratory and church are connected by a corridor entered
from the street which leads into the cloister. The entrance portal is sur-
mounted by a simple entablature above which is the only ornament — an
oval relief with the head of St. John the Baptist in a basin (the confra-
ternity's emblem) surrounded by the inscription *Arciconfraternitas
Misericordia.* The church facade is a temple front, made of brick, divided
into three narrow bays by shallow engaged pilasters. In the central bay the
portal, a miniature temple front bearing the inscription *Per Misericordia,* is
surmounted by a large, lunette-shaped window (now filled in with a grill
and screen). The side bays contain shallow niches on the upper level above
what must have once been niches or windows on the lower level but are
now filled in with brick. There is another small portal on the side facing

Via della Misericordia which bears the same inscription and is surmounted by the same lunette L-shaped window. All of the projections — entablatures and pilasters — are very shallow, and there is no other ornament.[1]

The site, which was occupied by the ruins of a late medieval church,[2] was assigned to the confraternity in a bull of Pope Innocent VIII along with permission to build a church and the granting of indulgences to donors of construction funds.[3] Moschini[4] assumes, on the basis of inscriptions cited by Forcella,[5] that construction of the church was begun in the 1490s. In fact, we know very little about the progress of the construction or when it actually was begun; the earliest record of any payment made for work on the fabric of the church is dated 1546.[6]

During the first two decades of the sixteenth century the confraternity held meetings in other churches; for example, in 1505 a meeting was held in S. Biagio della Pagnotta on Via Giulia,[7] and on 1 August 1518 the brothers assembled in Sta. Maria della Pace for the reading of their reformed statutes.[8] At that time Pope Leo X reconfirmed the privileges granted in the bull of Innocent VIII and granted indulgences to all who would visit the Church of S. Giovanni Decollato on the Feast of the Decollation of St. John the Baptist and also on Sundays.[9] The latter would suggest that there was a structure of some sort to visit, and there is mention of "la nostra chiesa" in the records of the confraternity as early as 1523.[10] However, it is most likely, as assumed by Lewine,[11] that very little progress was made prior to the late 1530s, and that the major portion of the structure is contemporary with Antonio da San Gallo's Church of Sto. Spirito in Sassia (1538–45), which is very similar in plan.[12] The "unknown architect" responsible for S. Giovanni Decollato may well have been Antonio's brother Battista da San Gallo, who had become a member of the confraternity in 1531.[13] As mentioned above, Battista was deeply committed to the brotherhood's mission of assisting condemned prisoners and was also involved in commissioning frescoes for the oratory. He remained an active member all his life, and on his death in 1552 left his manuscript of Vitruvius to the confraternity with the implication that it could be used to raise funds.[14] It seems logical that Battista, who was an architect in his own right, might have offered his services.[15] He might even have been given assistance by his brother Antonio, who himself joined the confraternity in 1540.[16]

The construction dragged on into the 1550s, and there are records of payments made to Francesco da San Gallo, "muratore," in 1552.[17] Moschini suggests that this was Francesco di Giuliano da San Gallo (1494–1576) known as "il Margotta," who was in Rome in 1552.[18] However, positive identification is made difficult by the number of Francescos (and Gianfrancescos) in the San Gallo family, including a Francesco di Bartol-

ommeo da San Gallo, who became a member of S. Giovanni Decollato in 1514.[19]

Completion of the oratory seems to have taken precedence over that of the church. Again we do not know when it was begun, but the oratory must have been completed by 1536/37, the presumed date of the first fresco.[20] Furthermore, the entire decoration of the oratory was nearly finished by the time the first painting for the church was commissioned in 1551.[21] This attests to the importance of the oratory, the first such oratory to be built in Rome after the Sack, and to the significance of its decorations in the context of the confraternity's activities.[22]

Though earlier oratories[23] similar in structure and with similar arrangement of fresco decorations did exist and might have provided a source for the structure and decorative program of S. Giovanni Decollato, as Lewine suggests,[24] the Sistine Chapel seems to have been the model for the design of the oratory and the arrangement of its decorations.

The oratory is entered through a doorway from the corridor which separates it from the church vestibule and leads into the cloister (fig. 8), and, like the Sistine Chapel, it is rectangular in plan with unarticulated planar walls decorated with a continuous fresco cycle. The illumination is from arched windows placed high on the side walls, above the frescoes and symmetrically opposite one another. (In S. Giovanni Decollato, the first window to the right of the entrance is false.) A further similarity is the placement of the single altar directly opposite the entrance, raised on a stepped platform, and flanked by two small doors (fig. 9).

In the oratory the long plaster walls are lined with wooden benches behind which is a dado extending halfway up the wall and continuing along the entrance wall (fig. 10). The frescoes are on the upper halves of the walls, above the dado and between the windows. They are surrounded by painted frameworks which include ficticious pilasters and molding around the windows and simulated reliefs in *grisaille* and bronze. Above the entrance is a simple niche containing a statue of St. John the Baptist. The *aedicula* surrounding the niche is illusionistically painted to simulate architecture as is the framework surrounding the altarpiece, which is set into an opening cut into the wall. Except for the ceiling and for shallow molding framing the doors on either side of the altar, there is no articulation or decoration that is not painted. The rather low, flat ceiling is divided by molding (of painted stucco in relief) into a pattern of polygonal forms containing garlands, rosettes, and fleurs-de-lis. A large octagon in the center contains the confraternity's emblem — the head of St. John the Baptist in a basin. This ceiling, which was restored in 1950,[25] is certainly of later date than the rest of the oratory decorations.[26] Also of later date is a large,

elaborate altar which until recently occupied the center of the oratory.[27] This structure, a three-tiered oval platform, made of wood, painted black, and decorated with gilt skulls and crossbones and other ornament, as well as sconces for candles, was presumably used as an altar during masses for the dead.

The design of the oratory is admirably suited to its function as a place where religious services as well as business meetings were held, and it became the model for other oratories built in Rome during the sixteenth century.[28] In the only other two such oratories to be decorated with frescoes, the Oratorio del Crocefisso di S. Marcello and the Oratorio del Gonfalone, the disposition of the frescoes is similar to that at S. Giovanni Decollato.[29]

That the oratory was used primarily for business meetings and religious services[30] does not mean that there is no relation between the function for which the brotherhood was founded—the assistance to the *giustiziati*—and the oratory. It was the place in which the brothers assembled as a group, and, if my interpretation of the decorative program is correct, the oratory meeting place and its paintings functioned as a constant reminder to the brothers of the pious mission of their confraternity.

3

The Decoration of the Oratory:
The Program and the Artists

The side and entrance walls of the Oratory of S. Giovanni Decollato are decorated with frescoes illustrating eight episodes from the life of St. John the Baptist: the *Annunciation to Zaccariah,* the *Visitation,* the *Nativity of St. John the Baptist,* the *Preaching of St. John the Baptist,* the *Baptism of Christ,* the *Arrest of St. John the Baptist,* the *Dance of Salome,* and the *Decollation of St. John the Baptist.* On the altar wall, frescoed figures of the Apostles Andrew and Bartholomew flank the altarpiece, the *Descent from the Cross* (fig. 11). The paintings were executed by at least four and probably five different artists over a period of almost two decades. The first fresco, the *Annunciation to Zaccariah* by Jacopino del Conte, was painted about 1536/37, and the final fresco, the *Decollation of St. John the Baptist,* by an unknown artist (probably an assistant of Salviati) is dated 1553 in the cartouche above the picture. Because of the scarcity of documents regarding the commissions and payments to the artists, our main source of information about the authorship of the paintings is Vasari.[1] The most certain dates are those appearing in cartouches over some of the frescoes: in the case of the *Nativity of the Baptist,* Vasari's attribution to Francesco Salviati and the date of 1551 in the cartouche are supported by records of payments made to the artist.[2]

The diversity of artists and the extended period of execution of the paintings contributed to a lack of stylistic unity. Though the decorative framework provides a first impression of consistency, closer examination reveals not only changes of hand but also an alteration in the concept of the program.

As was mentioned already, the building and decoration of such an oratory were not only unusual in Rome at the time, but its completion seems to have taken precedence over that of the Church of S. Giovanni Decollato. This attests to the importance of the oratory in the activities of

the confraternity and also suggests that the iconography of the decorative program was important in this context.

On the simplest level, the choice of subject matter is obviously appropriate as the illustration of the life of the titular saint of the confraternity, also the patron saint of Florence. And narrative cycles of the life of St. John the Baptist had played an important role in Florentine art since the Middle Ages. Two major decorative projects in Florence are relevant for our series: Ghirlandaio's frescoes in the choir of Sta. Maria Novella painted in the 1490s, and Andrea del Sarto's frescoes in the Chiostro dello Scalzo painted between 1511 and 1526.[3]

When the episodes from the life of St. John the Baptist selected for the oratory frescoes are compared with these two precedents, it become apparent that the subjects chosen by the confraternity were those which parallel episodes from the life of Christ[4] and which directly emphasize St. John's role as precursor. For example, Ghirlandaio's series, which consists of only seven frescoes, includes the *Naming of St. John the Baptist* as a separate episode from the *Nativity*. This event, which has no real counterpart in the life of Christ, is not represented in the oratory. In the Scalzo cycle, the *Naming* is included within the composition of the *Nativity,* and an engraving of the *Nativity of the Baptist* by Bonasone (fig. 12) after Jacopino del Conte[5] may represent an earlier intention to include the *Naming* within the *Nativity* in the oratory as well. However, in the end the episode was omitted entirely. Further, the Sta. Maria Novella cycle does not include the *Arrest of St. John the Baptist* nor the *Decollation.* These events, which do appear in the oratory, not only parallel events from the life of Christ but have obvious relevance to the mission of the confraternity. Their inclusion in the oratory cycle of only eight episodes suggests that the decorative program of the Oratory of S. Giovanni Decollato, as finally realized and including the altarpiece, should be viewed as a reinforcement of the confraternity's role in saving the souls of condemned prisoners.

We have no information regarding the original plan and who was responsible for it, but it is almost certain that changes were made during the almost twenty years of its execution. It would be dangerous, therefore, to insist upon a preconceived program of symbolic meanings in the relationships among the episodes and the manner in which they are disposed on the walls of the oratory.[6] It may be that even the emphasis on the parallels with the life of Christ and the emphasis on the role of the confraternity seen in the selection of episodes were not totally preplanned but rather evolved over the years as the program was developed.

Several episodes which appear in the larger, twelve-fresco program of the Scalzo, such as the apocryphal scenes of the *Blessing of St. John* and

the *Meeting of Christ and St. John* as well as the biblical episodes of the *Baptism of the People* are not included in the oratory. However, the presence of the episode *Zaccariah Appearing Mute before the People* (fig. 13)[7] as a simulated relief below the window which flanks the *Annunciation to Zaccariah* (fig. 16) suggests that the original plan at S. Giovanni Decollato was to include additional episodes, which do not have parallels in the life of Christ and do not serve to emphasize the mission of the confraternity, in smaller compositions as part of the decorative framework. If that was planned in the beginning, however, the idea was abandoned since the remaining simulated reliefs are of antique subjects.

The specific subject matter of most of these simulated reliefs is difficult to identify with certainty, but it seems clear that they are iconographically linked to the fresco program. For example, in the oval simulated relief below Salviati's false window, the *Sleeping Ariadne* is depicted (fig. 14).[8] The presence of Ariadne as a symbol of salvation through death[9] underlies the primary message of the decorative program. In fact, Roman Dionysiac sarcophagi seem to have provided a major source of motifs for the decorative framework. In addition to the *Sleeping Ariadne,* there is a Dionysiac scene of sacrifice on the socle of the fictitious pilaster to the left of the *Preaching of St. John* (fig. 15), and throughout the oratory there are fertility symbols such as herms and garlands of fruit that appeared frequently on such sarcophagi.[10]

A curious omission in the series of episodes from the life of St. John the Baptist in the oratory is the *Presentation of the Head of St. John,* which appears in the Scalzo following the fresco of the *Decollation.* It would seem that in the context of the oratory program, and particularly in view of the fact that the emblem of the confraternity was the head of St. John the Baptist in a basin, this episode would have been included. Again, it is possible that an earlier plan including this subject was subsequently changed.

The original plan may have, in fact, called for more episodes to be depicted in the large frescoes. This suggestion is supported by the change in format of the frescoes from the nearly square (2.9 m. by 3.3 m.) *Annunciation to Zaccariah* (fig. 16) painted in 1536/37 to the horizontally disposed rectangle (1.9 m. by 4.5 m.) of the *Visitation* (fig. 17) painted in the following year. This change of format would appear to have been dictated by the placement of the windows since both frescoes fill most of the available space. However, the existence of a preliminary drawing by Salviati for the *Visitation* (fig. 18)[11] in a nearly square format (15.5 cm. by 18 cm.), as well as a possible first idea for the *Nativity of the Baptist* (fig. 19)[12] also in a square format, suggests that the original plan was for a series of basically square narratives. Where the placement of the windows

resulted in leftover spaces, as would have been the case with a square *Visitation,* single figures may have been planned. These could have been Virtues, as in the Scalzo, or perhaps additional Apostles.[13] There would have been room for two roughly square frescoes and another figure in the long, windowless space (7.95 m. wide) which is actually occupied by the *Nativity,* the simulated window, and a landscape painted between this simulated window and the corner of the room (fig. 20). However, on the opposite wall the presence of the additional window would have made the same sequence of narratives and single figures impossible, resulting in a lack of symmetry between the two sides. It is likely that this soon became apparent, and the format was changed during the time that Salviati was planning the *Visitation.* Probably at this time the simulated window was planned in order to create symmetry between the two walls, and the ornamental framework was altered. The decorative motifs became more elaborate, and classical subjects were depicted in the simulated reliefs instead of additional episodes from the life of St. John the Baptist. Cartouches containing dates were added to the framework above the frescoes,[14] and the simulated frame with the meander design around Jacopino's fresco, which created a tapestrylike effect[15] or that of a *quadro riportato,* was replaced in the subsequent frescoes by an illusionism more stagelike in effect.[16]

All of these changes were most likely the result of Salviati's arrival on the scene in 1538, slightly after the program had been begun by Jacopino del Conte. The date of Jacopino's first fresco is not documented, and it has been variously dated between 1535 and 1537.[17] According to Vasari[18] Giovanni da Cepperello and Battista da San Gallo commissioned Salviati to paint the *Visitation* after having had Jacopino paint the *Annunciation to Zaccariah.* Therefore 1538 is the terminus ante quem for Jacopino's fresco, but the date of his arrival in Rome has not been determined with certainty. Zeri's [19] assertion that he could not have arrived before the end of 1536 has been refuted by Cheney,[20] who suggested an arrival date of 1534/35. In her reconstruction of Jacopino's first years in Rome, she explains his absence from the group of artists working for Antonio da San Gallo on the decorations for the triumphal entry of Charles V into Rome during the spring of 1536 by suggesting that Jacopino's talents and inclinations were not compatible with the program of mythological, historical, and allegorical scenes which comprised the triumphal decorations. However, the fact that such a program would be Salviati's forte but not Jacopino's may not have been apparent so early.

More likely than not, the intention of the confraternity was to hire a team of Florentine painters to execute the frescoes, such as the very group working on the triumphal decorations under the supervision of Antonio da

San Gallo, assisted by his brother Battista.[21] It is possible that Battista diverted Jacopino from that project in order to begin the oratory frescoes, and then hired Salviati after the triumphal decorations were completed. Whether or not this was due to the patrons' dissatisfaction with Jacopino's work, it seems apparent that Jacopino's conservative plan for the program, based more closely on the model of the Scalzo frescoes,[22] was modified by Salviati's more modern design, which with its antique subjects and motifs and illusionistic conceits, reflected the style of the triumphal decorations[23]

There may have been hard feelings between Jacopino and Salviati as a result. Vasari reported in the life of Battista Franco[24] that, after having painted the *Visitation,* "e dovendo dargli l'ultimo fine e mettere mano ad altre che moltj particolari desegnavano farvi, per la concorrenza che fu fra lui ed Iacopo del Conte, non si fece altro. . . ." Cheney[25] suggested that the rivalry between Jacopino and Salviati was over the commission for the *Nativity of the Baptist,* and it is true that both artists seem to have made designs for the composition. However, the difference in format — Salviati's still square, while Jacopino's was horizontal — indicates that Salviati had received the commission earlier, before the change of program, and that Jacopino made his design in an attempt to win the commission in Salviati's stead after the latter had departed for Florence. However, the *fratelli* did not give the commission to Jacopino, and the space was left empty until Salviati finally returned to paint the *Nativity* in 1550/51. Actually, Vasari's statement implies that Salviati's services were in demand for more than just one more fresco; he may have been originally commissioned to paint the *Baptism of Christ* as well. As noted by Cheney,[26] a print of the *Baptism* by Philippe Thomasin (fig. 21), labeled "Franciscus Salviatus Inventor," is similar in composition to the oratory fresco. More significantly, the design contains two half-length figures directing the viewer into the picture as in Salviati's *Visitation.*

The rivalry between the two artists may have been in fact for the rest of the program as a whole. In any case, after Salviati's departure, the patrons evidently chose to continue with his plan for the decorative framework around the remaining frescoes, regardless of which artist did the actual painting.[27]

Jacopino's *Preaching of St. John the Baptist* (fig. 22) on the entrance wall is dated 1538 in the cartouche, and it has been traditionally assumed that Jacopino received the commission and executed the fresco contemporaneously with Salviati's *Visitation.* More likely, it was not executed until after Salviati's departure. The fact that the composition is based upon a drawing by Perino del Vaga (fig. 23)[28] has been explained by the *concorrenza* with Salviati, which led Jacopino to seek assistance from Perino, who obliged with a drawing.[29] Another possibility is that Perino was

briefly involved with the project himself.[30] According to Vasari,[31] Perino had difficulty obtaining work when he first returned to Rome, and he may have accepted this commission only to default when he was asked to resume work in the Cappella del Crocefisso of S. Marcello al Corso.[32] Or perhaps he was prevented from fulfilling the commission by the "bad arm" mentioned by Vasari. Jacopino, then, might have been hired to execute Perino's composition rather than to produce his own design. This was then followed by the commission to paint the *Baptism of Christ* (fig. 24) — perhaps replacing Salviati.

This notion of Jacopino as the perennial second choice was recently reinforced by my discovery that the commission for the altarpiece, the *Descent from the Cross,* previously believed to have been painted by Jacopino during the 1540s,[33] was first awarded to Daniele da Volterra in 1551.[34] After executing the *Baptism,* which is dated 1541 in the cartouche, and probably during the same period, between 1538 and 1541, painting the decorative enframement on the entrance wall, including the simulated *aedicula* for the statue of the Baptist, Jacopino disappeared from the scene for at least a decade.

The next stage of decoration was undertaken by non-Florentines. According to Vasari,[35] Battista Franco won the commission to paint the *Arrest of St. John the Baptist* (fig. 25) by showing his design to Monsignore Giovanni della Casa.[36] In his account of the incident, Vasari states that it took place in 1538 when Battista learned that Salviati had quit work in the oratory. However, that contradicts his earlier statement that Battista Franco returned to Rome from Florence at about the time that Michelangelo's *Last Judgment* was unveiled in 1541. Since Battista was involved, along with Salviati, in the decorative apparatus for the wedding of Duke Cosimo to Eleanora da Toledo in June of 1539 and then did some work for the Camaldolite Monastery of Valdichiana,[37] 1541 seems the more accurate date for his return to Rome. This date can thus serve as an approximate terminus post quem for the fresco (the cartouche above the scene is blank). If Monsignore della Casa was indeed Franco's patron,[38] his departure in August of 1544 for Venice to take up the post of Apostolic Nuncio provides a terminus ante quem for the commission.[39]

The Venetian Battista Franco was followed by another non-Florentine, the Neapolitan Pirro Ligorio. The fresco of the *Dance of Salome* (fig. 26) has always been attributed to Ligorio by a process of elimination on the basis of Vasari's statement in the life of Salviati[40] that Battista Franco and Pirro Ligorio "avevano fatto alcune altre cose" in the oratory. The attribution to Ligorio is also supported by Baglione.[41] The cartouche above this fresco is again blank, and the suggested date of mid-1540s is based on its location — between the *Arrest* of ca. 1541–44 and

the *Decollation* which is dated 1553 in the cartouche. I have found nothing to contradict this dating. Keller[42] suggested a more precise date of 1544 when he discovered a document in the archives of the confraternity which reads, "A spese della compagnia per havere fatto levare il ponte del dipintore...7" and is dated 4 December 1544. He stated that neither in the oratory nor in the church is there another painting that could be dated 1544. Keller's hypothesis may be correct, but it is also possible that Battista Franco completed the *Arrest* as late as December 1544 and that the document refers to the removal of his scaffolding.

Gere,[43] on the basis of the existence of a drawing by Ligorio of the *Baptist Taking Leave of His Parents,* tentatively suggests that the confraternity considered commissioning Ligorio to paint this subject in the space left vacant by the unfulfilled commission for the *Nativity of the Baptist.* However, it seems more likely that if the confraternity had hired Ligorio to replace Salviati, the commission would have been for the same subject, the *Nativity.* The *Baptist Taking Leave of His Parents,* though it fits chronologically into that empty space, is an apocryphal subject and does not fit into the thematic program of the oratory frescoes as outlined here.

In 1550 Salviati painted the Apostles Andrew and Bartholomew (figs. 27 and 28) flanking the altarpiece, and in 1550/51 he painted the *Nativity of the Baptist* (fig. 29). In addition to the cartouche over the *Nativity,* confirmation of the dates for these works is provided by records of payments: the first, dated 1550, referring to the Apostles and the *Nativity;* a second one, in 1551, referring to the same paintings.[44]

The last fresco to be painted in the oratory was the *Decollation of St. John the Baptist* (fig. 30), dated 1553 in the cartouche. The painter of the *Decollation* is unknown. It has been attributed to Ligorio,[45] but the similarity of the composition to Salviati's fresco of the same subject in the Cappella del Palio (fig. 31) suggests that Salviati was given the commission, and the fresco was executed by an assistant after his design. Keller[46] suggests Roviale Spagnuolo as the executant on the basis of his association with Salviati during this period, but he provides no visual evidence to support the attribution.

Meanwhile, in 1551, as demonstrated by a recently discovered entry in the *Giornale del Provveditore,* Daniele da Volterra was commissioned to paint the altarpiece and given an advance payment.[47] The same entry states that Vasari was commissioned to paint the altarpiece for the Church of S. Giovanni Decollato, and a slightly later entry during the same year states that Vasari's model was approved by Michelangelo.[48] There are records of payments made to Vasari during 1551 and 1553.[49] It is apparent, therefore, that both altarpieces were part of a major effort initiated in the early 1550s to finally complete the decoration of the church.

That Daniele should have received the commission for the altarpiece rather than Jacopino del Conte, as previously believed, is not surprising. As the heir of Perino del Vaga and good friend of Michelangelo, Daniele was much employed in the late 1540s and early 1550s. After Perino's death in 1547, Daniele, who had been working as his assistant and was the principal executant of the decorations of the Cappela del Crocefisso in San Marcello, succeeded him as supervisor of the decorations of the Sala Regia in the Vatican. According to Vasari,[50] it was through the influence of Michelangelo that Daniele succeeded Perino in the Sala Regia and later received the commission for the decorations of the Stanza di Cleopatra in the Vatican. Conceivably, Michelangelo aided Daniele in obtaining the commission for the altarpiece in the Oratory of S. Giovanni Decollato as well. The fact that he was called in to approve Vasari's *modello* suggests that the *fratelli* of S. Giovanni Decollato turned to Michelangelo as an advisor just as later the members of S. Giovanni dei Fiorentini consulted him about the completion of their church.[51]

Another possibility is that Monsignore Giovanni della Casa intervened in the choice of artist for the altarpiece. He was back in Rome during 1550 and 1551 and might have become involved with the oratory decorations again. Later, in 1555/56, he commissioned several paintings from Daniele.[52]

In any case, Daniele did not fulfill the commission, and there is no evidence that he even began the project. There is no further mention of Daniele in the records of the confraternity, and there is no doubt that the actual altarpiece (fig. 32) was painted by Jacopino rather than Daniele. The altarpiece is mentioned twice by Vasari,[53] who considers it one of Jacopino's best works, and though some adjusting of the chronology of Jacopino's paintings is now necessary, the painting must also be attributed to him on stylistic grounds.

The fact remains that Daniele was advanced twenty-five *scudi* by the confraternity for the altarpiece, and one wonders if he did anything for the payment received. A drawing in the Louvre (fig. 33)[54] which was once attributed to Daniele, then reassigned to Jacopino del Conte when it was identified as a study for his altarpiece, and is now called a copy after Jacopino, should be reconsidered. If the Louvre drawing were a sketch (or copy of a sketch) submitted by Daniele which the patrons then presented to Jacopino to use as the *modello* for the painting,[55] it would account for the twenty-five *scudi* advance. Also, it would not be the first time that Jacopino had worked from another artist's drawing; he had done so in executing the *Preaching of St. John the Baptist.*[56]

Probably the demands of other and more prestigious commissions led to Daniele's failure to complete the project. During the early 1550s he was

working on the frescoes of the Rovere Chapel in SS. Trinità dei Monti as well as the decorations of the Stanza di Cleopatra in the Vatican,[57] and, according to Vasari,[58] he also painted a fresco in Sant'Agostino. We know from Vasari that Daniele was a slow and laborious worker, and it appears likely that the *fratelli* became impatient and called upon Jacopino to replace him.

In the records of the commission there is no mention of the subject matter for the altarpiece, and we have no way of knowing if the original program indeed called for the *Descent from the Cross* as was actually executed. In an oratory dedicated to S. Giovanni Decollato and decorated with scenes from his life, the more obvious choice of subject for the altarpiece would have been the *Decollation of the Baptist,* which is the subject of Vasari's altarpiece for the church, especially because the *Decollation of the Baptist* was traditionally considered the prototype for the death of Christ. It is possible that an earlier plan calling for this subject as the altarpiece was changed. The incorporation of the *Decollation* in the fresco cycle, as the last fresco, with the *Descent* as the altarpiece, actually strengthens the link between the lives – and deaths – of St. John and Christ and the emphasis on John's role as precursor. This link is further stressed by the placement of the figure of St. Andrew, a follower of St. John the Baptist before becoming Christ's disciple, between the fresco of the *Decollation* and the altarpiece.

Also, by the time the altarpiece was painted, the subject of the *Descent from the Cross* had become very popular for altarpieces in Rome and Florence. The discussion below will demonstrate that both the choice of and the approach to the subject matter of the oratory's altarpiece have relevance in the context of Counter-Reformation Rome and also in the more immediate context of the mission of the Confraternity of S. Giovanni Decollato.[59]

Part 2

Style and Meaning

4

The West Wall: Prophecy

The decoration of the west wall of the oratory, facing the cloister, with the three frescoes of the *Annunciation to Zaccariah*, the *Visitation*, and the *Nativity of St. John the Baptist*, not only contains the most obvious parallels to the life of Christ but also suggests parallels to the life of the Virgin. *Annunciation* and *Nativity* episodes appear in Mariological cycles as well as in the lives of Christ and the Baptist, and the *Visitation*, of course, appears in the lives of all three. Further, the Virgin Mary and St. John the Baptist are the only saints whose day of birth is celebrated as a feast day as is the birth of Christ.

These parallels underline the role of St. John the Baptist in the preordained plan for man's salvation. Thus, on this wall the prophecy of Christ's sacrifice is expressed through the life of St. John the Baptist.

The Annunciation to Zaccariah (fig. 16)

The traditional mode of representing the *Annunciation to Zaccariah*, followed by Florentine painters since Giotto,[1] is a composition in which Zaccariah and the angel are inside an architectural setting, the temple, with a crowd of bystanders outside the building. This follows the biblical text, "the whole multitude of the people were praying at the time of the incense," (Luke 1: 10).

Jacopino del Conte continued this tradition as Ghirlandaio had done in Sta. Maria Novella and Andrea del Sarto in the Chiostro dello Scalzo, but the three compositions are very different. In Ghirlandaio's frescoes in Sta. Maria Novella the biblical subjects are represented in the guise of contemporary Florentine life. His *Annunciation to Zaccariah* is populated with large numbers of figures in contemporary dress, mostly portraits of important Florentine citizens,[2] placed in an elaborate architectural setting with antique details and ornament. Andrea del Sarto in his Scalzo *Annunciation to Zaccariah* included only a few of the extra figures in a composi-

tion which, for its simplicity and dignity, is a high point of Renaissance classicism.[3]

Jacopino's composition resembles neither of these major Florentine precedents as much as it reflects his recent experience of Roman painting. It is obvious that in this, one of his earliest Roman works and, in fact, the first major commission of his career,[4] Jacopino responded to the impact of Raphael and especially of the Vatican tapestries. The composition with its stagelike architectural setting and its blocky groups of densely overlapping figures particularly resembles the *Sacrifice at Lystra* and *St. Paul Preaching in Athens*. In spite of the implied depth created by overlapping and diminution of the forms, the relieflike adherence of the figures to the surface plane makes the setting appear to be a backdrop as in the *Sacrifice at Lystra*. Closer to the *Preaching in Athens,* however, is the severely geometric organization of the composition created by the horizontal and vertical elements of the architecture, including the steps, and the use of the column marking the central axis to divide the composition in half—even though the figure groups are asymmetrical. The secondary figures, especially the two foreground pairs of classically garbed, gesticulating men, are similar both in appearance and function—reacting to the protagonists and pointing at them—to figures appearing in many of the tapestries. As in Raphael's tapestries and other projects, the inclusion of the extra figures here adds to the historical realism of the scene.[5] In sum, it is apparent that Jacopino has attempted to emulate the grandeur and rhetorical mode of Raphael's classical style of history painting.

Yet within the overall "restrained, even academically correct, interpretation of the mature Raphael,"[6] traces of Jacopino's Florentine origins remain. The draperies of the two men in the right foreground have an inflated, almost balloonlike quality that is similar to Pontormo's handling of draperies, for example in the Carmignano *Visitation* (fig. 55), which was in turn a blown-up version of the drapery handling of Andrea del Sarto, for example in the SS. Annunziata *Birth of the Virgin*. Also the use of the poses and gestures of the figures and the rhythms of the drapery folds to connect the figures and lead the viewer's eye to the central action, though derived from Raphael (and here reminiscent of the *Disputà*) goes beyond Raphael and suggests the influence of Pontormo in the intricacy of the linear network and the planarity of the overall design.

In addition Jacopino has included quotations of Florentine sources among the figures and motifs. The female figures in the background, the old woman and the mother and child, recall the figures in his own *Madonna and Child* paintings, for example the ex-Contini-Bonacossi *Madonna* (fig. 34), which were themselves derived from the works of Andrea del Sarto, Pontormo, and Michelangelo.[7] Along with the quota-

tion from the Roman works of Michelangelo, recognized in the beautiful youth sprawled on the steps (the fillet binding his hair makes the reference to the Sistine *ignudi* explicit), Jacopino included a statue in the background based on Michelangelo's *Apollo*.[8]

Another memory of Florence is found in the inclusion of the *cupolone* in the background, but on a building that resembles the Baptistry rather than the Cathedral. Although not a traditional motif in representations of this subject, the Baptistry was inserted here as an obvious reference to baptism. And the choice of the Appollo statue and its placement on the Baptistry is not just a tribute to Michelangelo but a reference to Christ.[9] The symbolic connection between the Sacrament of Baptism and Christ's sacrifice, a recurrent theme in the oratory, is introduced here by the presence of a wine cask and a shallow container, suggesting a baptismal vessel, next to the youth on the steps.

This youth and the female figures have no precedents in earlier representations of this subject in Florence or elsewhere but belong to the repertory of "stock figures" which had appeared in Roman paintings since Raphael. These figures in Jacopino's fresco could be viewed simply as his continuation of this tradition. In fact, Cheney[10] refers to the youth as a beggar. However, since the same types of figures appear in later frescoes in the oratory by different artists, it seems worthwhile to consider that their presence may have additional significance.

When the figure of the youth sprawling on the steps is associated with its source in the Sistine *ignudi*, this motif gains significance. Further, this significance is reinforced by the unusual position of the angel; instead of standing before Zaccariah, as in previous representations of the subject, he is hovering in the air. The figure is a quotation from Raphael's frescoes in Sta. Maria della Pace. In their original contexts both the youth and the angel are related to prophets and sibyls. Figures of prophets and sibyls appear in others of the oratory frescoes, and they refer to St. John's role as prophet and to the Old Testament prophets' forecast of his coming. In addition, there seems to have been a tradition in Renaissance theatre of including a sibyl or prophetess in the *sacre rappresentazioni* of the life of St. John the Baptist.[11] On the basis of this tradition Marilyn Lavin[12] suggests convincingly that the old woman in Rosso's *Holy Family* in the Los Angeles County Museum of Art should be identified as the Prophetess Anna as well as St. Anne.

The old woman in Jacopino's fresco should be read as a prophetess, and further, she and the sprawling youth are linked by the juxtaposition of their forms—in spite of the difference in scale between the figures which indicates their different locations in depth—and by the way they appear to be gazing intently at each other. The gesture of the youth is characteristic

of images of St. John the Baptist, and the fact that the objects next to him, in addition to the wine cask and the baptismal vessel, include a thin stick like the reed cross of the Baptist, indicates that this figure can be read metaphorically as St. John the Baptist. He is there as a prophet, and he can be interpreted as referring to the prophecy of his own coming by Isaiah. He is pointing to the figures of Zaccariah and the angel as witnesses to the announcement that, prior to the announcement to the Virgin, sets in motion the whole chain of events depicted in the subsequent frescoes, paralleling the events of the life of Christ culminating in the Passion.

The emulation of Raphael's classical style in the geometric ordering of the composition and the monumentality of the foreground figures was Jacopino's way of heightening the impact of this message. By borrowing from Raphael's tapestries, Jacopino also hoped to borrow the content of those forms.

The Visitation (fig. 17)

In Salviati's *Visitation* the purpose is also to represent a momentous and prophetic event through the depiction of a lively crowd scene. While the example of Raphael is as crucial as it was in Jacopino's fresco, Salviati was responding here to a later phase of Roman painting. Rather than continuing the post-Raphaelesque classicism of the *Annunciation to Zaccariah*, for which a model was available in Sebastiano del Piombo's *Visitation* in Sta. Maria della Pace,[13] Salviati turned in the direction that had been indicated by Perino del Vaga in his works of the 1520s, prior to his departure for Genoa. In fact Salviati's fresco signaled the emergence of high Maniera prior to Perino's own accomplishment after returning to Rome.

Again the iconography is in the mainstream of Florentine tradition, representing the subject with the two protagonists either embracing or clasping hands and flanked by other figures. However, Salviati elaborated and complicated the composition far beyond what Andrea del Sarto or even Ghirlandaio had done. In terms of the quantity, variety, and particular types of figures included, the closest Florentine precedent for this work is Pontormo's fresco of the *Visitation* in the courtyard of SS. Annunziata. But Salviati completely romanized even this source.

The point of departure for Salviati's design was certainly provided by Perino's *Visitation* in the Pucci Chapel, SS. Trinità dei Monti. Both frescoes are decorative compositions in which the figures are disposed in a stagelike architectural setting with an asymmetrical balancing of groups of figures and architectural forms. The protagonists are slightly off-center in the middle ground, and the foreground is dominated by active extra figures, making of the scene a festive public event. Other and earlier

sources for this type of composition were available to Salviati in Peruzzi's *Presentation of the Virgin* in Sta. Maria della Pace and in Raphael's *Incendio nel Borgo* and Vatican tapestries, particularly the *Sacrifice at Lystra*.[14] In fact, the stagelike quality of Salviati's setting is closer to Raphael and Peruzzi, both of whom actually made stage designs, than to Perino.[15]

As in Jacopino's *Annunciation to Zaccariah*, the extra figures here include motifs combining Florentine and Roman sources, which then recur throughout the fresco cycle. The woman carrying a bundle on her head on the far left is an old Florentine motif most commonly appearing in birth scenes, of the Virgin or of St. John the Baptist. The motif occasionally appeared in *Visitation* scenes, including Pontormo's fresco in the Annunziata, which also contained a nude youth sprawling on the steps, and a woman with a child. However, Salviati romanized and ornamentalized all of these figures. Thus, the woman with the bundle relates to the *Canephore* in Raphael's *Incendio*[16] and, less literally but no less importantly, to Michelangelo's *Libyan Sibyl* of which Salviati had made a drawing.[17] The influence of Michelangelo is apparent also in the figure of the seminude youth, half-reclining next to her, and in the female figure suckling a child on the right. This figure has been interpreted as a *Caritas*.[18] The vessels on the ground in front of her refer once again to the Baptism/Eucharist symbolism.

Salviati emphasized the message conveyed by these figures through their formal significance in the composition. They are striking for their beauty, their elegant, stylized postures with sinuous, elongated limbs arranged parallel to the picture plane, and the decorative calligraphy of their draperies and headdress, particularly of the *Canephore*. The decorative effect is heightened by the color of the *Canephore*'s draperies: pale and *changeant,* in tones of rose, blue, yellow, and green with white highlights. These same colors — dominated by the pale rose, which is also the color of the floor tiles — and the overall light tonality are in contrast to Jacopino's use of strong, local color in the *Annunciation to Zaccariah*.

The style of the figures, as well as their placement and the manipulation of their forms to set up a rhythmic design which then unites all of the figures into a decorative surface pattern, suggests the new style of Perino del Vaga before he himself had actually painted anything since his return to Rome. In fact, the closest contemporary parallel for these figures is to be found in Perino's drawing for the *Preaching of St. John the Baptist* (fig. 23). More than Jacopino, who executed the fresco of the *Preaching* from Perino's drawing, Salviati understood and shared Perino's concern with ornament.[19]

Salviati's forms are so decorative as to seem artificial, and this quality pervades the content as well, increasing the stagelike character. It is as

though the viewer were watching an enactment of the *Visitation* rather than the event itself. This effect is heightened by the presence of the two black-clad, contemporary, half-figures in the foreground. These two, almost certainly portraits of the patrons Giovanni da Cepperello and Battista da San Gallo, contrast with—and therefore emphasize—the decorative beauty of the other figures. Their placement in front of the "stage" and mounting steps leading into the scene from below, also adds to the theatrical effect.[20]

Florentine sources for such figures exist. For example, in Ghirlandaio's fresco of *Pope Honorious Confirming the Franciscan Order* in the Sassetti Chapel, Sta. Trinita, portraits of members of the Sassetti family, similarly cut off, are mounting stairs from an area between the viewer's space and the narrative. However, because the style of the contemporary portrait figures and the historical figures is the same and the setting is clearly recognizable as the Piazza della Signoria of Florence, the effect in Ghirlandaio's fresco is to increase the sense of actuality of the figures and the event. In Salviati's fresco these figures increase the sense of artificiality and theatricality.

They are pointing to the protagonists, as is the *Canephore*,[21] but whereas her gesture is parallel to the picture plane and part of the ornamental surface design, the two half-length figures, by their placement and gestures, seem to be emphatically addressing the viewer and directing his attention to St. Elizabeth and the Virgin. This is in order to emphasize the message of the scene: the significance of the moment when the unborn St. John the Baptist leapt in his mother's womb in recognition of Christ, thus beginning his mission as precursor and prophet, and when Elizabeth joyously proclaimed the fulfillment of God's promise (Luke 1: 40–45).

The message of the *Visitation,* a message of joy and faith in Christ's redemptive grace, is communicated within the context of a composition so beautiful and full of *grazia* that, as Vasari said, "non è maraviglia se tutta Roma ne restò ammirata."[22]

The Nativity of St. John the Baptist (fig. 29)

Vasari was less complimentary of Salviati's *Nativity of St. John the Baptist,* commenting that "la quale se bene condusse ottimamente, ella nondimeno non fu pari alla prima."[23]

By the time Salviati finally executed the fresco of the *Nativity* in 1550/51, his style had changed from the ornamental high Maniera initiated in his *Visitation* and developed by him in Florence, particularly in the frescoes of the Sala dell'Udienza of the Palazzo Vecchio. His first projects upon his return to Rome in 1548, the decoration of the Capella del Palio in

the Palazzo della Cancelleria (1548–ca. 1550) and the Margrave Chapel of Sta. Maria dell'Anima (1549–50), reflected the sobered atmosphere of Counter-Reformation Rome and the increasingly powerful influence of Michelangelo, particularly of his latest paintings, the *Last Judgment* and the frescoes of the Pauline Chapel. The graceful, elongated figures and animated movements of the *Visitation* were replaced in the *Nativity* by massive figures and slow, almost lethargic movements. Instead of a lively public event like the *Visitation*, Salviati depicted in the *Nativity* a somber and almost ceremonious gathering.

The iconography appears at first glance to be unexceptional and, in fact, more within the Florentine tradition than the previous two frescoes. The new mother reclines in bed attended by friends and servants. Some women are bringing offerings, and others are preparing to bathe the newborn babe. This is the standard Florentine iconography for both the *Nativity of the Virgin* and the *Nativity of St. John the Baptist*. Here the parallel between the lives of the Virgin and St. John which appears in this episode, and in all of the episodes on this wall of the oratory, is especially stressed. The absence of the *Naming of St. John* from the scene makes it indistinguishable from representations of the *Birth of the Virgin*. And, in fact, Salviati's fresco with its massive figures, canopied bed, and putti resembles Andrea del Sarto's *Nativity of the Virgin* in SS. Annunziata more than his Scalzo fresco of the *Nativity of St. John*, which includes the naming but not the washing of the baby. Also reminiscent of Andrea's Annunziata fresco, which has the inscription "Andreas faciebat" over the mantle, is the inscription F. S. F. F. (Francesco Salviati Fiorentinus Faciebat) on a stone socle to the left of the bed.

Within the traditional iconographical elements Salviati included and particularly emphasized the washing of the baby. This rite of purification of the newborn is a prefiguration of the Baptism in this subject, referring once again to the symbolic connection between the Baptism and the Eucharist that is such an important element throughout the oratory program. On the far right of the painting is a woman carrying a pyx, the vessel containing the Host, and specifically used to carry it to the sick or bedridden. This motif appeared in earlier Florentine representations of the subject, including the relief by Andrea Pisano on the south doors of the Florentine Baptistry and in Giotto's fresco in the Peruzzi Chapel, Sta. Croce.

Cheney describes the pose of the infant as "influenced by Michelangelo's *Jonah* in the Sistine Ceiling."[24] Actually, the figure is a reflection of Jonah in reverse. Cheney attaches no significance to this quotation, but it is possible that the pose was intended to be recognized and to refer, as did Jonah, to the death and resurrection of Christ.[25] The pose is repeated in a

dimly seen nude figure slightly behind and to the left of St. Elizabeth. Although it is easy to take this figure for one of the group of *putti* surrounding the bed canopy, close examination reveals that the torso is heavily muscled, resembling Michelangelo's *ignudi* rather than the plump, immature form of a *putto*. Further, next to this figure is the socle with the inscription, similar to those upon which the Sistine *ignudi* sit. On this socle is a relief of a seated woman holding a book on her lap. Certainly she is a sibyl, and it is possible that the figures of Jonah, the *ignudo,* and the sibyl refer to the meaning as well as to the forms of the Sistine Ceiling and that they symbolize the prophecy of redemption, again an important and heavily stressed theme throughout the oratory.

The oddest element in the composition, and one that is very prominent, is the young girl accompanied by Zaccariah, who is offering two doves to St. Elizabeth. This motif is completely unprecedented in representations of this subject, but it appears in the drawing in the Victoria and Albert (fig. 19), which was mentioned above as a possible reflection of Salviati's first design for the fresco. In fact, the presence of the doves in the drawing provides a strong argument in support of such an identification, because the motif is so rare. The only other instances that I know of where this motif appears in a birth scene are two frescoes by Siciolante da Sermoneta, one in the Fugger Chapel, Sta. Maria dell'Anima, datable to the 1550s,[26] and the other in S. Tomaso dei Cenci of 1565. Siciolante's frescoes not only are dependent upon Peruzzi and Raphael, as has been noted by Freedberg,[27] but they appear to be heavily influenced by Salviati's frescoes in the oratory.[28]

The motif of the offering of the two doves, which is unprecedented for this subject and apparently invented for the oratory fresco, does appear frequently in representations of the *Presentation of Christ in the Temple*, where Joseph carries two turtle doves. This follows the biblical text, Luke 2: 22–24.

> And when the days of her purification according to the law of Moses were accomplished, they brought him to Jerusalem, to present him to the Lord; (As it is written in the law of the Lord, Every male that openeth the womb shall be called holy to the Lord;) And to offer a sacrifice according to that which is said in the law of the Lord, A pair of turtle doves or two young pigeons.

Thus the motif, in addition to suggesting a parallel with the life of Christ, should be interpreted as a reference to purification and even more explicitly to sacrifice, reinforcing the Baptism/Eucharist symbolism already present in the ritual of the bathing of the newborn babe.

In this connection it is worthwhile to look at Jacopino's project for the *Nativity,* as known through the Bonasone print (fig. 12). In Jacopino's

composition the figures are placed in a classical and severely geometric architectural setting, containing statues in niches, most of which are figures of prophets. Precisely identifiable by the horns is Moses; Abraham is also identifiable—in fact, the *Sacrifice of Isaac* is represented in the statue. This would indicate that the references to Mosaic law and the themes of purification and sacrifice were to have been included in the fresco from the beginning and reflect the wishes of the patrons. The sacrifice theme is reinforced in the simulated relief. Between Salviati's false window and narrow landscape painting and Jacopino's *Preaching of St. John the Baptist,* the base of the ficticious pilaster at the corner is decorated with a Dionysiac sacrifice scene (fig. 15). This portion of the decorative framework was painted by Jacopino, probably in 1538 when he executed the fresco of the *Preaching.*

Evidently the patrons preferred to wait for Salviati rather than charge Jacopino with the execution of the *Nativity.* If the drawing in the Victoria and Albert does indeed reflect Salviati's project, it would have been more in harmony with the adjacent *Visitation* than Jacopino's design. As finally executed, the overall composition is still a rhythmic grouping of figures as in the drawing and in the *Visitation* fresco, but the tempo of movement is slow and ponderous rather than animated. In the *Visitation* profiles, limbs, gestures, and movements were arranged parallel to the picture surface; in the *Nativity* this is again the case, but the figures are further compressed into almost a single plane. The darker and more somber coloring,[29] the heaviness of the figures, and their slow, turgid movements emphasize the symbolic over the narrative import of the fresco more than if Salviati had executed it in his style of the late 1530s.

Thus, the lack of a harmonious style that characterizes the program as a whole is apparent on this wall. In fact, the three frescoes serve as illustrations of three phases of Roman Maniera painting. Nevertheless, the three have in common the references to Florentine sources and iconographical tradition combined with motifs that do not appear in the Florentine sources and tradition but are borrowed from earlier sixteenth-century paintings in Rome, particularly those of Raphael and Michelangelo. These borrowings are at once hallmarks of Maniera and carefully chosen and repeated cues to reading the meaning of the frescoes with the context of the confraternity's mission.

5

The North Wall: Mission

On the north or entrance wall of the oratory the two frescoes of the *Preaching of St. John the Baptist* and the *Baptism of Christ,* flank a statue of St. John the Baptist[1] in a shallow niche. The niche is painted to simulate an elaborate *aedicula* with Ionic columns of porphyry supporting a pediment surmounted by two *putti* holding the Florentine lily and garlands of fruit (fig. 36). Below the statue is a ficticious socle with two volutes under the columns and a tablet held by two winged, serpent-tailed female figures. On the tablet is the inscription, "Vox clamantis in deserto: parate viam Domini." This inscription is taken from the Gospel texts in which all four evangelists cited the Prophet Isaiah, and it states the theme of the entrance wall—the mission of St. John the Baptist as preacher of repentance of sins and purification by baptism.

The Preaching of St. John the Baptist (fig. 22)

After Salviati's *Visitation*, Jacopino's *Preaching of St. John the Baptist* is the oratory fresco which most exemplifies high Maniera. Jacopino's change of style, the abandonment of the post-Raphaelesque classicism of the *Annunciation to Zaccariah*, may have been due as much to rivalry with Salviati as to the presence in Rome of Perino del Vaga. Whatever the precise nature of the *concorrenza* described by Vasari, Salviati had thrown down the gauntlet with the painting of the *Visitation* which, as was no doubt apparent to Jacopino and to the patrons as well, made the *Annunciation to Zaccariah* look old-fashioned.

As was mentioned in the discussion above, there is no agreement among scholars as to whether this rivalry led Jacopino to seek Perino's assistance or whether the commission was first given to Perino, who then provided a drawing for the patrons (fig. 23), with Jacopino later called in to execute Perino's composition. In any case, the important point here is that just as Salviati had done earlier during the same year, Jacopino

achieved with the painting of the *Preaching* a "landmark of high Maniera accomplishment"[2] in Rome prior to any such accomplishment by Perino.

In the *Preaching*, in fact, Jacopino went beyond Salviati himself in anticipating the style of the Sala dell'Udienza frescoes. As in Salviati's *Triumph of Camillus* of 1543–45, the figure composition of Jacopino's *Preaching* is a compressed, overlapping relieflike group that appears to be encrusted on the surface of the wall and in front of, rather than within, an atmospheric landscape setting with hills, trees, and antique buildings. Both paintings recall Giulio Romano's frescoes in the Sala di Costantino, particularly the *Vision of Constantine*. The resemblance to Giulio is more apparent in Salviati's fresco because of the similar archaeological quality and obvious derivations from Roman relief which are not present in Jacopino's *Preaching*. However, in the landscape Jacopino, like Giulio, combined reference to ancient Rome with reference to contemporary Christian Rome.[3] Also Jacopino's figures have a heavy sculptural quality similar to that of Giulio's figures and are less elegant and animated than Salviati's or the figures in Perino's drawing. Jacopino fell short of Salviati and Perino in the ability to use line to make figures believable, to energize them, and to shape them into ornament all at the same time. Nevertheless, the overall design of the *Preaching*—the complex weaving together of the figures, the inclusion of precise description of nature in parts and surface details within the artificiality of the total structure, and the hard, almost metallic, relief quality of the figure composition—does indeed anticipate Salviati's frescoes in the Sala dell'Udienza more than any of Salviati's, or anyone else's, previous work.

There are fewer references to Jacopino's Florentine background than in the *Annunciation to Zaccariah*, though again the iconography is within the Florentine tradition. As in Andrea del Sarto's Scalzo fresco and Ghirlandaio's in Sta. Maria Novella, in Jacopino's composition the central figure of St. John the Baptist is standing on a mound that raises him above the surrounding group of seated and standing male and female figures. Jacopino's fresco resembles Andrea's precedent more than Ghirlandaio's, and, as noted by Freedberg,[4] Jacopino has made reminiscences of Sarto that were already present in Perino's drawing more explicit. This is particularly true of the setting, a landscape with less architecture than in Perino's drawing, and of the relationship of the figures to space.

Also, a motif referring to Florentine tradition, though it is not usually connected with this subject, appears in the pair of female figures entering the picture from the upper left carrying vessels (one of them an amphora on her head). These two figures are in a space where there are no discernible figures in the Perino drawing but where the figure of Christ appears in

both Andrea's and Ghirlandaio's frescoes. The presence of Christ in the background of the *Preaching* anticipates the next episode in the biblical text — and in the fresco cycles — the *Baptism of Christ*. Jacopino's substitution for the figure of Christ of the two women carrying vessels for wine and water again emphasizes the symbolic connection between the Sacraments of Baptism and the Eucharist.

It is significant that this motif, which is a departure from the traditional iconography for the subject, and other such departures in the fresco do not appear in the drawing. Whether this is because, as Hirst suggests,[5] Perino made the drawing for his Pisa Cathedral project and later gave it to Jacopino to use for the oratory fresco or because these departures represent a second stage of the oratory project, they were most likely made at the request of the patrons. All of the additions express meanings that are consistent with the program as a whole, and this is not the only example of such changes between drawing and finished painting in the oratory. A similar situation exists in the case of the altarpiece; several motifs appear in the painting that are not in the drawing and were again probably added at the request of the patrons.[6]

In addition to the women with the water and wine vessels, the changes include: the mother and children in the left foreground;[7] three contemporary figures, two on the extreme left and one directly to the left of St. John, which are presumably portraits of the members of the confraternity who commissioned the fresco; the bare and leafy trees flanking St. John; and most striking of all, the two bearded, turbaned men seated at either side in the foreground and holding large, open books. Though these two figures do not appear in this form in Perino's drawing of the *Preaching*, they are derived from him. As has been pointed out,[8] these two figures are based on Perino's evangelists in the Cappella del Crocefisso, S. Marcello al Corso. This project, begun prior to the Sack of Rome, was resumed after Perino's return from Genoa and Pisa and finally completed in the early 1540s by Daniele da Volterra. A new contract was signed in April of 1539, but Perino's drawings from the evangelists must have been available to Jacopino prior to that time.[9] The two turbaned figures in Jacopino's fresco are explicitly based upon Perino's drawings from St. Matthew and St. Luke (figs. 37, 38) which themselves were derived from Michelangelo's prophets on the Sistine Ceiling.[10]

The presence of these two figures in the *Preaching* and their derivation from Perino's evangelists rather than directly from Michelangelo's prophets suggest that they are intended to represent evangelists rather than prophets and refer specifically to the Evangelists Matthew and Luke and their texts. All four Gospels mention the Baptist's preaching and include

the citation from Isaiah of "a voice crying in the wilderness," but it is Matthew and Luke, and particularly the latter, who included the most lengthy and detailed description of this event. This interpretation is strengthened by the presence of the old man next to Luke who is pointing, as is Luke, to the text with one hand and with the other hand to the figure of the Baptist.

The bare and leafy trees traditionally refer to the Tree of Knowledge of Good and Evil and the Tree of Life in the Garden of Eden and thus to the original sin and redemption. Perhaps here they also refer to St. John's statement during his sermon on repentance and charity just before Christ appeared to be baptized, "Already the axe is laid to the roots of the trees; and every tree that fails to produce good fruit is cut down and thrown on the fire," (Matthew 3: 10 and Luke 3: 9).

The message of the fresco, the importance of St. John the Baptist's preaching of charity and repentance of sins and the impact his sermons had upon the people, would have provided a crucial example for the confraternity's mission of charity and its exhortations to condemned prisoners to repent their sins. In addition, I believe the fresco has significance within the larger context of the contemporary Roman Church, in which the role of preaching was being increasingly emphasized by the new forces of the Catholic Reformation.

In connection with an attempt to identify one of the portraits in this fresco as that of St. Ignatius Loyola, Josephine von Henneberg[11] suggests that reference was being made to the public, outdoor preaching of St. Ignatius and the Jesuits which had begun in Rome in the spring of 1538.[12] Her identification of the portrait is not convincing. However, her point about the significance of the preaching of St. Ignatius is important. Under his leadership the practice spread to other orders, and preaching became part of regular religious practice, rather than being restricted to Advent and Lent. This new emphasis on preaching led to a change in church design and the creation of an independent nave to be used as an audience hall for regular preaching.[13]

As discussed by Lewine,[14] the Church of S. Giovanni Decollato was an early, perhaps the first, example of this new type of plan. This fact and the unusual iconography of Jacopino's fresco can be interpreted as expressing the concern of the patrons for the new role of preaching within the Catholic Church. This is also expressed by the style of the fresco. In spite of the artificial quality created by the ornamental design, as in the *Visitation*, the decorativeness injects a note of excitement to the composition, suggesting an important public event. The compression of the figure composition enhances the sense of rapt attention expressed in the crowd by the number of profiles and upward glances directed toward the central figure of the Baptist.

The Baptism of Christ (fig. 24)

With the painting of the *Baptism of Christ* in 1541, the year of the unveiling of Michelangelo's *Last Judgment*, Jacopino entered a new phase of Roman painting. In fact, this fresco serves as an illustration of the problem facing artists who worked in Rome during the 1540s, noted by Davidson[15] and described by Cheney[16] as the problem of "absorbing the diverse influences of Perino and Michelangelo, of merging the decorative and the expressive, the monumental and the ornate."

Whereas in Salviati's *Visitation* and Jacopino's *Preaching*, the references to Michelangelo's Sistine Ceiling were absorbed into the complex and ornamental vocabulary of high Maniera, in the *Baptism* there is an awkward dichotomy between the tendency towards Maniera *grazia* and Michelangelesque monumentality. The concern for ornamental form remains in the postures of the figures; Christ, though massive, stands in a gracefully swaying posture, and St. John the Baptist, with his swinging, forward-striding movement and billowing drapery, is almost a paraphrase of the *Canephore* in Salviati's *Visitation*. However, in contrast with the animation and excitement and the dense and complex pattern made of the figure group in the *Preaching*, in the *Baptism* the composition is quieter, more sober, and simpler with an emphasis on the expressive value of single figures. This is especially true of the three foreground figures of the Baptist, Christ, and the river god which dominate the composition—still in front of, but now silhouetted against, the atmospheric landscape background. The secondary figures have also gained importance as individual forms, and as a result the quotations from Michelangelo stand out more obviously than before, almost approaching what appears in the next fresco by Battista Franco.

In this fresco, however, these quotations still appear within the context of a composition that reflects Perino del Vaga. In fact, it is possible that Jacopino had access to a Perino drawing for this subject as well as for the *Preaching*. The composition is similar to an engraving by Francesco Rosaspina (fig. 39) which Popham[17] suggests reflects a lost drawing by Perino for his Pisa Duomo project. In both compositions St. John the Baptist is on the left rather than, as is more frequent, on the right. Also, both include other figures dressing and undressing in the background, an elaborate heavenly apparition, and perhaps most significantly, the unusual motif of a river god with a large jar.

Popham convincingly relates the print to Perino's drawing in the Albertina which combines the designs for the Pisa Duomo project with a sketch after Michelangelo's *Cascina* cartoon, and it may be that the group of men dressing in the right middle ground came via Perino rather than

directly from Michelangelo. However, the fact remains that the Michelangelesque quotation, particularly of the man pulling on his stocking,[18] is obvious. Next to him is a woman suckling a child (*Caritas* perhaps) who is a combination of various Michelangelo Madonnas (particularly the Doni and the Medici Madonnas); in the sky hovers a group from the Sistine *Creation of Man* — God with billowing draperies and *putti*. Most striking is the river god in the foreground, however. And though this motif appears in the Rosapina engraving, Jacopino's figure is based on Michelangelo's models for the river gods planned for the Medici Chapel (fig. 40) and perhaps also refers to motifs in some of the Cavalieri drawings — for example, the *Fall of Phaeton*.

None of these quotations is out of place in the context of the subject matter. According to the text (Luke 3: 21–22) the Baptism of Christ took place "during a general Baptism of the people," and it was not unusual for partially dressed figures to be included in Florentine representations of the subject. They are not included in Andrea del Sarto's Scalzo fresco, which is the simplest possible image of the *Baptism* and contains only the figures of Christ, St. John, and two angels, but Ghirlandaio included them in his *Baptism* in Sta. Maria Novella. He also included a half-length figure of God surrounded by angels.

Jacopino's inclusion of the image of God in the form of a quotation from Michelangelo's *Creation of Man*, in addition to being a tribute to that artist, may reflect the traditional typological relationship between the first creation and the Baptism as re-creation. In early Christian sepulchral art the *Baptism* was often depicted next to Adam and Eve.[19] However, more common and of more recent tradition was the parallelism between the *Baptism* and the *Crucifixion*.[20] Christ himself referred to his passion as a baptism (Luke 12: 50) and Paul (Romans 6: 4–12) in terms more relevant to this context and to the mission of the confraternity relates baptism to the death and resurrection of Christ and to the redemption of man. The drooping head of Jacopino's Christ here suggests the image of the dead Christ (in the *Crucifixion* of the *Pietà*) while the muscular body, the hairstyle, and the facial type with its sharp, classical profile, resemble Michelangelo's *Risen Christ* of Sta. Maria sopra Minerva. Another reference to this theme is Christ's pose with his arms folded across his chest in the form of a cross. This pose is a departure from traditional representations of the *Baptism*[21] but appears in Michelangelo's finished drawing of the *Resurrection*,[22] and I believe it is intended here to reinforce the reference to the Passion.

The inclusion of the river god is the only other striking departure from traditional Florentine iconography for the subject. This figure, which was also included in the Rosaspina engraving, was a part of the early Christian

and Byzantine iconography for the subject, prior to the introduction of angels in the representation of the *Baptism*. The motif still appeared occasionally during the later Middle Ages, for example in a stone relief of the *Baptism* on the facade of Sta. Maria della Pieve, Arezzo, dated 1221.[23].

The landscape here, as in the *Preaching*, is a view of Rome. Thus, the figure of the river god stands not only for the River Jordan but also the Tiber, and reference is again being made to the setting of the activities of the confraternity of S. Giovanni Decollato.[24] In this connection it may be significant that among the statues of antique river gods to be seen in Rome were a pair on the Campidoglio (fig. 41). The Campidoglio was not only located near the Church and Oratory of S. Giovanni Decollato but was also the location of one of the prisons visited by the confraternity members.

One remaining feature of the composition is unusual, though not unprecedented, and that is the reversal of the position of St. John the Baptist from the right side, where he normally appears, to the left of the composition. It is apparent that Jacopino placed St. John on the left in order to close the composition off at the corner of the room with the figure of the river god. The mother and child group on the left of the *Preaching* closes off that corner in a similar manner. Thus, in spite of the difference in style, Jacopino caused the two frescoes to balance and complement one another: each composition is dominated by a central standing figure, and each is completed at the corner of the room with a seated figure, and on the other side each contains a standing figure pointing or gesturing toward the central figure.

Because of these correspondences and because the decorative framework for the entire wall was done by one hand, Jacopino's, and probably all at the same time, the entrance wall is more harmonious in style than any other wall in the oratory.

At the same time, the difference in style of the two frescoes remains apparent and striking. This difference, in addition to the art-historical significance discussed above, serves to convey the difference in religious content and significance of the two subjects as they were represented: one the compelling preaching of the repentance of sins, the other the solemn ritual of purification by water; one a sermon, the other a Sacrament — Baptism and, implicitly, the Eucharist.

6

The East Wall: Martyrdom

The east wall of the oratory, facing the street, is decorated with the three frescoes of the *Arrest of St. John the Baptist,* the *Dance of Salome*, and the *Decollation of St. John the Baptist*. The history of the martyrdom of the Baptist, serves to emphasize St. John's role as precursor to Christ's sacrifice.[1] And on this wall, the message is stressed more than ever by the selection of episodes as well as the manner in which they are depicted. The *Dance of Salome* or *Feast of Herod* is almost always included in cycles of the life of St. John the Baptist, but the *Arrest* and *Decollation*, as was mentioned above, though included in Andrea del Sarto's extensive cycle in the Scalzo, were not represented in Ghirlandaio's shorter cycle in Sta. Maria Novella. The *Arrest*, in particular, was rarely depicted in cycles with as few episodes as those in Sta. Maria Novella or the Oratory of St. Giovanni Decollato. Thus, the inclusion of these two subjects among the frescoes in the oratory attests to their significance in the program, and they are, indeed, the episodes from the Baptist's life with the most relevance to the contemporary mission of the confraternity.

In all of the frescoes on this wall the departures from Florentine tradition are more striking than in any of the previous frescoes. In fact, the contrast serves to emphasize how much the frescoes of the first two walls, in spite of the stylistic and iconographic innovations, do still relate to Florentine precedents. The east wall presents a totally different aspect which may be due in part to the fact that at least two of the frescoes were painted by non-Florentines. However, when viewed in the context of their function as decorations of an oratory in which men devoted to comforting condemned prisoners held meetings and conducted religious services, the stylistic transformations and departures from traditional Florentine iconography in the representations of these subjects become meaningful.

The Arrest of St. John the Baptist (fig. 25)

Vasari[2] discussed the *Arrest of St. John the Baptist* by Battista Franco at greater length than any other painting in the oratory, but his comments are

mostly negative. It is important to realize that this is not just another example of Vasari's Tuscan chauvinism at work in the assessment of a Venetian painter. His criticism that the painting was too labored, that there was too much attention to parts and details and too little to the ordering of the composition as a whole, and particularly his admonition that "nel servirsi delle cose d'altri si dee fare per si fatta maniera, che non si conosca cosi agevolmente," anticipates later criticism of Mannerist painting, as though predicting that paintings like Franco's would eventually give his whole generation a bad name. Recent criticism of the fresco has, in fact, borne out Vasari's judgement. For example, Rearick[3] characterized the fresco as illustrating "Franco's most repulsive efforts to mime his early idol, Michelangelo," and added that the borrowed forms "serve no apparent function other than onlookers at the drama, which is pushed into the distance and obscured to such a degree that the subject is at first glance, lost in a confusion of irrelevant activity." More recently, Freedberg[4] has written that

> Franco abstains, apparently deliberately, from any action of invention and takes it as a matter of principle that art can be made by compilation — regardless of thematic relevance — of forms and motifs aped respectfully from Michelangelo's repertory.[4]

Certainly the inclusion of easily recognized quotations from Michelangelo is the hallmark of Battista Franco's style, and most frequently these quotations seem to have no meaningful connection to the subject matter being represented. In the case of the *Arrest of St. John the Baptist,* there is no precedent in Florentine tradition for the inclusion of so many extra figures, and if one compares Franco's composition to that of Andrea's Scalzo fresco of the *Arrest*, it appears to be filled with extra and irrelevant figures at the expense of the clarity of the narrative. However, Andrea's *Arrest* is among the most rigorous demonstrations of his commitment to the High Renaissance classical style, comparable in principle to Raphael's accomplishment in the *Tapestry* cartoons,[5] while Franco had no such commitment. Further, Andrea was illustrating only one event of the narrative, the arrest of St. John the Baptist by Herod, while Franco combined the *Arrest* with the *Baptism of the People*.[6] The latter episode is depicted in the Scalzo in a separate fresco preceding the *Arrest*, and Franco's combination of the two episodes is unprecedented, as far as I know. However, by depicting the *Arrest* — the beginning of St. John's martyrdom — within the context of the general baptism of the people, Franco repeated the connection between baptism and the Passion expressed in the preceding fresco of the *Baptism of Christ,* and he reinforced the symbolic connection between the Sacraments of Baptism and the Eucharist which is stressed throughout the fresco

cycle.[7] Thus, the inclusion of extra figures in the fresco is justified and meaningful and probably reflects the wishes of the patrons.

The obvious quotations from Michelangelo among the individual figures can be explained in a similar way. As I have been stressing, quotations from other artists' works appear throughout the cycle and convey meaning through association with their sources and original contexts.

In the *Arrest*, as was noted by Rearick[8] and later by Keller[9] and Partridge,[10] the seated female figures in the left and right foreground are based on Michelangelo's sibyls from the Sistine Ceiling. This obvious reference to the sibyls who prophesied the coming of the Redeemer is, of course, the continuation of a theme that had appeared in previous frescoes. Also, it is important that the older of the two women at the left is not derived from Michelangelo's sibyls[11] but from the old woman in Jacopino's *Annunciation to Zaccariah*. Franco's quotation supports the identification of Jacopino's figure as a prophetess.

The quotation that is most blatant, distracting, and characteristic of Franco is the figure of the reclining male nude dominating the foreground—if not the entire picture. Traditionally, this figure has been associated with Michelangelo's *Venus* cartoon.[12] The visual link is convincing; the cartoon was also being copied by artists during Franco's Florentine sojourn. Franco himself made a copy of the *Noli Me Tangere*[13] and it is possible that he copied the *Venus* as well. However, due to Michelangelo's own predilection for self-quotation, the figure resembles not only the *Venus* but Michelangelo's river gods. As was first noted by Popp,[14] the pose of Venus is based on the river gods planned for the Medici Chapel (fig. 40). Rearick[15] later suggested the river gods as the source for Franco's figure. And more recently Partridge[16] has related Franco's nude to the Adam from the Sistine Ceiling.

Whereas reference to the Venus alone would be meaningless in the context of this fresco, as a double indicator to the Sistine Adam and to the river gods, the figure can be understood to function on two levels. First, as noted by Partridge, as a quotation of the Sistine Adam, "the figure suggests the fulfillment of prophecy, i.e., Christ, the second Adam."[17] Therefore, placed in the context of the *Baptism of the People,* the figure can be interpreted as referring to the typological relationship between the first creation and baptism as re-creation. This was already suggested in the preceding fresco of the *Baptism of Christ* by the inclusion of the figure of God derived from the Sistine *Creation of Man*.

On a second level of meaning, as a quotation of the Medici Chapel river gods, the figure can be identified as a river god. This identification is supported by his placement in the picture. Like the river god in the *Baptism of Christ*, the figure is actually lying in the water of the river.

The other figures are distributed along the banks of the river which consist of a series of ledges on different levels, leading up to the highest point. There, in the center, St. John is being dragged by his captors toward a rusticated building on the left, which is cut off by the frame at the top and by the left edge of the picture. In the background on the far right is an atmospheric landscape with Roman ruins. As in the *Preaching* and the *Baptism*, the character of the landscape suggests that the setting is Rome and the river is intended to represent the Tiber as well as the Jordan. There are no modern church buildings in the background, as there are in the *Preaching,* to suggest contemporary Christian Rome. However, the building of the prison can be read as a reference to contemporary Rome and explicitly to the Tor di Nona, the prison in which the *fratelli* of S. Giovanni Decollato most frequently comforted condemned prisoners: the shape of the building and the manner in which it is cut off suggests the structure of a tower,[18] and its placement just above the river bank suggests the location of the Tor di Nona in what is today the Lungotevere Tor di Nona. Paintings and prints of the banks of the Tiber in this area made prior to the construction of the modern embankments show a very similar topography (figs. 42, 43).[19]

A very pointed reference was then made in this fresco to the locality of the contemporary activities of the patrons. Thus, the suggested parallel between the fates of the *giustiziati* and that of St. John the Baptist (as well as, implicitly, that of Christ) serves as a visual reinforcement of the written instructions to the *confortatori* to remind the prisoners of the martyrdoms of St. John the Baptist and Christ, both verbally and by holding before their eyes the painted images of the *Decollation of St. John the Baptist* and the *Crucifixion.*

As was noted by Rearick,[20] Franco makes no reference to Michelangelo's *Last Judgment* except for the "gloomy, grey-green colour." This fact led Rearick to suggest that the design must have been prepared prior to the unveiling of the *Last Judgment.* However, this is unlikely and probably Franco turned to the Sistine Ceiling rather than the *Last Judgment* as a source because it provided meaningful motifs.[21]

Franco's borrowings from the Sistine Ceiling frescoes seem to be primarily from the area occupied by the Noah episodes. The seated woman on the left relates most closely to the Erithrean sibyl flanking the *Sacrifice of Noah*, while the seated woman on the right relates most closely to the Delphic sibyl flanking the *Drunkenness of Noah*. Several of the other figures are derived from the narrative panels: for example, the man on the right carrying the sheep is taken from a figure carrying a bundle in the *Deluge,* and the couple—a man and woman, nude, with outstretched arms—seated on the left reflect other figures in the *Deluge*; the sheep sug-

gests a sacrificial animal as in the *Sacrifice of Noah*; and the pointing woman behind the sibyl on the right reflects the figures pointing at Noah in the *Drunkenness of Noah*. In addition to the individual motifs, the overall structure of the composition, in which separate groups of active and gesticulating figures disposed at different levels in the fore and middle ground build up to and encircle the upper center group of St. John and his captors, resembles the grouping of figures and the relationship of groups to the ark in the *Deluge*.

These similarities are neither accidental nor meaningless. There was a long tradition for interpreting the Deluge as a symbol of salvation by water, and, thus, as a typology of the Christian Sacrament of Baptism, with a reference also to the Passion. St. Augustine wrote,

> What does it signify that Noah is saved through water and wood? The water signifies Baptism, and the wood signifies the Cross. As Noah is liberated through water and wood, so the Church is made safe through Baptism and the seal of the passion of Christ.[22]

As discussed by Wind,[23] Michelangelo was certainly aware of this tradition and further stressed the prophecy of the Passion contained in the Noah scenes by placing the Delphic sibyl, who foretold the coming of a saviour who would be crowned with thorns, next to the *Derision of Noah* as a "prophetic image, foreshadowing the Derision of Christ."[24] And the Erithrean sibyl was placed next to the *Sacrifice of Noah* to refer to the traditional belief that she was one of the daughters-in-law of Noah and thus to her traditional association with the history of the Deluge.[25]

The quotations from Michelangelo's Noah scenes in the *Arrest* were intended to carry the same meanings with them and thus serve to emphasize the role of St. John the Baptist, Prophet and Precursor, in the preordained plan for man's redemption. Franco's stylistic hallmark, his imitation of Michelangelo, was in this case admirably suited to the needs of the patrons and for expressing the ideas of the program. That the visual results disappointed the patrons as much as they have displeased later critics is suggested by the fact that Franco was not further employed in the oratory.

The Dance of Salome (fig. 26)

If Battista Franco's *Arrest of St. John the Baptist* is the least attractive fresco in the oratory, Pirro Ligorio's *Dance of Salome* is the most bizarre. This fresco, the only extant painting of Ligorio's Roman period,[26] is difficult to categorize in the context of Roman Mannerist painting. The frescoes of the other two walls could serve as textbook illustrations of different phases of Maniera, and Franco's fresco is an example — an extreme one — of

Mannerist imitation of Michelangelo. Partridge[27] refers to the style of
Ligorio's painting as Counter-Maniera. However, he does not explain his
use of the term, and the painting does not reflect that style as characterized
by Freedberg.[28] Freedberg, in discussing the *Dance of Salome,* said, "By this
time an archaeologist and architect more than a painter, Ligorio in this
fresco demonstrates a set of special interests that are not informative for
the situation of painting in Rome about the middle of the century."[29] How-
ever, there is a counterpart to Ligorio among midcentury Roman painters
in the person of Taddeo Zuccaro. Ligorio and Zuccaro combine the vari-
ous ingredients of Maniera, including reference to the Raphael School and
the antique, into something that is not the Maniera of Perino, Salviati, nor
even of Jacopino del Conte, but is not Counter-Maniera either. Both
artists painted facade decorations in Rome at midcentury, and the similar-
ity of some of their drawings[30] suggests that their facade paintings, which
are no longer extant, might also have been similar.

Ligorio represents the culmination of the learned archaeology prac-
ticed earlier in Rome by Peruzzi, Giulio Romano, and Polidoro da Cara-
vaggio, and revived at midcentury by Girolamo da Carpi, Taddeo Zuccaro,
and Ligorio himself. In fact, Ligorio's fresco in the Oratory of S. Giovanni
Decollato provides us with an idea of the appearance of his lost facade
paintings in the same way that the simulated reliefs of the decorative
framework provide us with an idea of the appearance of the ephemeral
decorations of the period, for example, for the triumphal entry of Charles
V into Rome in 1536.

Actually, the *Dance of Salome* is closer in style to the simulated reliefs
than to the style of any of the narrative frescoes. The setting, a huge *exedra*
with colossal porphyry columns, smaller twisted columns, relief panels,
statues in niches, and free-standing statues, is more consistently antiquar-
ian than the settings of any of the previously executed frescoes. The simu-
lated sculpture in the fresco is similar in style and derivation to the simu-
lated sculpture of the decorative framework throughout the oratory. Fur-
ther, with a few exceptions, to be discussed below, the figure style of this
simulated sculpture is carried over into the figures of the narrative itself.
Even the palette, though not *grisaille,* is so dominated by the greyed tones
of the architecture and sculpture and the pale rose of the floor tile that the
colors of the draperies, pale and *changeant* in tones of green, red, and
gold, suggest colored marble.

The composition of the *Dance of Salome* makes a *pendant* to Salviati's
Visitation on the west wall, directly opposite Ligorio's fresco. Though the
antique architecture of Ligorio's setting is more archaeological than Salvi-
ati's Renaissance-Antique stage set, it also suggests a theatrical scene.
Ligorio, like Salviati, included steps leading into the scene from the

viewer's space, and a space between the "stage" and the viewer's space occupied by men in contemporary dress. As in Salviati's *Visitation*, these men are certainly portraits of the patrons.[31] Entering the scene from the left is a woman carrying an enormous basket of fruit on her head, a counterpart to Salviati's *Canephore,* and on the right, as a parallel to Salviati's *Caritas* group, is a seated woman with three children.

However, none of the figures function in the same manner as their counterparts in the *Visitation*, where the portrait figures and the *Canephore* point and direct our attention to the protagonists of the drama. And, along with the *Caritas* group, the *Canephore* is also part of the scene. Though one of Ligorio's portrait figures is looking at the viewer, the other two look at each other, and none show any awareness of the event being enacted behind them. The female figures, though looking toward the protagonists, are not part of the scene as in Salviati's fresco, but are explicitly separated by their placement on or next to the steps in front of the stage, and their separation is emphasized by their gigantic size, roughly twice that of Salome. The difference in size is not justified by the spatial location, and they are also twice as large as the portrait figures. It is interesting that the only one of these figures that appears in the preliminary drawing (fig. 46)[32] is the *Canephore*. There, however, she is far less prominent, her size less exaggerated, and she relates more to the other figures in the narrative. Also, in the drawing she carries a bundle on her head similar to that of Salviati's *Canephore,* rather than the basket of fruit.

The changes between the drawing and the fresco were probably made at the instructions of the patrons, who also had their portraits inserted, in order to continue some of the significant motifs of the previous frescoes. However, Ligorio did not integrate these figures into his composition as successfully as Salviati, Jacopino, or even Battista Franco. As a result the figures stand out obviously as symbolic figures more than in any of the other paintings in the oratory.

The woman seated in the foreground on the far right should be identified as a sibyl. Though the presence of the children suggests a perhaps intentional connection with the *Caritas* motif, her pose and lack of involvement with the children argue against this interpretation.[33] As pointed out by Coffin,[34] this figure bears a very strong resemblance to the statue of the Tiburtine sibyl, executed later by Ligorio for the Villa d'Este; and further, the children next to her also resemble the one child included in the statue. That Ligorio's sibyl is based on a Roman statue of a seated matron[35] rather than on Michelangelo's sibyls is not surprising in view of Ligorio's antiquarian tendencies. However, the presence of the extra children in the painting might be a reference to the "genii" accompanying the Sistine Ceiling sibyls. And it is the children, of whom one points to Salome while

another holds a tambourine like hers, that connect the group to the narrative.

The extra prominence given to the *Canephore* in the painting emphasizes the continuation of a motif that had appeared in previous frescoes, particularly in the *Visitation*, where the figure is in an analagous position. Another motif continued from the previous frescoes is reference to the Sacrament; several bunches of grapes are included among the fruit in the basket on the *Canephore's* head, and a woman carrying a wine or water jug is entering through a doorway in the rear. In spite of her location and small size, this figure is given prominence by the strong color of the jug.[36]

In Ligorio's fresco, the subject itself is represented according to a fairly standard iconography: Salome is dancing before Herod, who is seated with Herodias at a table in a large hall with many other figures, including musicians and servants. The figure of Salome, however, is unusual. In the rubbery plasticity and stocky proportions of her body and the heaviness and prominent features of her face, she is more similar to the *Canephore* and sibyl in the foreground than to any of the other figures in the narrative. Also, her body is twisted into the extreme torsion of a double *contrapposto*.[37] In fact her pose, along with the tambourine she is holding, makes her resemble a Maenad from an antique relief. This is not surprising in a work by Ligorio, of course, but it is particularly interesting that the probable source of the motif was a Roman Dionysiac sarcophagus.[38]

As mentioned above, Roman Dionysiac sarcophagi served as the sources for motifs used in the decorative framework throughout the oratory.[39] The association between the Dionysiac mysteries, with their connotations of life achieved through death, and the death and resurrection of Christ and thus the redemption of man, has special implications here for the *giustiziati*.[40] This association, suggested throughout the oratory by the motifs of the decorative framework, seems to have been made explicit here by the depiction of Salome in the guise of a Maenad.[41]

Ligorio's archaeological style provided an admirable vehicle for this message and at the same time, though less relevant to the study of Maniera painting at midcentury than the styles of the other frescoes, it is an example of modern Roman decorative style which was fully developed by Ligorio in his later projects, such as the Villa d'Este and the Casino of Pius IV.

The Decollation of St. John the Baptist (fig. 30)

The archaeological quality that characterizes the *Dance of Salome* appears also, though to a lesser degree, in the *Decollation of St. John the Baptist*. This was the last fresco, perhaps the last painting, to be completed in the

oratory. It is not mentioned in the early sources, neither by Vasari nor Baglione, and the artist is unknown. It has, in this century, been variously attributed to Salviati, to Salviati with execution by a pupil, to Salviati with Ligorio's architectural setting, to Ligorio entirely, and most recently to Roviale Spagnuolo.[42]

The execution is quite crude, and it seems likely that the fresco is a pastiche thrown hastily together, possibly from designs left by both Salviati and Ligorio, in order to finish the decoration of the oratory in 1553.

The architectural setting is based on the tragic scene design published by Serlio in 1545 (fig. 47). Like Serlio's scene, the setting of the fresco combines antique and Renaissance structures, but it is more archaeological and richly decorated with sculpture than Serlio's design and thus more similar to Ligorio's setting for the *Dance of Salome*. The theatrical quality of the setting is enhanced by its serving as a backdrop for a figure composition that is separate rather than integrated with it.

The figures are compressed within a narrow foreground space, and their poses and gestures link them together creating a rhythmic pattern across the surface. This type of composition refers to Salviati's style of ca. 1550 as seen in the *Nativity of the Baptist* in the oratory and, particularly, in the Cappella del Palio frescoes of the *Martyrdom of St. Lawrence* (fig. 48) and the *Decollation of St. John the Baptist* (fig. 31). The latter seems to have provided the model for the overall composition, which is also full of motifs and figures taken from other works by Salviati.[43] Salviati probably provided designs for the fresco during the period of 1550 through 1551 while he was working on the *Nativity* and the Apostles.

In any case, by the time the fresco was executed, both Ligorio and Salviati were involved with major commissions elsewhere. The unknown executant may indeed have been a pupil or assistant of Salviati's, but I think Keller's arguments for attributing the fresco to Roviale Spagnuolo are unconvincing.[44] The crude execution and the inept drawing of the figures suggest a weaker artist than Roviale.[45]

The style and iconography are closer to Salviati's fresco in the Cappella del Palio than to previous representations of the subject in Florence or to Vasari's contemporary altarpiece in the Church of S. Giovanni Decollato (fig. 49). There is, however, a striking difference in the moment of action chosen for depiction. In the Cappella del Palio fresco, as also in Vasari's altarpiece and Sarto's Scalzo fresco, the executioner is placing the severed head of St. John the Baptist onto the platter held by Salome. In the oratory fresco, Salome extends the empty platter toward the executioner, who is on the steps in the center just stooping down to grasp the head. As first noted by Cheney,[46] the executioner is a quotation of the figure holding a rosary and pulling two of the blessed toward paradise in Michelangelo's

Last Judgment (fig. 50). As Leo Steinberg said, "The gentlest of Michelangelo's merciful figures, the one drawing two supplicants up by the rosary, turns executioner, stooping to pick up the severed head of St. John."[47] In another context Steinberg[48] stated that Salviati was not interested in the context of the motif but in using Michelangelo as a source of *scorci*. He also identified the pose of St. John's body as a quotation of the Torso Belvedere and suggested, though granting that Salviati himself may not have had this in mind, that the relationship of the two motifs "celebrates a pattern of supercession: the triumph of painting over sculpture, of the moderns over the ancients, of Michelangelo over antiquity."

This is an ingenious idea to which might be added the further concepts of the triumph of Christianity over paganism; and, within the contemporary context of midsixteenth-century Rome, a reference to the triumph of orthodoxy over heresy could even be suggested. However, the identification of the figure of St. John the Baptist as a quotation of the Torso Belvedere, or, as believed by David Summers,[49] the Discobolus, depends upon a misreading of the visual form. Though in a black and white photograph the corpse might appear as a truncated torso with arms and legs chopped off, in the original fresco it does not. Neither does a reasonable color photograph give that impression; rather, what becomes evident is that the figure is lying with knees bent so that the lower legs are brought back beneath the body, and a portion of the right upper calf is visible in the space between the knees. The left arm is hidden underneath the chest, and the right arm disappears beneath the red sash of the figure to the left of the corpse. It is the combination of inept anatomical rendering and crude shadowing that makes the limbs appear to end in stumps, but in fact they are quite different in form and color from the actual stump of the neck from which issues a spurt of bright red blood. And the *contrapposto* pose, rather than quoting any specific antique statue, simply repeats the leitmotif of the composition which consists of a row of figures in *contrapposto* variously disposed across the foreground of the picture. It should be noted that due to the artist's difficulty with drawing figures, St. John the Baptist is not the only one whose limbs abruptly disappear and seem to be chopped off: for example, the two men in the far right foreground; the figure to the left of the corpse; and Salome, who appears at first glance to have only one arm.

Furthermore, I disagree with Steinberg's judgment that Salviati was not interested in the context of the motif from Michelangelo's *Last Judgment*. If Michelangelo were simply being used as a source of *scorci*, many other of his figures would have served as well. In fact, the pose of the figure chosen does not really lend itself to an efficient performance of the action depicted. It is more likely that this figure, whose pose is a striking

departure from tradition, was consciously chosen, intended to be recognized, associated with its source, and to convey meaning through the association. In the *Last Judgment* this figure is lifting the two supplicants to their salvation by the rosary; the rosary symbolizes the vehicle for their redemption — faith and prayer. In the oratory fresco the same figure (turned executioner) is lifting the severed head to emphasize the preordained role of St. John the Baptist in man's salvation; his martyrdom was the prototype for the death of Christ — the vehicle for man's redemption. Thus, the fresco is a visualization of the written instructions to the *confortatori* to exhort the *giustiziati* to think of the executions of St. John the Baptist and Christ and to be confident, as they themselves mounted the scaffold, that their sins would be forgiven and their souls received in paradise, "ricoperata col pretiosissimo sangue del Sig. N. Giesù Christo."[50]

And this is also the message of the altar wall.

7

The Altar Wall:
Salvation Through Death

Jacopino del Conte's altarpiece of the *Descent from the Cross* is the only panel painting in the oratory. It is flanked by Salviati's frescoes of the Apostles Andrew and Bartholomew (fig. 51). Consistent with the decoration of the other walls, the figures of the apostles are framed by a simulated architecture of pilasters decorated with grotesques, supporting a frieze of antique motifs and cartouches. In contrast to this the altarpiece is surrounded by a frescoed enframement painted to simulate a massive tabernacle. This fictitious structure, which projects illusionistically into the space of the oratory, consists of two huge red porphyry columns with gilded Corinthian capitals, standing on tall socles and supporting a heavy cornice with a frieze of gilded acanthus leaves. The wall behind the tabernacle is painted to simulate marble paneling which overlaps and almost completely obscures the fictitious pilasters at either side.

The visual effect of the overlapping and of the contrasting architectural styles depicted is unfortunate.[1] However, a partial explanation for this lack of unity may be found by examining the sequence of events as we now know them. It is most likely that Jacopino painted the decorative framework surrounding the apostles between 1538 and 1541 when he was painting the entrance wall, and that he simply left blank spaces between the pilasters to be filled in at a later date.[2] Though some scholars[3] have believed that Jacopino painted the altarpiece at this same time, that is, ca. 1540, the discovery that the altarpiece was not commissioned until 1551 indicates that the wall above the altar was also temporarily left empty. It is possible, in fact, that the subject matter of the altar wall might not even have been decided upon at the time the decorative framework was executed. But by 1550, when Salviati painted the apostles, the plan probably included some sort of image of the dead Christ over the altar, perhaps a devotional image with a large figure of Christ, which would have been not only appropriate but also necessary because of the gigantic size of the

apostles. When the altarpiece was finally painted as a narrative of the *Descent from the Cross*, the many relatively small figures in the composition must have been dwarfed by the seven-foot tall figures of Sts. Andrew and Bartholomew. It is likely therefore that the massive size of the tabernacle was intended to provide a sense of scale for the painting in order to prevent it from being eclipsed. It is also possible that the frame of the oratory's altarpiece was made larger and grander than originally planned in order to match the magnificent marble tabernacle in the Church of S. Giovanni Decollato, in which Vasari's alterpiece is mounted.[4]

In any case the result is that the altarpiece is the focal point of the oratory decorations. And although the paintings on the altar wall lack a harmonious formal relationship, they are united by their thematic relationship. The message is salvation through death. Just as the martyred apostles faced their executions, following in the path of Christ and believing that his sacrifice had ensured their life after death, so the *giustiziati* should face theirs.

The Apostles: St. Andrew and St. Bartholomew (figs. 27, 28)

The choice of St. Andrew as one of the apostles to be depicted has particular relevance to this theme. According the the *Golden Legend*,[5] St. Andrew embraced his martyrdom of crucifixion, rejoicing at the prospect of dying the same manner as Christ. In the context of the program as a whole, the inclusion of St. Andrew, who was a follower of St. John the Baptist before becoming Christ's disciple, emphasizes the Baptist's role of precursor. And the placement of the figure of St. Andrew between the fresco of the *Decollation of St. John the Baptist* and the altarpiece of the *Descent from the Cross* further stresses the significance of the martyrdom of St. John as prototype for Christ's Passion.

The reasons for selecting St. Bartholomew as the other apostle to be represented are not so obvious. According to some accounts of the lives of the Saints, Andrew and Bartholomew were companions,[6] and some of the legends of St. Bartholomew state that he was first crucified, taken down before he died, flayed, and finally beheaded. Thus he was subjected to the same tortures as Christ and the Baptist.[7] Hirst[8] suggests that St. Bartholomew was chosen because he was the name saint of the patron Bartolommeo Bussotti. All of these factors may have been considered.[9]

Whatever the reason for the specific choices made, the inclusion of apostles suffering execution, holding the instruments of their martyrdoms, and depicted gazing at the image of the Savior — just as the *giustiziati* were encouraged to gaze at the images held before them by the *confortatori* — served as a visualization of the confraternity's mandate.

The style of the figures reflects the dominant influence of Michelangelo at midcentury. This had appeared already in Salviati's work in the frescoes of the Cappella del Palio and the Margrave Chapel, particularly in the niche figures where the Michelangelesque proportions, *contrapposto* poses, and illusionistic projection of the figures and their attributes into the viewer's space forecast the apostles. However, in the oratory the breadth of the figures and their movement in and out of space is developed further, and these effects are enhanced by the apostles' not being confined in enclosed niches. They are placed between pilasters suggesting an open loggia framing a view of the sky.

Though other sources for the figures have been suggested,[10] their massiveness and slow, spiraling torsion reflect most of all the figures in Michelangelo's *Last Judgment*. In fact, as Hirst[11] pointed out, the figures were conceived as a pair and "bound together, despite the intervening space, as are the figures who crowd on the farther sides of Christ and His Mother in Michelangelo's *Last Judgment*." And just as in the *Last Judgment* the image of Christ in the center is the focus of attention of the other figures, in the Oratory of S. Giovanni Decollato, it must already have been the intention when the apostles were painted to place an image of the dead Christ between them as the focus of their gazes, which are turned inward and slightly downward but not at each other. Thus, it is likely that the plan at that time was for a large devotional image of Christ—perhaps simply a crucifix.

The Descent from the Cross (fig. 32)

The record in the *Giornale del Provveditore*[12] of Daniele da Volterra's being commissioned to paint the altarpiece in 1551 does not mention the subject. There is no way of knowing whether or not the narrative of the *Descent from the Cross*, rather than a devotional subject, had been decided upon by that time. However, the fact that Daniele had recently completed a striking example of that subject as the altarpiece for the Orsini Chapel, SS. Trinità dei Monti (fig. 52) might have been a factor in the selection of the theme for the oratory altar. Daniele's painting was often cited as the compositional source for Jacopino's *Decent,*[13] even before it was known that Daniele had been involved in the commission. It is possible, as suggested above,[14] that Daniele provided a *modello* which the patrons turned over to Jacopino when he was hired to replace Daniele. Whether the Louvre drawing (fig. 33) is by Daniele or Jacopino,[15] it may reflect Daniele's project for the altarpiece. However, the drawing and, to a far greater degree, the oratory altarpiece as finally executed by Jacopino are very different in their motifs, style, and expressive content from the Orsini altarpiece as well as from other contemporary depictions of the subject.

Iconographically and stylistically unique, Jacopino's *Decent* is the visualization of the final instructions given by the *confortatori* to the condemned prisoners in their care: to gaze at an image of the crucified Christ, to repeat the last words of Christ, to commit their souls to Christ. The inclusion of the thieves, an uncommon motif for this subject reflects the advice aften given the *giustiziati* to identify with the the repentant thief, who was crucified with Christ and went straight to paradise. The thieves appear in the drawing and the painting as does an unusual depiction of the Virgin who, rather than swooning or lying or sitting on the ground, is standing upright and gazing at Christ. Two additional unusual motifs which do not appear in the drawing were added to the composition by the time the painting was executed: a *putto* carrying a chalice in the upper right and a Roman centurion standing at the foot of the cross and holding Christ's legs.

All of these elements are very significant when considered within the context of the oratory program and the activities of the patrons. The changes made during the evolution of the composition most likely reflect the close involvement of the patrons in the project. The fact that the thieves and the standing pose of the Virgin appear in the drawing indicates that these were to be included from the beginning. The group of the standing Virgin and the three Maries would not have fit in a representation of the *Pietà*, and this may have been a factor in the choice of the narrative of the *Descent from the Cross,* rather than a devotional subject such as the *Pietà*, for the altarpiece.[16]

In any case, by the middle of the sixteenth century the *Descent from the Cross*, as well as the *Pietà*, had become a very popular subject for altarpieces in Rome and Florence.[17] Frederick Hartt[18] points out that though representations of the dead Christ had been relatively rare during the early years of the sixteenth century, from 1517 on there was an increase in the number of representations of the *Pietà*. All the *Pietàs* of this period have a new content; there is less stress on grief and the tragic aspects of the subject, and the figure of Christ is displayed in a way designed to cause the viewer to visualize the Sacrament in the dead body of Christ. The timing of this tendency coincides with the founding of the Roman Oratory of Divine Love.[19] This group was made up of clergy and laity and included among its founding members Gaetano da Thiene, later canonized as San Gaetano, and Gian Pietra Carafa, Bishop of Chieti and later Pope Paul IV. The rules of the Oratory of Divine Love stress the importance of frequent Communion stating "let each [brother] communicate at least four times a year, besides Easter and Christmas...and let this be done in the Oratory, if possible."[20] San Gaetano's devotion to the Eucharist is well documented; he

was known to prostrate himself for hours before the Eucharist and often seen to burst into tears at the moment of consecration.[21]

Such devotion to the Eucharist became a common feature of religious orders, including those made up of laymen, and may already be reflected in the manner in which the dead Christ is treated in altarpieces of the 1520s painted in Rome and Florence. For example, in a *Pietà* by Andrea del Sarto painted in 1526 for the high altar of the Church of San Piero a Luco (fig. 53), now in the Pitti, a chalice is placed in the center foreground with an almost invisible host on top of it. In Pontormo's altarpiece of ca. 1526–28, in the Capponi Chapel, Sta. Felicità (fig. 54), the body of Christ is held suspended above the altar in a manner to emphasize the bodily presence of Christ in the consecrated Host which would have been displayed on the altar directly below. The concern for the Eucharist on the part of the patron, who purchased the chapel in 1521, can be seen in the fact that he endowed it with a perpetual Chaplaincy, stipulating that Mass be performed five times a week for the future benefit of his soul.[22]

By the 1540s the issue of Christ's bodily presence in the Eucharist, an issue which not only divided the Catholics and the Lutherans but also Luther and Zwingli, the Swiss reformer, was a matter of significant controversy. This was one of the issues which led to the summoning of Pietro Carnesecchi, the Florentine reformer and former secretary and protonotary to Pope Clement VII, before the Inquisition in 1546.[23] He was eventually convicted of heresy, hanged, and burned—with the brothers of S. Giovanni Decollato in attendance.[24]

As might be expected, given the repeated references to the Eucharist throughout the program of decorations, the sacramental meaning of Christ's body is being stressed in the altarpiece. The *putto* with the chalice is an obvious eucharistic symbol. This motif appears frequently in early Renaissance *Crucifixions* where angels are shown catching the blood from Christ's wounds in chalices, and it appears occasionally still in the sixteenth century.[25] But no previous depiction of the *Descent from the Cross* includes a figure with a chalice. As stated above, the *putto* does not appear in the Louvre drawing. Presumably, it was added at the request of the patrons and specifically to strengthen the eucharistic content of the image.

The way the body of Christ has been depicted in the painting seems more characteristic of the *Pietà*—a devotional subject—than the narrative of the *Descent from the Cross*. Instead of showing a dead weight being lowered with difficulty as in Daniele's Orsini altar, Salviati's altarpiece of ca. 1547–48 for the Dini Chapel, Sta. Croce (fig. 35), and other contemporary representations of the subject, in Jacopino's painting the body is held upright and frontal, in a graceful, curved posture as if it were being

displayed. There is no emphasis on the wounds or suffering. As noted by Freedberg,[26] the posture of Christ's body and the way he is held by St. John the Evangelist and Nicodemus is a quotation from Michelangelo's *Pietà*, which was begun in Rome during the late 1540s. And I believe that here, as in the case of quotations throughout the decorative program of the oratory, the motif must have been consciously chosen and intended to be identified with its source, and to convey the same meaning—the *Pietà*.

The fact that the Virgin is standing and looking up at Christ rather than sitting or lying on the ground in a swoon is very unusual. In fact, the motif of the Virgin's swoon was so commonplace in contemporary representations of the *Descent from the Cross* that Vasari,[27] writing from memory, evidently took for granted that Jacopino's Virgin would be swooning. He speaks of "lo svenimento di Nostra Donna" in his description of the picture. Actually, the propriety of the Virgin's swoon had been questioned early in the sixteenth century. In a tract *De Spasimo Beatae Mariae*, first published in 1506 and reprinted in 1529, Tomaso de Vio, Cardinal Cajetan, stated that since the Virgin participated with full knowledge in Christ's sacrifice she could not have swooned as the painters show her.[28] Steinberg[29] cites this tract pointing out that the Virgin in Pontormo's Capponi altar is not swooning. A theme stressed throughout the oratory is the role of St. John the Baptist in the pre-ordained plan for man's salvation, and it is possible that here the Virgin's role in this plan is also being stressed by showing her not swooning but gazing intensely at the body of her son.

This interpretation is strengthened by the similarity of the standing female figures to the *Visitation* subject. In fact, it has been suggested that in the grouping of the figures and handling of draperies Jacopino is quoting Pontormo's Carmignano *Visitation* of about 1538.[30] If this is correct, the quotation has more than stylistic significance; again, the motif was consciously chosen to convey the meaning of its source—the *Visitation*. As a reference to the moment when St. Elizabeth and the unborn St. John the Baptist recognized Christ as the Savior, and thus to the beginning of St. John's role as prophet and precursor, the motif reinforces this message, which is stressed through the decorations of the oratory and is crucial to the whole mission of the Confraternity of S. Giovanni Decollato.

The presence of the thieves, though unusual, is not without precedent. There are several examples of *Descents* with thieves in Florentine art of the early sixteenth century.[31] However, none of them resembles the oratory altarpiece at all. The closest precedent, and one that would have been known to both Daniele da Volterra and Jacopino del Conte, is an altarpiece painted by Perino del Vaga in the 1520s for the Chapel of the Apostolic Protonotary in the Church of Sta. Maria sopra Minerva (figs. 56, 58). This painting was heavily damaged by flood in 1530, but enough was still

visible during the 1530s to be seen and described by Vasari, who particularly admired the thieves.[32] It may be that the thieves, fragments of which are still extant (now in Hampton Court), were the most visible part of the painting by the time Vasari and Jacopino saw it.

In any case, when the presence of the thieves has been commented upon in the literature, Perino's influence has been cited.[33] Partridge also suggests that Jacopino "intensified the horror of the Deposition by the inclusion of the otherwise rarely used good and bad thieves."[34]

However, except for the pose of the bad thief, the handling of the thieves in Jacopino's painting does not resemble that of Perino, where they indeed must have added to the desolate and tragic mood. In fact, Jacopino was not intensifying the horror at all. Most contemporary representations of the subject, even without the thieves, are more dramatic and emotional than this one. In contrast, for example, with Daniele's Orsini altar, which is filled with strong, angular postures and gestures, moving sharply in and out, Jacopino's painting is filled with curved postures and gestures making a rhythmic, almost ornamental, pattern contracting and expanding upwards on the picture surface. The ornamental quality of the design relates more closely to Salviati's Dini altarpiece. However, even though Salviati's picture was described as early as 1584 by Borghini[35] and as recently as 1971 by Hall[36] as showing a lack of concern for the dramatization of the event, the iconography is more conventional; Christ's body is definitely being lowered, and the Virgin is seated on the ground with an anguished expression, ministered to by the other Maries.

If the Louvre drawing does reflect Daniele's project for the oratory altarpiece, he transformed his own earlier composition. And though Daniele's Orsini altar has been traditionally cited as a source for Jacopino's painting, the differences in iconography and expression are more significant than any compositional similarities. In fact, the comparison serves to emphasize the contrast between the violent and dramatic narrative impact of the Orsini altar and the lyrical quality of the oratory altar in which the emotion expressed is not wild grief and horror but an exquisite anguish tempered by reverence and awe, by worship of the body of Christ. Thus the subject takes on the quality of a devotional altar.

This treatment of the subject is certainly in response to the wishes of the patrons, as is the inclusion and manner of handling of the thieves. Except for the distinction made between the older, bearded unrepentant thief and the more youthful, unbearded repentant thief, there is no reference to the traditional treatment of the thieves. Usually the bad thief is contorted and writhing in the agony of his sinful death while the repentant thief has died peacefully, having just said, "Lord, remember me when thou comest into thy kingdom." And Christ has answered, "Verily I say unto

thee, To-day shalt thou be with me in paradise" (Luke 23: 42–4). In Jaco-pino's painting the bad thief is obviously dead; his head is drooping, his eyes are closed, and his body hangs limply on the tree. The repentant thief, emphasized by the light, is in an animated posture, turned, yearning toward the figure of Christ at whom he seems to be gazing with his head raised. This is more apparent in the painting as executed than in the draw-ing, where his head is thrown back sharply rather than being tilted toward Christ. This change may have been at the suggestion of the patrons and supports the idea that the inclusion of the thieves had special significance in the context of the confraternity's mission.

The presence of the thieves certainly reflects the fact that the *conforta-tori* were explicitly instructed to exhort the *giustiziati* to identify with the repentant thief.[37] Just as the figure of Christ on the cross is the last thing the repentant thief saw before he died, confident of joining Christ in para-dise, the *fratelli* of S. Giovanni Decollato hoped that the *giustiziati* in their care would die confident of salvation, gazing at the image of the crucified Christ being held before them, repeating the words *Gesù Gesù Gesù*. If one of the functions of the decorative program of the oratory was to rein-force the mandate of the confraternity and to serve as a constant reminder of its mission to the brothers who assembled there for business meetings and religious services, the presence of the thieves makes the altarpiece the culmination of the program.

One more motif that seems significant is the Roman centurion stand-ing at the foot of the cross embracing the legs of Christ. The inclusion of a centurion is more common in the *Crucifixion*; however there is contempor-ary precedent in *Descents*, in fact, in two of the works most frequently cited as sources for this composition: Perino's *Descent* from Sta. Maria sopra Minerva, where a centurion is standing by the cross, at least in the drawing, and Daniele's Orsini altar, where a centurion is actually helping to lower Christ's body. In terms of the narrative, the latter would be the centurion's role in Jacopino's painting also. However, the body language of the figure suggests something different. His pose and action resemble those often seen in the figure of Mary Magdalen in representations of the *Crucifixion, the Descent from the Cross*, and the *Pietà*. I think the cen-turion is there as a repentant sinner. But the sin of the centurion was not that of wrong doing but wrong thinking (not believing), and his repentance was not contrition for misdeeds but conversion to right thinking (to belief). According to the *Golden Legend*,[38] Longinus (the name given to the cen-turion who pierced Christ's side with his spear, causing the flow of blood and water—symbols of the Sacraments of Baptism and the Eucharist) experienced his conversion when the blood of Christ, falling on his face, healed his blindness. This blindness should be taken as metaphor for spiri-

tual blindness. In the midsixteenth century in Rome, spiritual blindness was synonymous with Lutheranism.

As mentioned above, from the 1540s on heresy appears more frequently in the confraternity's records as the crime for which a prisoner was condemned to death. In such cases the task of the *confortatori* of St. Giovani Decollato was to persuade the prisoner to recant, confess, and take the Sacrament, and thus die "ben disposto e pentito del suo errore." This was actually the notation after the report of a prisoner hanged and burned "come Luterano."[39] More frequently the notation stated that the prisoner refused to confess, refused the Sacrament, would not look at the image of the crucified Christ, and was "sempre più fermo nella sua falsa oppinione," or "più perfido nella sua ostinatione," or "sempre strette in quella sua maledetta ostinatione."[40] The frustration of the *fratelli* is apparent in these comments, and at this time the whole mission of the confraternity was charged with a new significance.

The centurion does not appear in the Louvre drawing. Instead there is a cowled or hooded figure (perhaps a *confortatore*) embracing and possibly kissing the feet of Christ, as the prisoner would be urged to kiss the crucifix. By the time the painting was executed, presumably at the request of the patron whose portrait was also added to the left, the *confortatore* figure was replaced by the centurion. The centurion should be identified as Longinus — converted and *pentito del suo errore*.

Thus the altarpiece as painted not only summed up the message of the entire program of decorations but also conveyed a timely and urgent reminder to the brothers of S. Giovanni Decollato of their new mission to exhort the increasing numbers of those condemned to death for heresy — numbers which would include well-known theologians and reformers such as Pomponio Algerio di Nola, Archbishop Macario of Macedonia, Pietro Carnescchi, Aonio Paleario, and Giordano Bruno — to recant and to die "nel grembo della santa romana chiesa."[41]

This message was expressed in a painting that was rightly characterized by Vasari[42] as a "bonissima pittura e la migliore opera che insino allora (Jacopino) avesse mai fatto." Daniele's failure to fulfill the commission for the altarpiece had positive results. Jacopino was able to temper Michelangelesque monumentality through his retrospective emulation of Pontormo as Daniele would have had neither the inclination nor ability to do. Jacopino's *Descent from the Cross* is far superior to his just-preceding efforts in S. Luigi dei Francesi[43] and to his later works.[44] It is as though he rose to the occasion in order to produce a work, as Freedberg[45] describes, "almost even in its quality, an accomplishment of matured high Maniera comparable to the contemporary Salviati's."

If, as Zeri suggested,[46] Jacopino's involvement with St. Ignatius

Loyola and the Jesuits at midcentury led to his artistic decline, this was preceded by a brief period during which Jacopino was able to combine his Florentine artistic heritage with Counter-Reformation religious feeling to achieve a superlative monument of religious art—at once the climax of the oratory decorations and of Roman Maniera.

Appendix A

The Louvre Drawing

Panofsky[1] was the first to recognize the relationship between the Louvre drawing of the *Descent from the Cross* (fig. 33), which had been attributed to Daniele da Volterra, and the altarpiece in the Oratory of S. Giovanni Decollato (fig. 32). This led him to attribute the drawing to Jacopino del Conte and to identify it as a preparatory drawing or *modello* for the oratory altarpiece.

Recently Monbeig-Goguel[2] has suggested that the drawing is after Jacopino rather than by his own hand. She bases her argument on the weak draftsmanship, which she views as a contrast to the richness of the completed painting. In her opinion the drawing is "une dérivation présentant de notables variantes, soit une copie d'après une première pensée de Jacopino."[3]

The drawing (which is in pen and brown ink, with brown wash, gone over with grey wash) shows the influence of Perino del Vaga and bears a superficial resemblance to his pen-and-ink drawings of the 1540s.[4] However, though the ornamental calligraphy that characterizes Perino's pen drawings has been imitated, the fluidity that is the hallmark of his style is absent. Perino's animated, vibrating, repeated contours have been replaced with heavy, mechanical outlines. His brilliant shorthand for internal anatomical and facial details has become schematic with short, curved strokes resembling parentheses to indicate muscles; circles or dots for nipples; and splotches for eyes. The handling of extremities with pointing fingers, clawlike curling of hands, sharply bent wrists, and sketchily drawn feet with high arches and long toes is a heavy-handed imitation of Perino. This is also true of the treatment of drapery, in which the softness suggested by the modeling with wash is contradicted by brittle, angular pen lines.

At the time Panofsky suggested that the attribution be changed from Daniele to Jacopino, neither artist's drawing style had been defined by scholars. Jacopino's style as a draftsman still has not been characterized,

and because of the lack of comparative material, it is difficult to support or reject an attribution to Jacopino on the basis of draftsmanship. However, contributions by Oberhuber, Hirst, Davidson, and Barolsky[5] have added to our understanding of Daniele's drawing style. Though his chalk style is better understood than his pen-and-ink style, recent attributions by Davidson[6] and Oberhuber[7] suggest a pen-and-ink style that is comparable to the Louvre drawing. Since these attributions have not all gained acceptance as yet, it is premature to argue for a reattribution of the Louvre drawing to Daniele on the basis of draftsmanship. Nevertheless, my discovery that Daniele was originally commissioned to paint the altarpiece in 1551 indicates that such an attribution should at least be considered.

If one turns to a study of the composition and its relationship to the completed altarpiece, the argument for attribution to Jacopino appears stronger. In both the drawing and the painting the figure composition is a vertically ascending and expanding *serpentinata* pattern. It is dominated by the central figure of the dead Christ, whose sinuous curved form is echoed by that of the Virgin below him and the thieves on either side. This pattern is integrated with a geometric framework made of two intersecting triangles: one triangle is formed by the cross and ladders,[8] and the other, an inverted triangle, is formed by the placement of the figures. The graceful and ornamental quality of the figure composition is enhanced by the flowing draperies of the female figures (particularly those of Mary Magdalen in the painting, whose draperies appear on the figure to the far right of group in the drawing). Panofsky[9] noted the relationship of the four standing female figures to Pontormo's Carmignano *Visitation* (fig. 55) — in pose and handling of draperies. As discussed above,[10] Jacopino's earliest works showed his indebtedness to Pontormo as well as to Michelangelo, and he seems to have been profoundly affected by a re-exposure to Pontormo's works during a visit to Florence in 1547. The basic structure and the eurhythmy of the composition of intertwined, curving bodies and limbs is closer to Pontormo's works of the later 1520s than to any of the traditionally cited sources for the composition — including Salviati's Dini altarpiece, which Jacopino would have also seen during his visit to Florence.

Nevertheless, this relationship to Pontormo is so much stronger in the painting than in the drawing that familiarity with the painting is necessary for the recognition of the Pontormesque qualities of the drawing. In the drawing the configuration of the cross and the ladder on the right more closely resembles the rectilinear, gridlike design of the cross and ladders in Daniele's Orsini *Descent* (fig. 52). In Jacopino's painting the strong horizontal formed by the arms of the cross and the grid of the ladder are less prominent, hidden by the *serpentinata* pattern of the figure

composition. The individual figures and the design as a whole are more ornamental in the painting, and the curvilinear, rhythmic pattern, contracting and expanding upwards on the surface, which was incipient in the drawing, is fully developed. Whereas in the drawing there is a suggestion of spatial recession on the lower left, created by the relationship of the foreground tree to the ladder and foot in the middle ground, in the painting these elements have all but disappeared; our attention is kept on the surface by the fluttering draperies and ointment jar of the Magdalen. In the painting Jacopino followed the general layout of the Louvre drawing, but he compressed the spatial composition into a dense, relieflike adherence to the surface plane.

The compositional structure of the drawing not only reflects the rectilinear, gridlike design of the cross and ladders in Daniele's painting, but also resembles Michelangelo's drawing of the *Descent from the Cross* in the Teylers Museum, Haarlem (fig. 60), which has been associated with Daniele's composition. In a closely related drawing in a private collection[11] and in a stucco relief in the Casa Buonnarroti (fig. 61) the standing figures of the Maries are similar to the group in the Louvre drawing.

The presence of Michelangelesque elements, though more characteristic of Daniele's works of the 1550s, does not rule out the possibility of Jacopino's authorship of the drawing. Jacopino was, of course, aware of Daniele's Orsini altarpiece, and, especially since the commission for the oratory altarpiece had first been given to Daniele, it is to be expected that elements from Daniele's painting would be carried over into Jacopino's design. However, it seems significant that the relationship between the Louvre drawing and the completed altarpiece is similar to the relationship between Perino del Vaga's drawing for the *Preaching of St. John the Baptist* and Jacopino's completed fresco. In both cases the painting contains motifs not in the drawing which add to the meaning of the painting in its oratory context; in both cases the style of the painting more closely reflects Jacopino's Florentine sources than does the style of the drawing.

Further clarification of Daniele's pen-and-ink style, as well as further knowledge of Jacopino's style as a draftsman, is needed for a firm attribution of the drawing. However, the possibility of Daniele's authorship at least of a *modello* which is reflected in the Louvre drawing should be left open.

Appendix B

The Portraits

Four of the frescoes in the oratory, the *Annunciation to Zaccariah,* the *Visitation,* the *Preaching of St. John the Baptist,* and the *Dance of Salome,* as well as the altarpiece of the *Descent from the Cross,* contain one or more figures in contemporary dress. Their strongly individualized features stand out from the more generalized faces of the other figures, and they are obviously portraits. However, none of them can be identified with certainty.

The inclusion of portraits in biblical narratives was a well-established tradition in Florentine painting. In many cases, for example Ghirlandaio's frescoes in Sta. Trinita and Sta. Maria Novella, precise identification of portraits of the patrons, members of their families, and other prominent Florentine citizens is made possible by mention in contemporary sources, by resemblance to other known portraits of the subjects, and by a rationale for the inclusion of portraits of the persons identified. Without such evidence, identification of such portraits is hypothetical at best and can become very subjective. This is the case with most of the suggested identifications of the portraits in the oratory paintings. Vasari does not mention any of the portraits; nor are they mentioned by any other contemporary source. However, identifications on the basis of resemblance have been suggested for the portrait in Jacopino del Conte's *Annunciation to Zaccariah* and *Preaching of St. John the Baptist,* and in the latter case an explanation for the presence of the portrait was also suggested.

Steinmann[1] was the first to suggest that the portrait in Jacopino's *Annunciation to Zaccariah* (fig. 62) was of Michelangelo, and he compared it to the ex-Chaix d'Estanges portrait (fig. 63).[2] This identification, which Steinmann admitted should remain hypothetical,[3] has been repeated enough that von Henneberg has stated it as accepted fact.[4] However, not only is the resemblance to known portraits of Michelangelo superficial, but there is not logical reason at all for his portrait to have been inserted into the fresco. Though Michelangelo had joined the Confraternity of S.

Giovanni Decollato in 1514, he was not an active member. In fact, as I recently discovered, he was so inactive that by 1560 the *fratelli* were unaware that Michelangelo had once been one of them.[5]

Cheney[6] suggests that this portrait should be identified not as Michelangelo but as the sitter depicted in the *Portrait of a Papal Notary* (fig. 65) in the Fitzwilliam Museum, Cambridge, which she attributes to Jacopino. The resemblance to this sitter is indeed stronger than it is to Michelangelo, but if the nose in the fresco is not mashed and lumpy enough to be Michelangelo's, neither is it long and aquiline enough to be that of the notary. The notary has been tentatively identified as one Francesco de'Pisis by the signature which appears on the document in front of him. However, there also is no known reason for him to be included in the fresco, and Cheney's argument that "apparently he was a Tuscan — since his portrait also appears in the Florentine oratory at San Giovanni Decollato,"[7] is circular.

Von Henneberg also employs circular argument in her proposed identification of the figure to the left of St. John the Baptist in Jacopino's fresco of the *Preaching* (fig. 66) as St. Ignatius Loyola. She supports her identification on the basis of Jacopino's known association with St. Ignatius and then argues that the presence of the portrait in the fresco indicates that this association must have begun as early as 1538 — earlier than previously believed.[8] Furthermore the resemblance to known portraits of St. Ignatius is not particularly compelling. The fact that all of these other known portraits are taken from a plaster cast made after his death because St. Ignatius "never allowed any portrait to be made"[9] during his lifetime does not strengthen von Henneberg's case and almost contradicts it. Her suggestion that a portrait of St. Ignatius was included as a reference to his introduction of public outdoor preaching in Rome in the spring of 1538 is her strongest argument,[10] but the identification of the portrait must remain hypothetical.

Moreover, it is dangerous to assume that Jacopino had the freedom to insert portraits of his own choice: a portrait of Michelangelo, presumably because he admired him; a portrait of St. Ignatius because of their alleged association. It is more likely that all of the portraits are of members of the confraternity which were included according to instructions by the patrons, and that they depict the patrons themselves or other active and important members.

Thus the most convincing identification of any of the oratory portraits is that of the two figures in Salviati's *Visitation* as Battista da San Gallo and Giovanni da Cepperello. Cheney was the first to suggest this identification.[11] Since according to Vasari they commissioned the *Visitation* as well as Jacopino's *Annunciation,* and according to the *Libri di Testamenti*

they were very active as *confortatori,* it seems logical that their portraits should have been included.

Their counterparts on the opposite wall, in Ligorio's *Dance of Salome* (fig. 26), should be identified as the patrons of that fresco and perhaps also of the other frescoes on the same wall.[12] One of the three figures is a bishop, possibly Monsignore Giovanni della Casa who, according to Vasari, commissioned Battista Franco's *Arrest of St. John the Baptist.* However, in the absence of any contemporary reference or strong resemblance to other known portraits of Giovanni della Casa,[13] this is a very tentative identification.

The one remaining portrait is in Jacopino's altarpiece (fig. 67). If the portrait in the *Annunciation to Zaccariah* resembles other portraits attributed to Jacopino and datable to the 1530s, as pointed out by Cheney,[14] this one resembles portraits which are attributed and datable to the 1540s (fig. 68). It is not possible to identify this portrait without identifying the patron. Presumably he is one of the "tre fratelli" empowered to commission the altarpiece "in nome di tutta la compagnia."[15] One could speculate that Ruberto Ubaldini or Bindo Altoviti were among these three.[16] However, in the absence of any evidence, identification of the patrons of the altarpiece or the subject of the portrait is not possible.

Illustrations

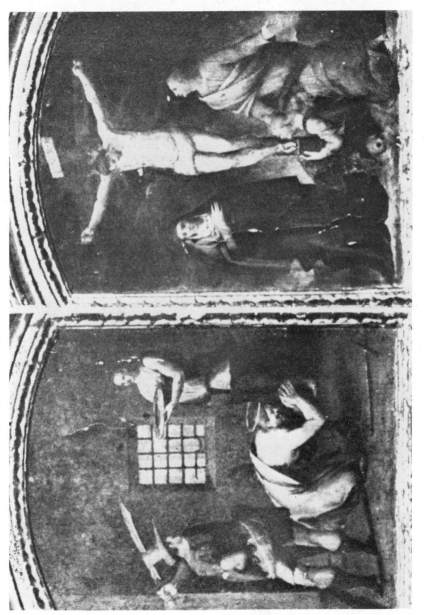

1. Anonymous, *Tavola* with *Crucifixion* and *Decollation of St. John the Baptist*, Camera Storica, S. Giovanni Decollato, Rome. Photo: courtesy of the Archconfraternity of S. Giovanni Decollato and Samuel Y. Edgerton, Jr..

2. Anonymous, *Tavola* with *Decollation of St. John the Baptist*, Camera Storica, S. Giovanni Decollato, Rome. Photo: courtesy of the Archconfraternity of S. Giovanni Decollato and Samuel Y. Edgerton, Jr..

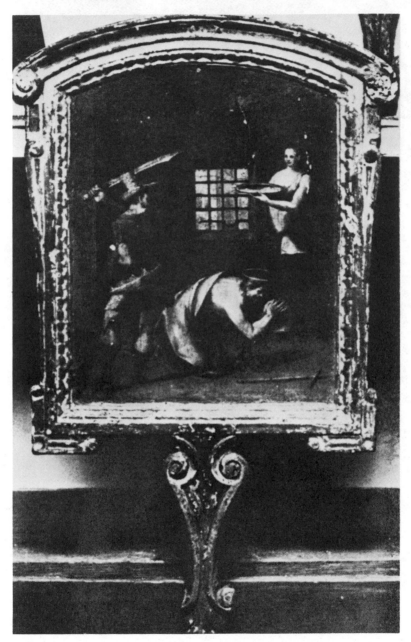

3. Photograph of a brother of the Archconfraternity of S. Giovanni Decollato dressed in black robe and hood and holding a *tavola* and lantern. Photo: Gabinetto Fotografico Nazionale, Rome.

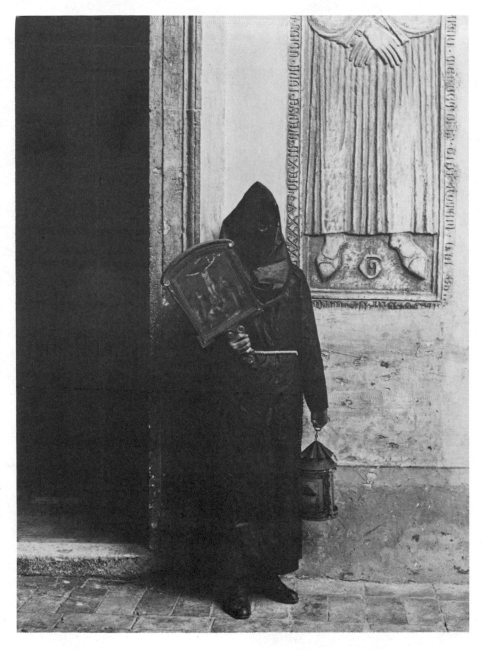

4. View of the Camera Storica, S. Giovanni Decollato, Rome, showing the Crucifix and torches used in processions. Photo: courtesy of the Archconfraternity of S. Giovanni Decollato.

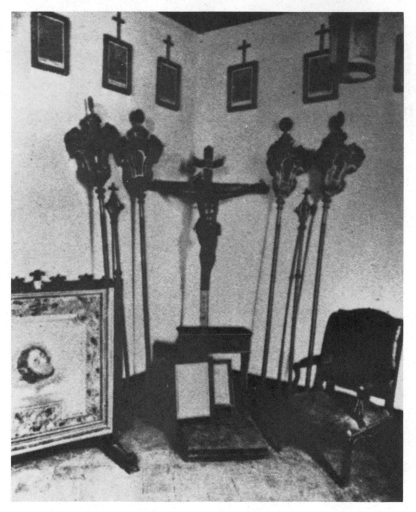

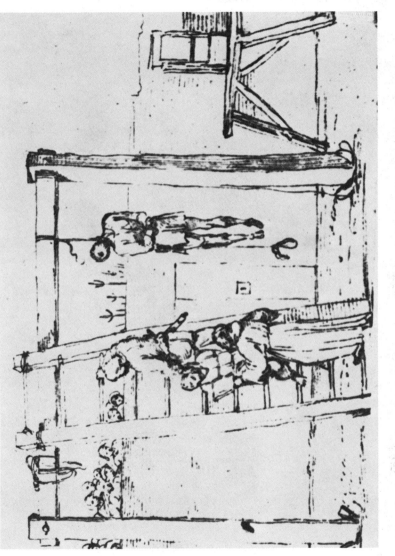

5. Annibale Carraci, *A Hanging*, drawing, Royal Library, Windsor Castle, England. Photo: courtesy of the Royal Library.

6. Detail of a map of Rome showing location of the Church and Oratory of S. Giovanni Decollato.

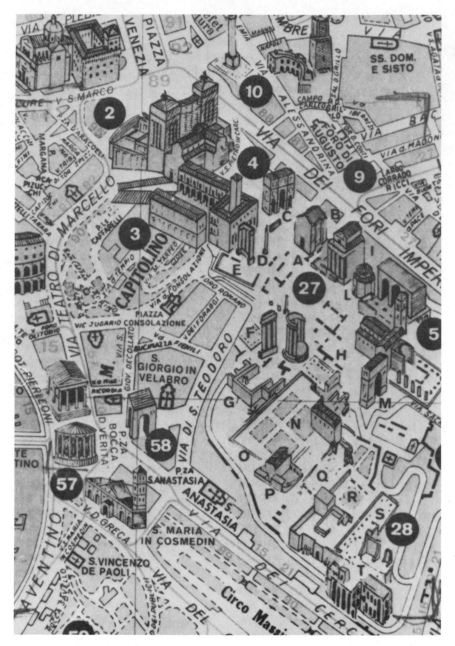

7. Church and Oratory of S. Giovanni Decollato, Rome.
 Photo: author.

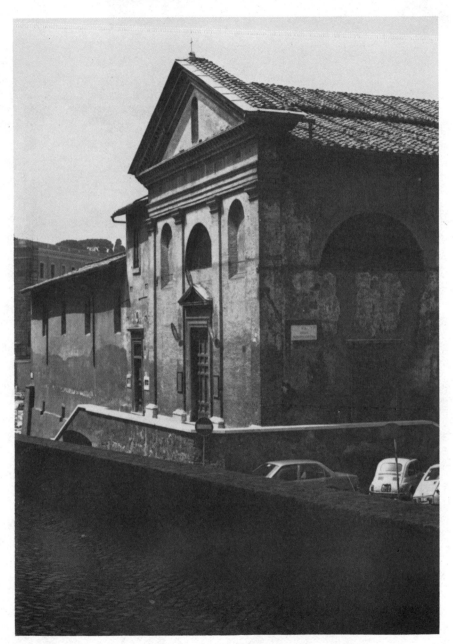

8. Plan of Church and Oratory of S. Giovanni Decollato. After Letarouilly.

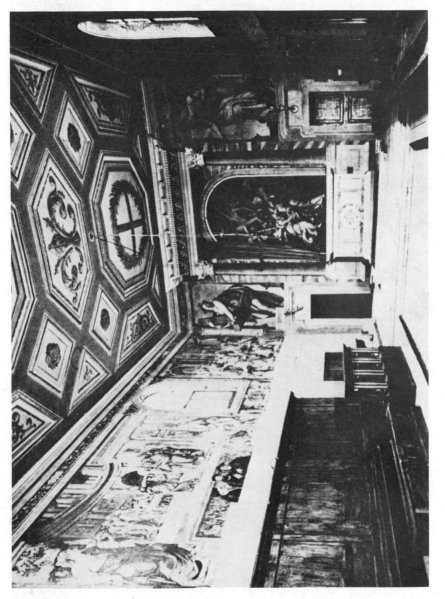

9. Interior of the Oratory of S. Giovanni Decollato towards the altar.
Photo: Soprintendenza per i Beni Ambientali e Architettonici del Lazio, Rome.

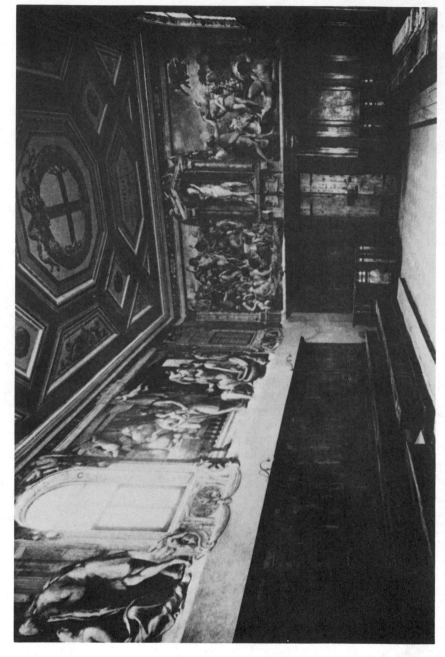

10. Interior of the Oratory of S. Giovanni Decollato towards the entrance.
Photo: Soprintendenza per i Beni Ambientali e Architettonici del Lazio, Rome.

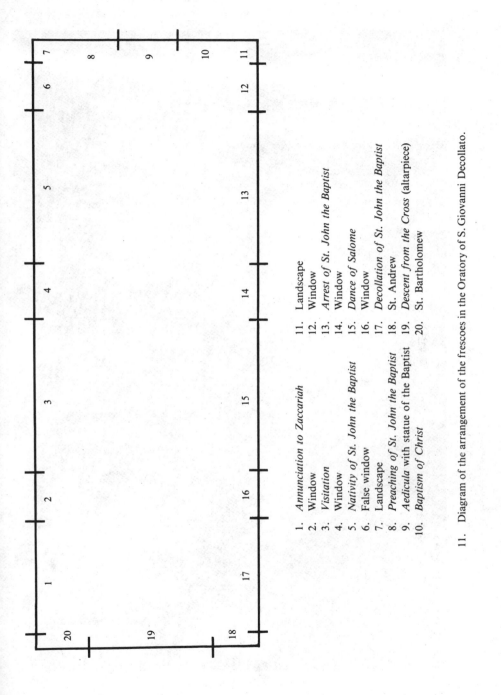

1. *Annunciation to Zaccariah*
2. Window
3. *Visitation*
4. Window
5. *Nativity of St. John the Baptist*
6. False window
7. *Landscape*
8. *Preaching of St. John the Baptist*
9. *Aedicula* with statue of the Baptist
10. *Baptism of Christ*
11. *Landscape*
12. Window
13. *Arrest of St. John the Baptist*
14. Window
15. *Dance of Salome*
16. Window
17. *Decollation of St. John the Baptist*
18. St. Andrew
19. *Descent from the Cross* (altarpiece)
20. St. Bartholomew

11. Diagram of the arrangement of the frescoes in the Oratory of S. Giovanni Decollato.

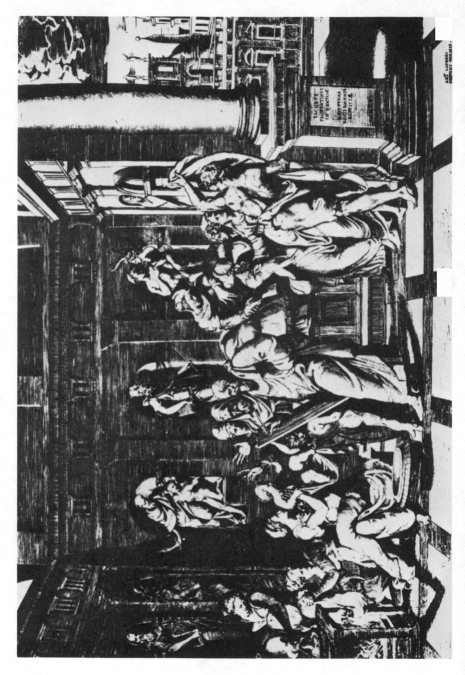

12. Bonasone, engraving after Jacopino del Conte, *Nativity of St. John the Baptist.*
Photo: Gabinetto Fotografico Nazionale, Rome.

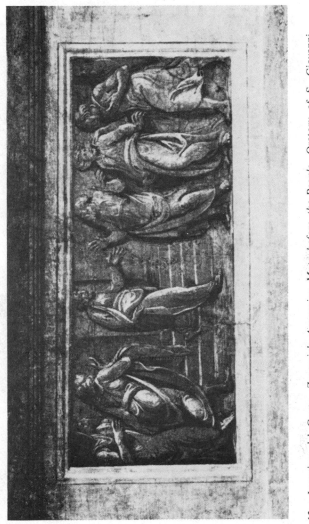

13. Jacopino del Conte, *Zaccariah Appearing Mute before the People*, Oratory of S. Giovanni Decollato, Rome. Photo: Soprintendenza per i Beni Ambientali e Architettonici del Lazio, Rome.

14. Francesco Salviati, *Sleeping Ariadne*, Oratory of S. Giovanni
Decollato, Rome. Photo: Soprintendenza per i Beni Ambientali
e Architettonici del Lazio, Rome.

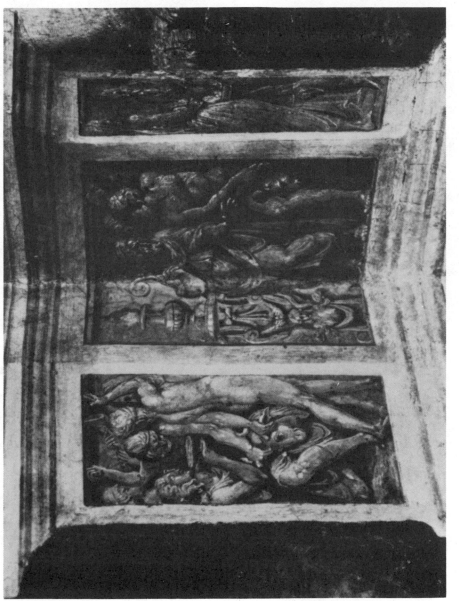

15. Jacopino del Conte, *Sacrifice*, Oratory of S. Giovanni Decollato, Rome.
Photo: Soprintendenza per i Beni Ambientali e Architettonici del Lazio, Rome.

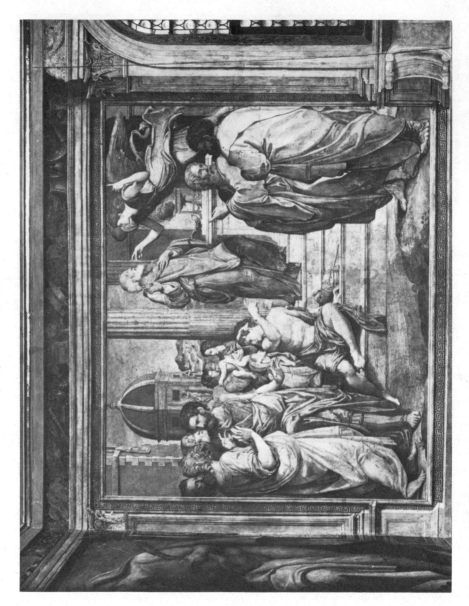

16. Jacopino del Conte, *Annunciation to Zaccariah*, Oratory of S. Giovanni Decollato, Rome.
Photo: Gabinetto Fotografico Nazionale, Rome.

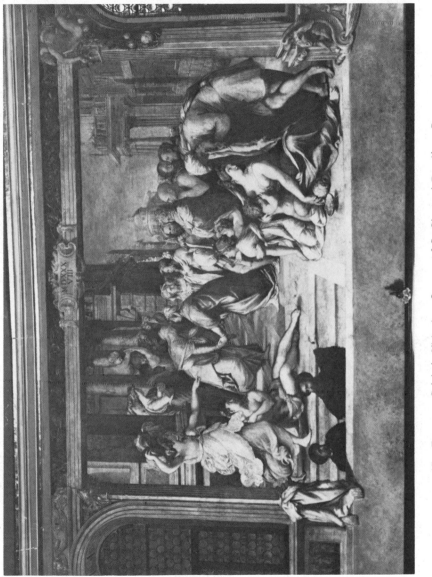

17. Francesco Salviati, *Visitation*, Oratory of S. Giovanni Decollato, Rome.
Photo: Gabinetto Fotografico Nazionale, Rome.

18. Francesco Salviati, study for the *Visitation*, British Museum, London. Photo: courtesy of British Museum.

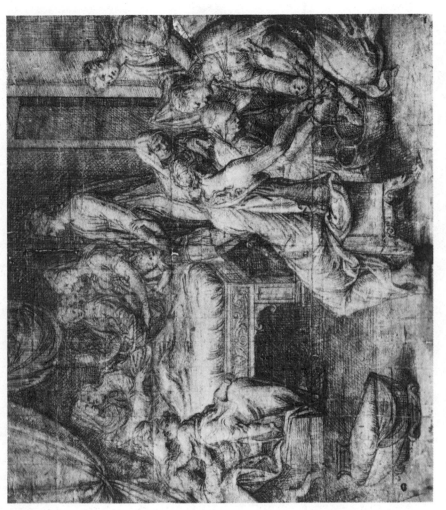

19. Giuseppe della Porta (?), drawing after Francesco Salviati, *Nativity of St. John the Baptist*. Victoria and Albert Museum, London. Photo: courtesy of Victoria and Albert Museum.

20. Diagram of proposed first arrangement of the frescoes on the west wall of the Oratory of S. Giovanni Decollato.

1. *Annunciation to Zacariah*
2. Window
3. *Visitation*
4. Virtue or Apostle
5. Window
6. *Nativity of St. John the Baptist*
7. Virtue or Apostle
8. Another narrative

21. Philippe Thomasin ("after Francesco Salviati"), *Baptism,*
British Museum, London. Photo: courtesy of British Museum.

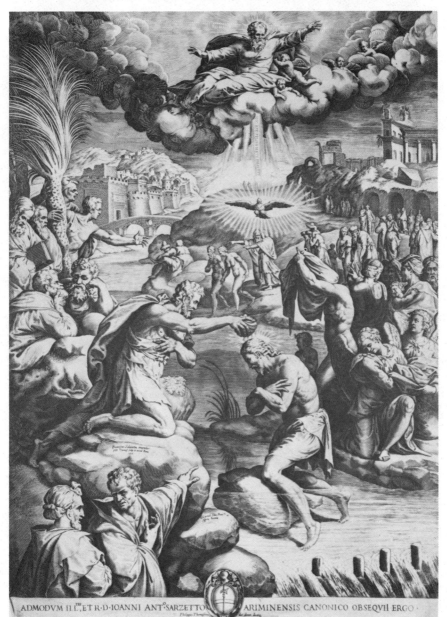

22. Jacopino del Conte, *Preaching of St. John the Baptist,* Oratory
 of S. Giovanni Decollato, Rome. Photo: Gabinetto Fotografico
 Nazionale, Rome.

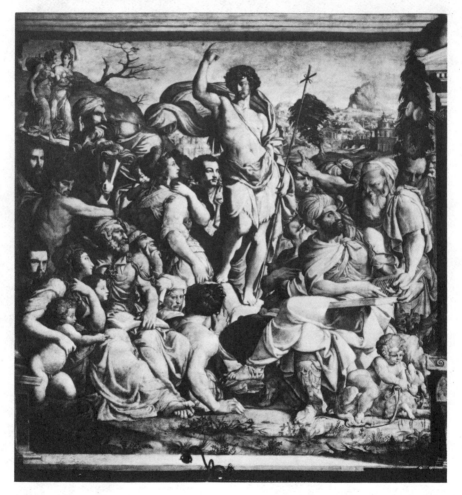

23. Perino del Vaga, study for *Preaching of St. John the Baptist,*
Albertina, Vienna. Photo: courtesy of the Albertina.

24. Jacopino del Conte, *Baptism of Christ*, Oratory of S. Giovanni
Decollato, Rome. Photo: Gabinetto Fotografico Nazionale,
Rome.

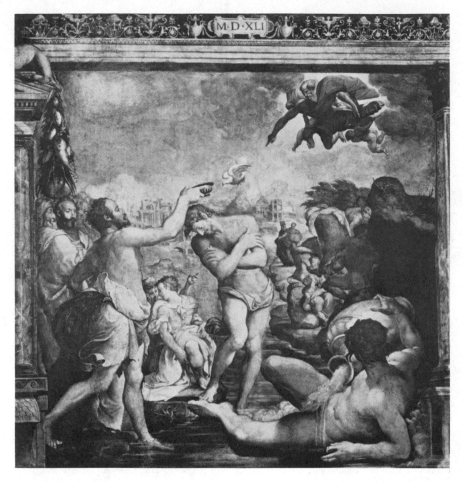

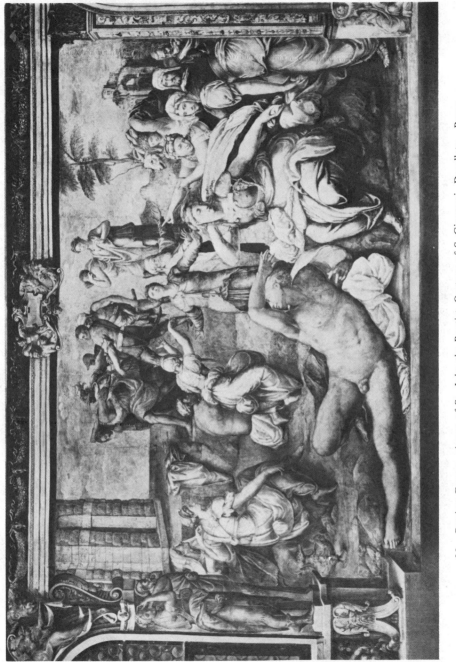

25. Battista Franco, *Arrest of St. John the Baptist*, Oratory of S. Giovanni Decollato, Rome.
Photo: Gabinetto Fotografico, Rome.

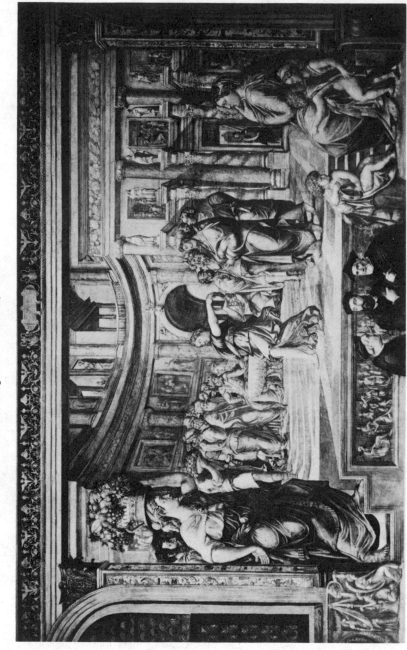

26. Pirro Ligorio, *Dance of Salome*, Oratory of S. Giovanni Decollato, Rome.
Photo: Gabinetto Fotografico Nazionale, Rome.

27. Francesco Salviati, *St. Andrew*, Oratory of S. Giovanni Decollato, Rome. Photo: Gabinetto Fotografico Nazionale, Rome.

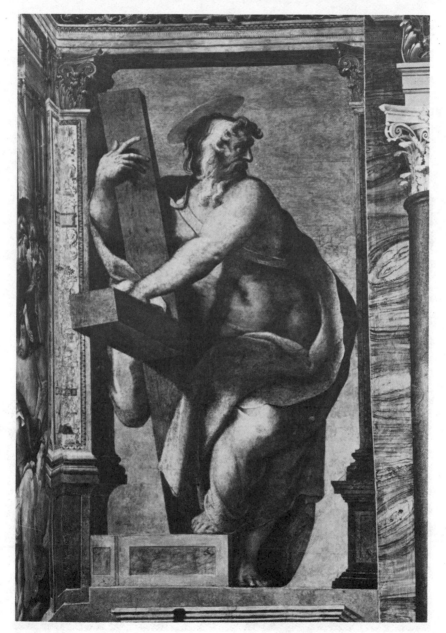

28. Francesco Salviati, *St. Bartholomew*, Oratory of S. Giovanni Decollato, Rome. Photo: Gabinetto Fotografico Nazionale, Rome.

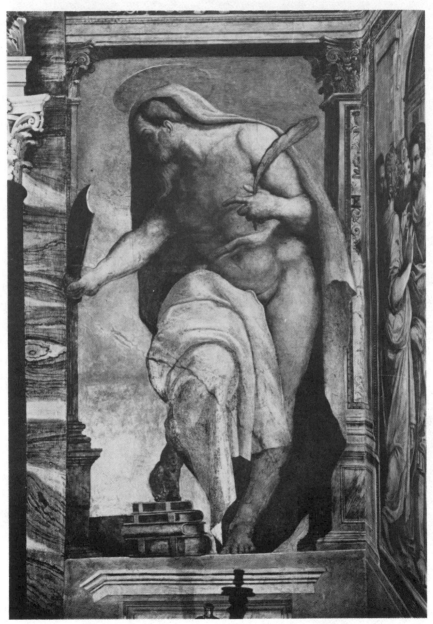

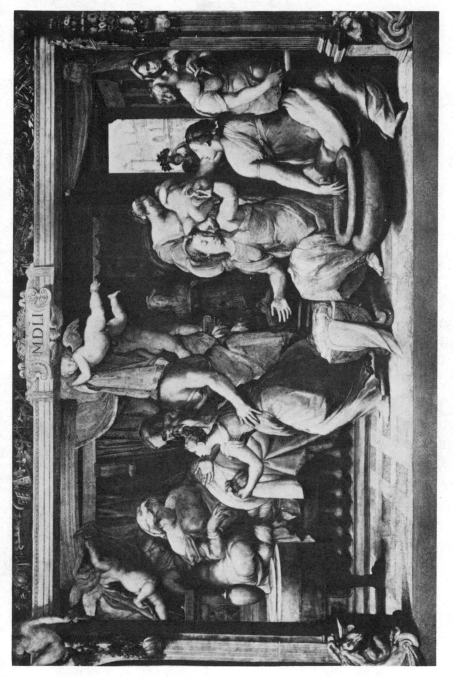

29. Francesco Salviati, *Nativity of St. John the Baptist*, Oratory of S. Giovanni Decollato, Rome.
Photo: Gabinetto Fotografico Nazionale, Rome.

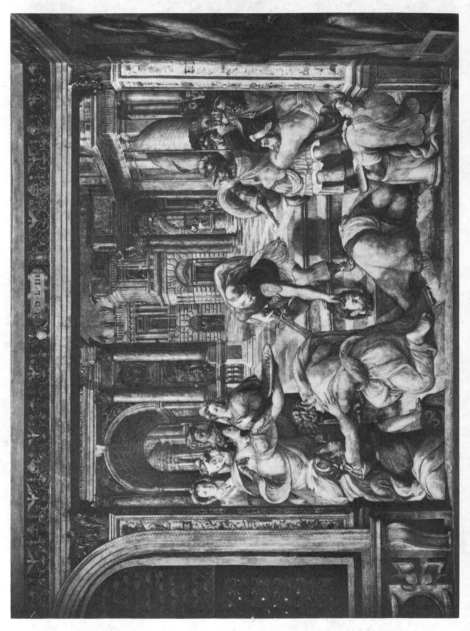

30. Assistant of Francesco Salviati (?), *Decollation of St. John the Baptist*, Oratory of S. Giovanni Decollato, Rome. Photo: Gabinetto Fotografico Nazionale, Rome.

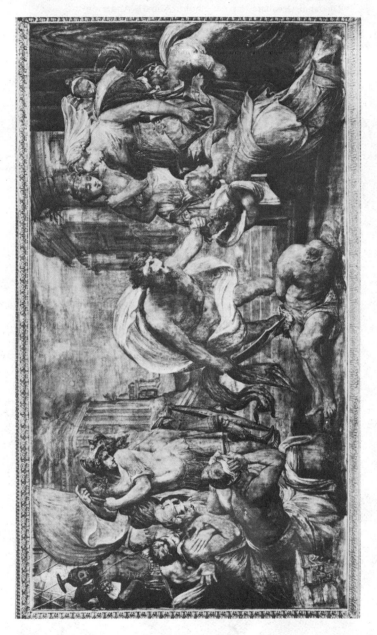

31. Francesco Salviati, *Decollation of St. John the Baptist*, Cappella del Palio, Palazzo della Cancelleria, Rome.
 Photo: Gabinetto Fotografico Nazionale, Rome.

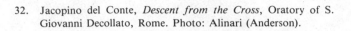

32. Jacopino del Conte, *Descent from the Cross*, Oratory of S. Giovanni Decollato, Rome. Photo: Alinari (Anderson).

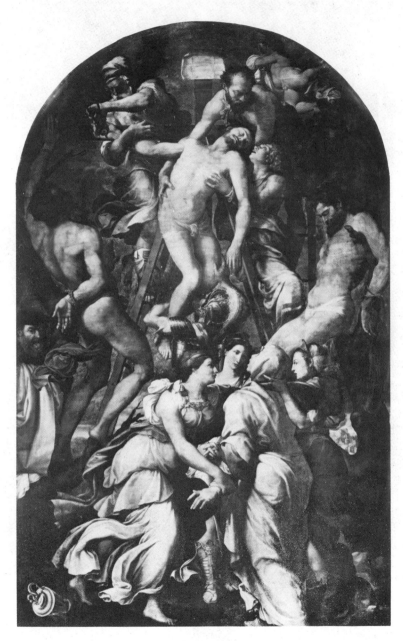

33. After Daniele da Volterra (?), study for the *Descent from the Cross*, Cabinet des Dessins, Musée du Louvre, Paris. Photo: courtesy Musée du Louvre.

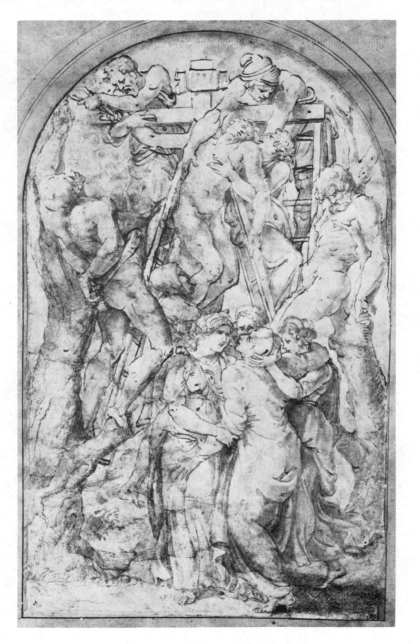

34. Jacopino del Conte, *Madonna, Child, St. Elizabeth, and little St. John*, ex-Contini-Bonacossi Collection. Photo: Alinari.

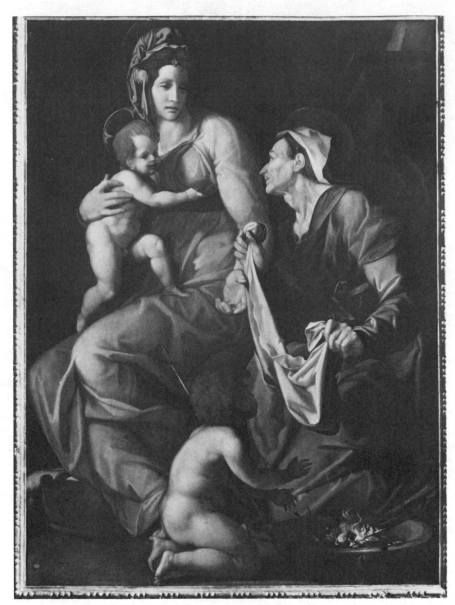

35. Francesco Salviati, *Descent from the Cross,* Museo di Santa Croce, Florence. Photo: Alinari.

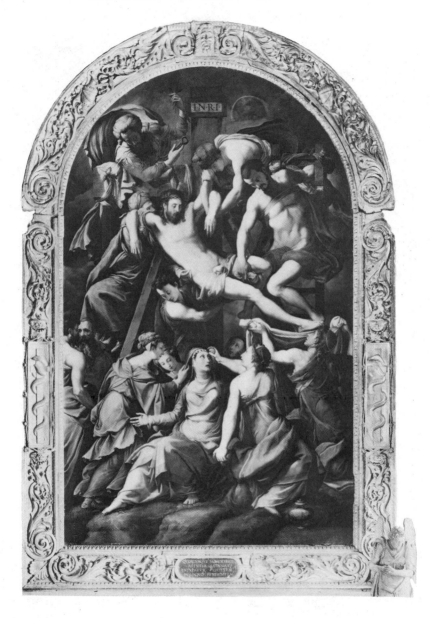

36. Anonymous, *St. John the Baptist*, statue over entrance, Oratory of S. Giovanni Decollato, Rome. Photo: Soprintendenza per i Beni Ambientali e Architettonici del Lazio, Rome.

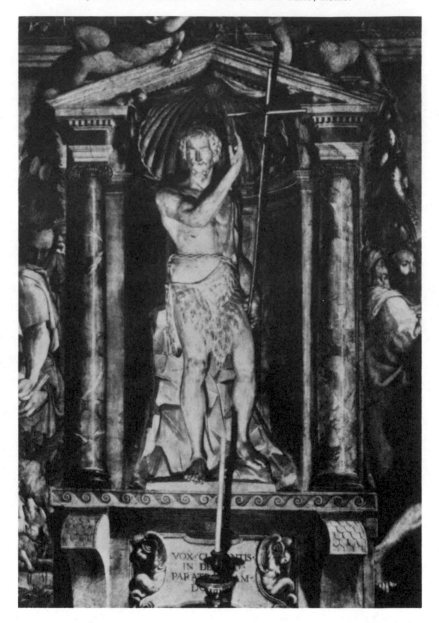

37. Perino del Vaga, study for *St. Matthew*, Cabinet des Dessins, Musée du Louvre, Paris. Photo: courtesy of Musée du Louvre.

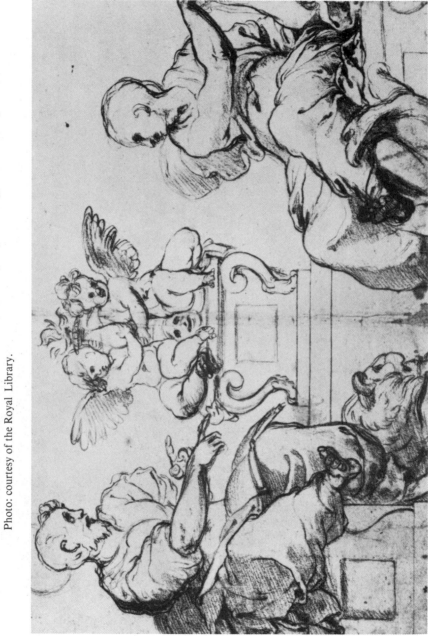

38. Perino del Vaga, study for *St. Matthew* and *St. Luke*, Royal Library, Windsor Castle, London. Photo: courtesy of the Royal Library.

39. Francesco Rosaspina, engraving after Perino del Vaga (?),
Baptism of Christ, British Museum, London. Photo: courtesy
of British Museum.

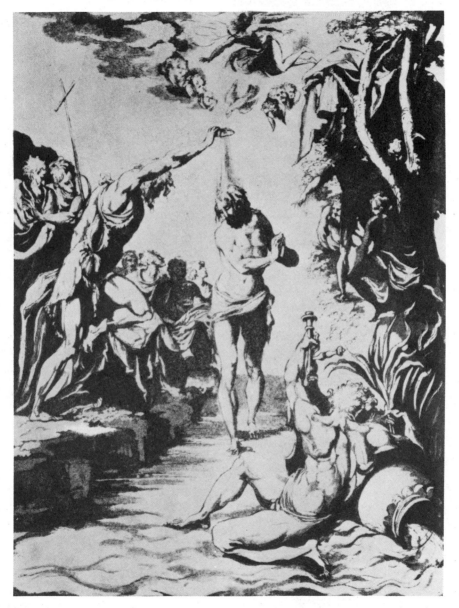

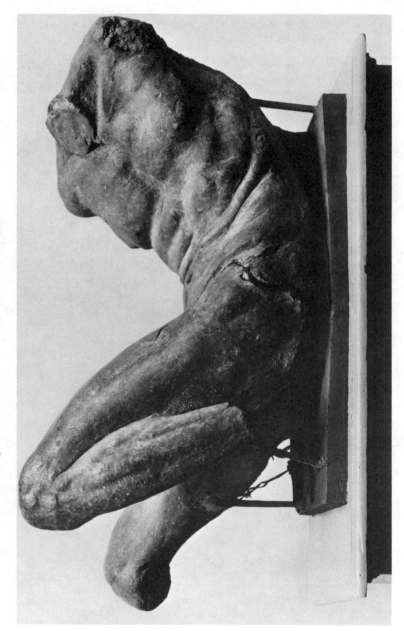

40. Michelangelo, model for a *River God*, Casa Buonarroti, Florence. Photo: Alinari.

41. Marten van Heemskerck, *View of the Capitoline Hill* (detail), Hülsen-Egger, fol. 72r.

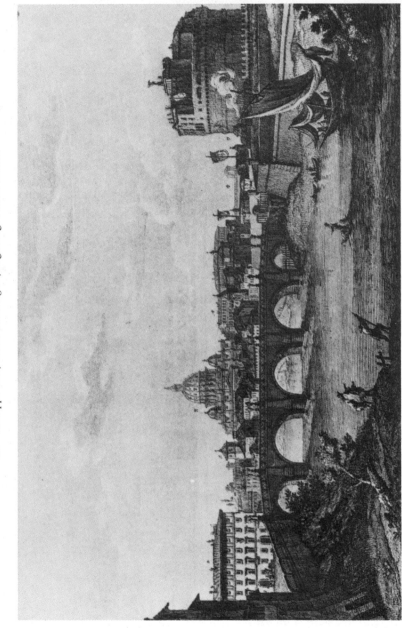

42. Giuseppe Vasi, *Ponte Sant'Angelo*, engraving. Photo: author.

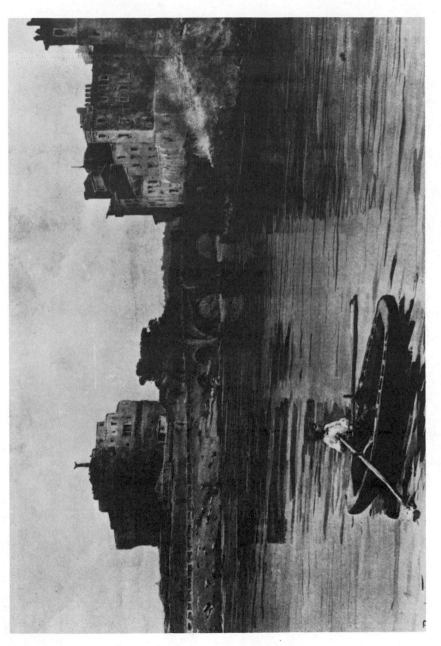

43. Ettore Roesler Franz, *The Bend of the Tiber at Castel Sant'Angelo*, Museo di Roma, Rome. Photo: courtesy of Museo di Roma.

44. Battista Franco, study for *Arrest of St. John the Baptist*, British Museum, London. Photo: courtesy of British Museum.

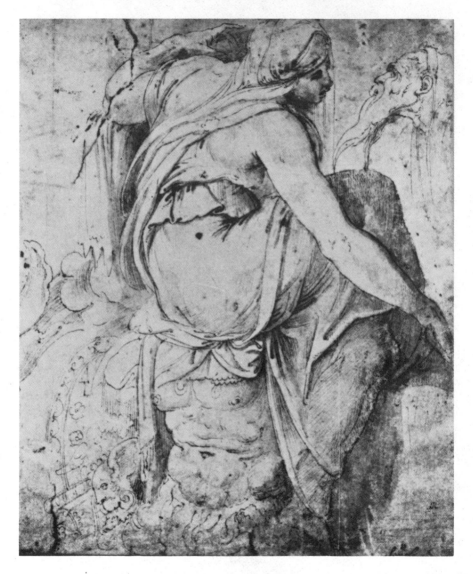

45. Battista Franco, figure studies for *Arrest of St. John the Baptist*, Cabinet des Dessins, Musée du Louvre, Paris. Photo: courtesy of Musée du Louvre.

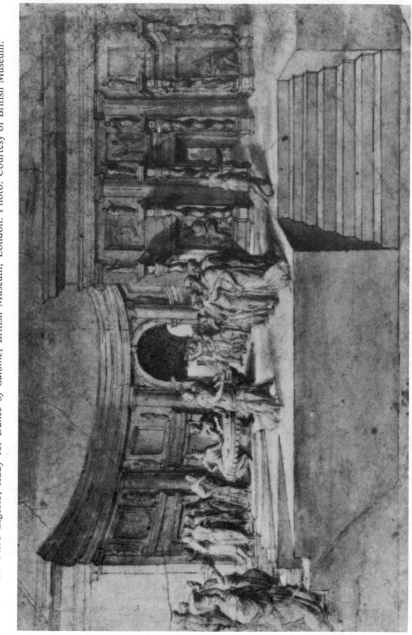

46. Pirro Ligorio, study for *Dance of Salome*, British Museum, London. Photo: Courtesy of British Museum.

47. Sebastiano Serlio, *Design for a Tragic Scene*.

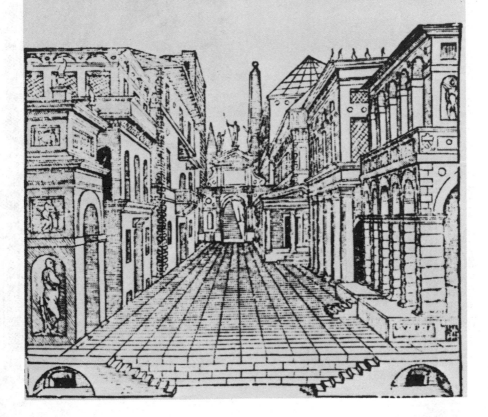

DI M. SEBASTIAN SERLIO

si saranno di grosso cartone, ò pur di tauola sottile, ben ombreggiate, & tagliate intorno, poi si metteranno alli suoi luoghi: ma siano talmente discoste, & lontane che gli spettatori non le possino vedere per fianco. In queste Scene, benche alcuni hanno dipinto alcuni personaggi, che rappresentano il viuo, come saria vna femina ad un balcone, ò dentro d'una porta, et iandio qualche animale: queste cose non consiglio che si faccino, perche non hanno il moto & pure rappresentano il viuo: ma qualche persona che dorma a buon proposito, ouero qualche cane, ò altro animale che dorma, perche non hanno il moto. Ancora si possono accommodare qualche statue, ò altre cose finte di marmo, ò d'altra materia, ò alcuna historia, ò fauola dipinta sopra un muro, che io loderò sempre si faccia cosi. Ma nel rappresentare cose viue, le quali habbino il moto: nel-l'estremo di questo libro ne tratterò, & darò il modo come s'habbino a fare.

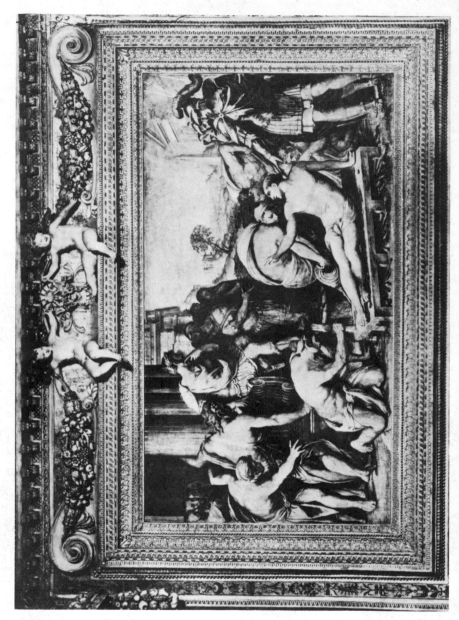

48. Francesco Salviati, *Martyrdom of St. Lawrence*, Capella del Palio, Palazzo della Cancelleria, Rome. Photo: Gabinetto Fotografico Nazionale, Rome.

49. Giorgio Vasari, *Decollation of St. John the Baptist*, Church of
S. Giovanni Decollato, Rome. Photo: author.

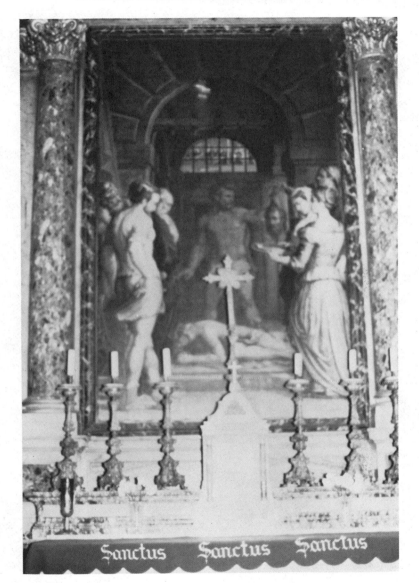

50. Michelangelo, *Last Judgment* (detail), Sistine Chapel. Photo: Alinari.

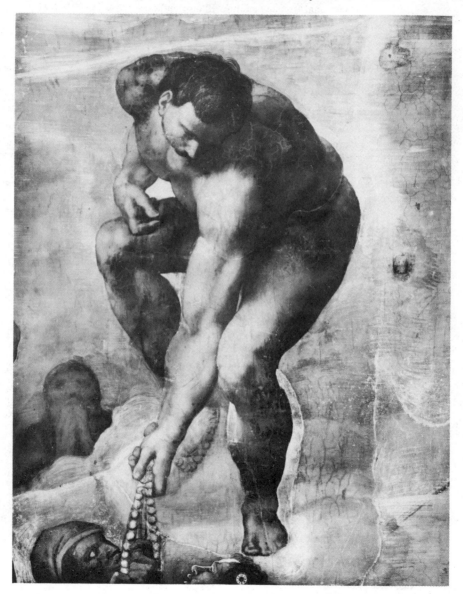

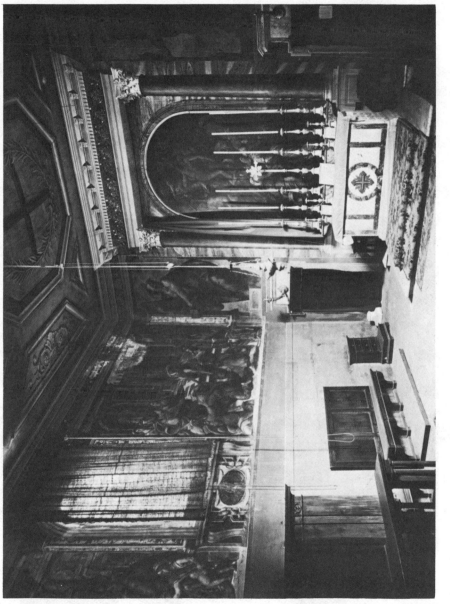

51. Altar wall of the Oratory of S. Giovanni Decollato, Rome. (Detail of fig. 9)

52. Daniele da Volterra, *Descent from the Cross*, Orsini Chapel,
SS. Trinità dei Monti, Rome. Photo: Gabinetto Fotografico
Nazionale, Rome.

53. Andrea del Sarto, *Pietà*, Palazzo Pitti, Florence.
Photo: Alinari (Anderson).

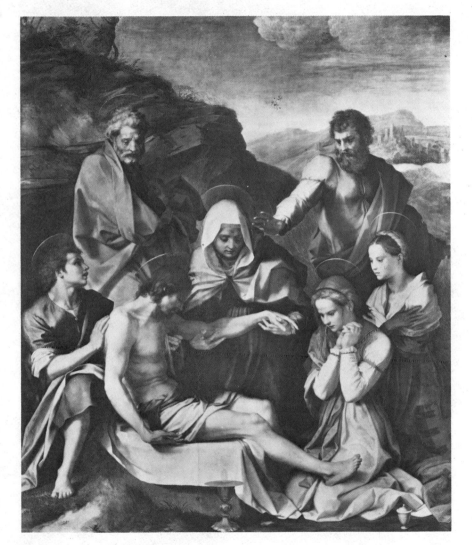

54. Pontormo, *Pietà,* Capponi Chapel, Sta. Felicità, Florence.
Photo: Alinari.

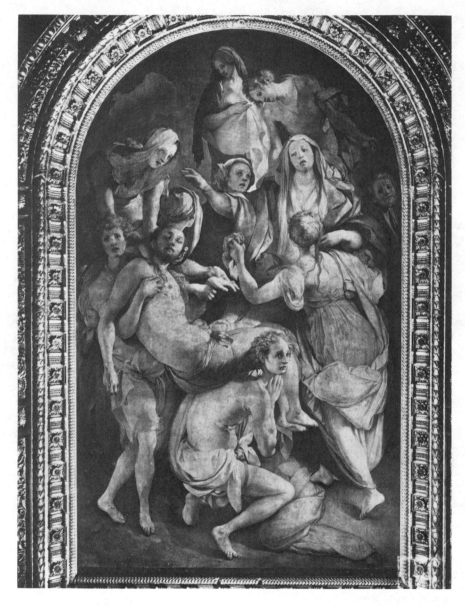

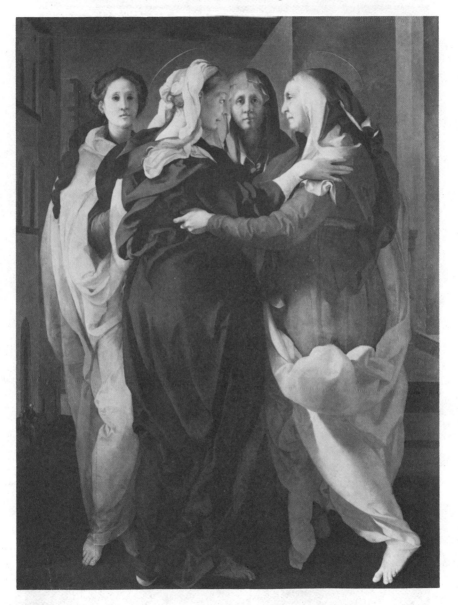

56. Perino del Vaga, *Repentant Thief*, Hampton Court Palace,
England. Photo: courtesy of Hampton Court Palace.

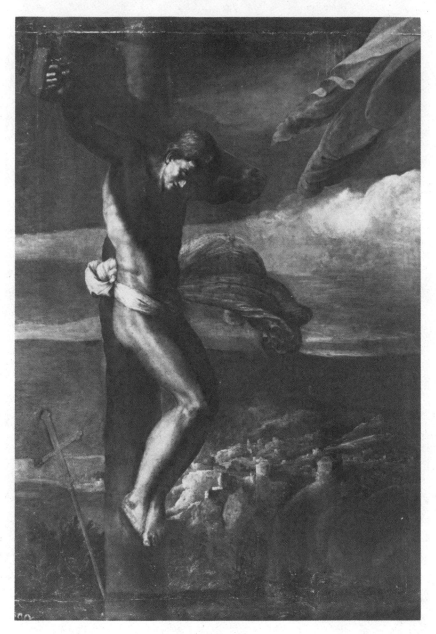

57. Perino del Vaga, *Unrepentant Thief*, Hampton Court Palace, England. Photo: courtesy of Hampton Court Palace.

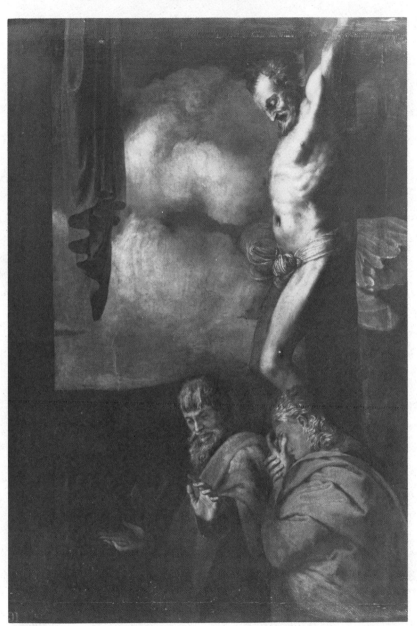

58. Perino del Vaga, study for the *Descent from the Cross*, British
 Museum, London. Photo: courtesy of British Museum.

59. Marc Antonio Raimondi, engraving after Raphael, *Descent from the Cross.* Photo: courtesy of British Museum.

60. After Michelangelo, study for the *Descent from the Cross,* Teylers-Museum, Haarlem. Photo: courtesy of Teylers-Museum.

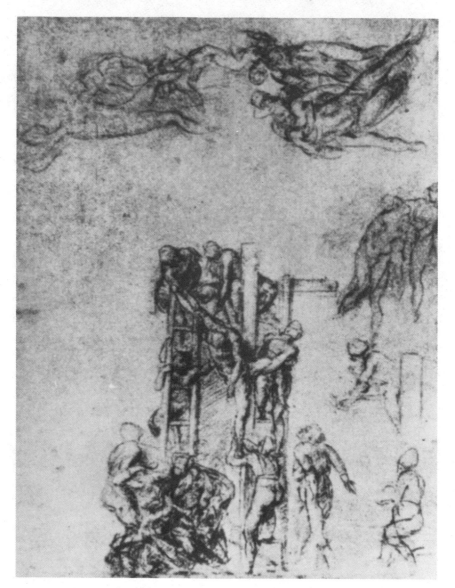

61. Anonymous, *Descent from the Cross*, stucco relief, Casa Buonarroti, Florence. Photo: courtesy of Casa Buonarroti.

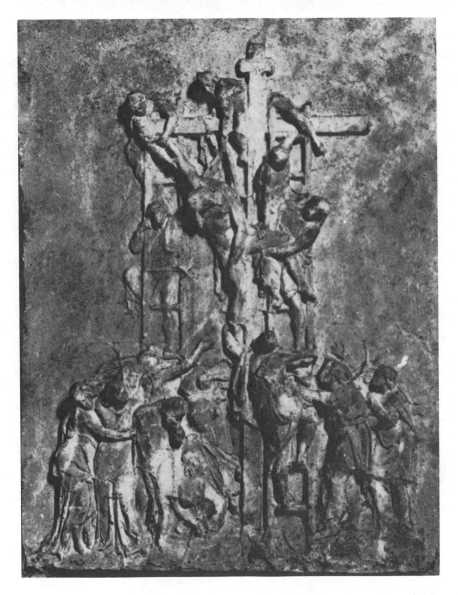

62. Jacopino del Conte, detail from *Annunciation to Zaccariah*, Oratory of S. Giovanni Decollato, Rome. (Detail of fig. 16)

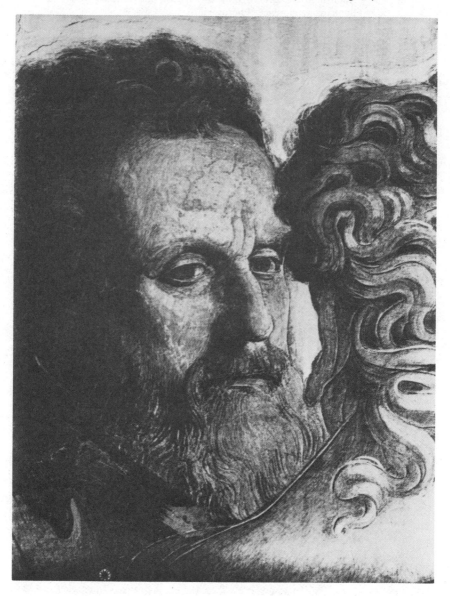

63. Jacopino del Conte (?), *Portrait of Michelangelo*, Metropolitan Museum, New York. Photo: Courtesy of Metropolitan Museum. All rights reserved.

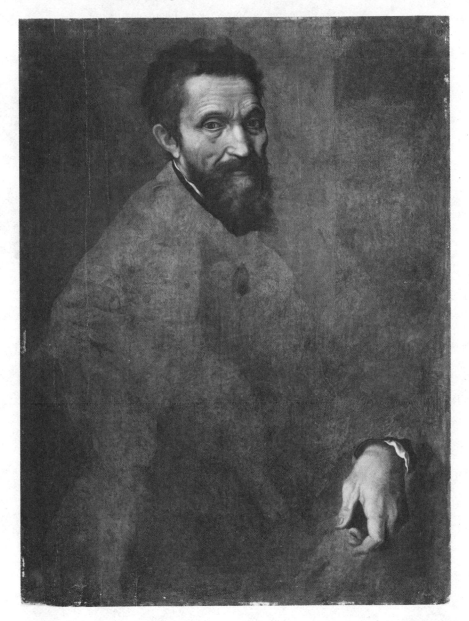

64. X ray of *Portrait of Michelangelo*. Photo: courtesy of
Metropolitan Museum. All rights reserved.

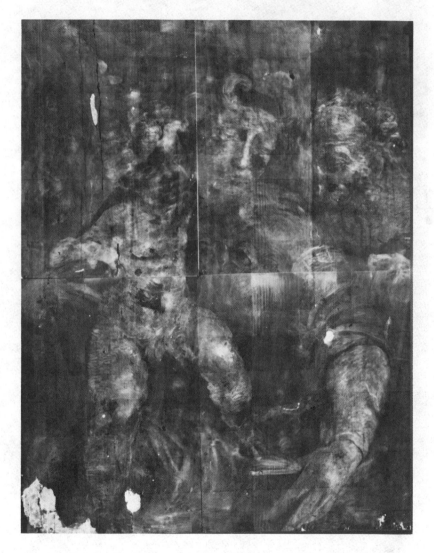

65. Jacopino del Conte (?), *Portrait of a Papal Notary,* Fitzwilliam Museum, Cambridge. Photo: courtesy of Fitzwilliam Museum.

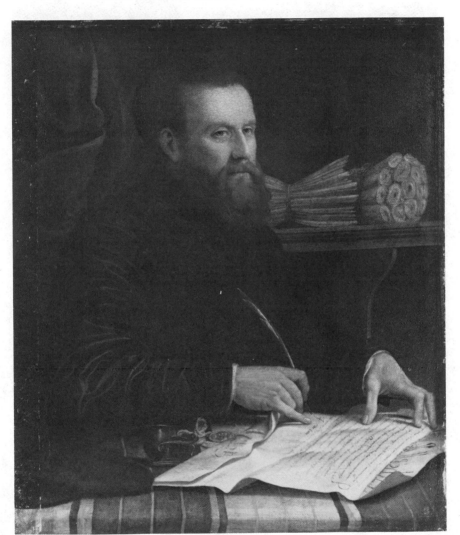

66. Jacopino del Conte, detail from *Preaching of St. John the Baptist*, Oratory of S. Giovanni Decollato, Rome. (Detail of fig. 22)

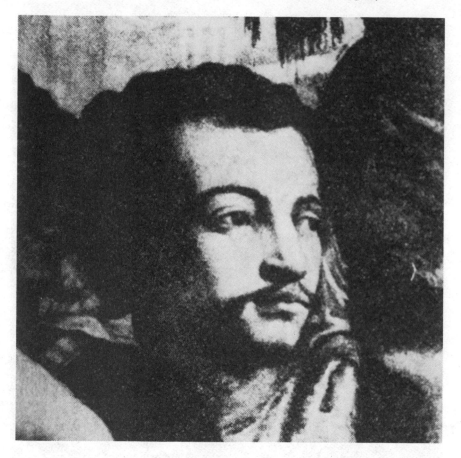

67. Jacopino del Conte, detail from *Descent from the Cross*, Oratory
of S. Giovanni Decollato, Rome. (Detail of fig. 32)

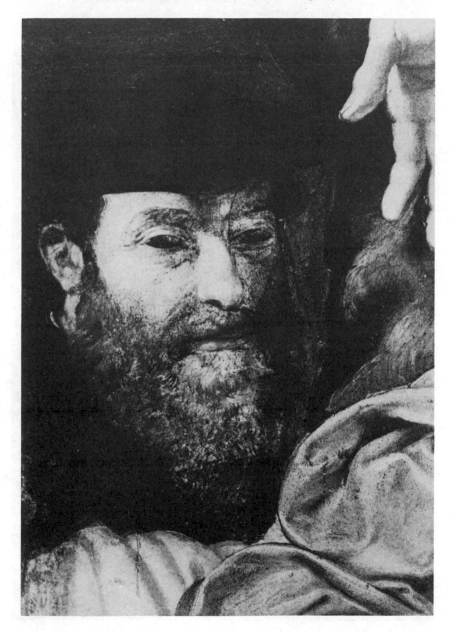

68. Jacopino del Conte (?), *Portrait of Antonio da San Gallo the Younger*, Chamber of Deputies, Rome. Photo: Gabinetto Fotografico Nazionale, Rome.

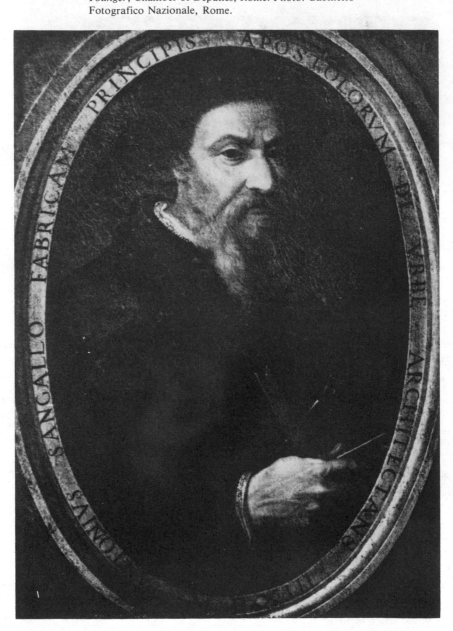

Notes

Notes for Introduction

1. For a discussion of these materials and their suppression by the Catholic Church, *see* Domenico Orano, *Liberi Pensatori Bruciati a Roma* (Rome, 1904) and Achille Pognisi, *Giordano Bruno e l'archivio di San Giovanni Decollato,* (Turin, 1891).

2. Sydney J. Freedberg, *Painting in Italy: 1500–1600,* Pelican History of Art (Harmondsworth, 1971).

3. *See* for example, Herman Voss, *Die Malerei der Spätrenaissance in Rom und Florenz,* 2 vols. (Berlin, 1920), and Adolfo Venturi, *Storia dell'arte italiana,* 9, La Pittura del Cinquecento, parts 5 and 6 (Milan, 1933).

4. Noteworthy are Michael Hirst, "Francesco Salviati's *Visitation,*" *Burlington Magazine* 103 (1961): 236–40; Michael Hirst, "Salviati's Two Apostles in the Oratorio of S. Giovanni Decollato," *Studies in Renaissance and Baroque Art presented to Anthony Blunt on his Sixtieth Birthday,* London, 1967, 34–36; Josephine von Henneberg, "An Unknown Portrait of St. Ignatius Loyola," *Art Bulletin* 49 (1967): 140–42; and Iris Cheney, "Notes on Jacopino del Conte," *Art Bulletin* 52 (1970): 32–40.

5. Vittorio Moschini, *San Giovanni Decollato. Le Chiese di Roma illustrate,* No. 26 (Rome, 1926).

6. Rolf Keller, *Das Oratorium von San Giovanni Decollato in Rom: Ein Studie seiner Fresken* (Neuchâtel, 1976).

7. Some of which had been previously published by Hirst (1967, 34). Some documents regarding the church were published by Moschini (1926, 9–10).

8. Keller, 1976, 19.

9. Loren Partridge, review of Keller's *Das Oratorium, Art Bulletin* 60 (1978): 171–73.

10. Samuel Y. Edgerton, Jr., "Maniera and the Mannaia: Decorum and Decapitation in the 16th Century." F. W. Robinson and S. G. Nichols, eds., *The Meaning of Mannerism,* papers presented at the 1970 Symposium of the New England Renaissance Society (Hanover, N. H., 1972), 67–105.

11. Freedberg, 1971, 300.

12. Often quotations in Maniera paintings consist of borrowed forms without reference to the meaning originally conveyed; *see* Freedberg, 1971, 288. However, such quotations

can also be used to communicate levels of meaning in a picture by association with the sources of the motifs; *see* Marcia B. Hall, *Renovation and Counter-Reformation* (Oxford, 1979), 40–41 and 62–63. *See also* Kurt Förster, "Metaphors of Rule," *Mitteilungen Kunsthistorisches Institut Florenz* 15 (1971): 65–104; and Chandler Kirwin, "Vasari's Tondo of 'Cosimo I with his architects, engineers, and sculptors' in the Palazzo Vecchio," *Mitt. K. I. F.* 15 (1971): 104–22.

Notes for Chapter 1

1. *Bullarum diplomatum et privilegiorum sanctorum romanorum taurinensis editio,* 5 (1860): 343–46.

2. Diomede Toni, ed., *Il Diario Romano di Gaspare Pontani: Gia riferito al "Notaio del nantiporto" (30 gennaio 1481-25 luglio 1492,* in *Rerum Italicarum Scriptores,* vol. 3, part 2, Città di Castello, 1907, 69. *See also* p. 50, n. 1; Camillo Fanucci, *Trattato di tutte l'opere pie del'alma città di Roma* (Rome, 1601), 335, states that the confraternity was founded 8 May 1488; this is also the founding date given in the statutes (*Statuti dell'arciconfraternita di S. Giovanni Decollato,* Rome, 1883, 1).

3. Fanucci, 1601, 321–22; *see also* Emilio Rufini, *S. Giovanni de'Fiorentini. Le Chiese di Roma illustrate,* no. 39 (Rome, 1957), and Armando Pozzolini, *Arciconfraternite Fiorentini in Roma* (Florence, 1904), 11.

4. The Confraternity of Santa Maria della Misericordia was founded in Florence during the thirteenth century for the same purpose. *See* Howard Saalman, *The Bigallo: The Oratory and Residence of the Compagnia del Bigallo e della Misericordia in Florence* (New York, 1969), 5.

5. Keller (1976, 11, n. 3) states incorrectly that S. Giovanni Decollato did not originate in the Compagnia della Pietà, which began in 1519 with the construction of S. Giovanni dei Fiorentini. He may be confusing the Compagnia della Pietà, which was founded in 1448, with the Arciconfraternita della Carità, which was founded in 1519 by Cardinal Giulio de Medici. He also seems to have been confused by the application of the term Battuti, but the Compagnia della Pietà was referred to during the fifteenth century as the Compagnia dei Battuti. Careful reading of the diary makes it quite clear that Pontani is referring to the Compagnia della Pietà. Edgerton, 1979, 57, n. 9, states that S. Giovanni Decollato was affiliated with the Florentine Company of the Misericordia. I have found no evidence to support this statement, however, Cheney, 1970, 35, also refers to S. Giovanni Decollato as the Roman branch of the Florentine Company of the Misericordia.

6. On 7 March 1488. *See* Pontani-Toni, 1907, 69.

7. The Tor di Nona, which was built in the fourteenth century by the Orsini, became a prison early in the fifteenth century. The brothers of S. Giovanni Decollato assisted prisoners in all of the Roman prisons (the other two largest prisons during the late fifteenth and sixteenth centuries were the Campidoglio and Corte Savella), but they were most frequently called to the Tor di Nona, and most executions took place on the Piazza di Ponte Sant'Angelo (though the Campidoglio and Piazza Navonna were also used).

8. For discussion of the practices of the Compagnia dei Neri, *see* Samuel Y. Edgerton, Jr., "A little known 'purpose of art' in the Italian Renaissance," *Art History* 2 (1979): 45–61. *See also* Giovanni Battista Uccelli, *Della Compagnia di S. Maria della Croce al Tempio* (Florence, 1861), and Eugenio Cappelli, *La Compagnia dei Neri* (Florence, 1927).

9. The earliest extant is Zanobi de Medici, *Trattato utilissimo in conforto de condennati a morte in via di giustizia,* Ancona, 1572. This trattato not only provides instructions for the members of the confraternity but emphasizes the importance of their role in helping the condemned to die with repentance, acceptance, and dignity. Pompeo Serni, *Memorie a fratelli della Ven. Arciconfraternita di S. Giovanni Decollato detto della Misericordia della Natione fiorentina in Roma. Per la solita prattica d' aiutare a ben morire i condannati a morte,* 1653 (Cod. Vat. Reg. 2084), is a later elaboration of Medici's material. Francesco Riccardi, *Direttori per il Maestro de' Cerimonie della Ven. Arciconfraternita di S. Giovanni Decollato in Roma* (Rome, 1773), discusses the mechanical details of the processions—dress, torches, carrying the crucifix, and so on. He also discusses in detail the procedure for freeing a prisoner once a year. The privilege of selecting a prisoner to be freed once a year on the Feast of the Decollation of St. John the Baptist (29 August) had been granted by Pope Paul III in 1540.

10. This is the material that was taken from the Archive of S. Giovanni Decollato by the state in 1891. The following were relevant to this study: list of *giustiziati* in the *Inventario* #285; *Libri di Testamenti,* vols. 30 (1526–33), 31 (1540–64), and 32 (1542–50); and *Giornale del Provveditore,* vols. 1 (1506–10), 2 (1510–17), 3 (1517–22), 4 (1556–65), and 5 (1562–66). It is unfortunate that the volumes of the *Giornale del Provveditore* for the years during which the construction and decoration of the oratory took place are missing. However, some of the contents of the missing volumes are available in a later compilation. *See* archives of S. Giovanni Decollato, Credenza F, *Rubricella Generale di tutto ciò si contiene nei giornali del provveditore, compilata dal fratello Guido Bottari, Archivista.* This compilation is undated, but the handwriting appears to be of the eighteenth century and material is included through the seventeenth century. I was able to check the accuracy of Bottari's compilations by comparing entries with the original ones in the existing volumes of the *Giornali del Provveditore.*

11. In addition to helping condemned prisoners, the Confraternity of S. Giovanni Decollato engaged in other acts of charity, such as giving assistance to needy Florentines, particularly spinsters, widows, and orphans.

12. Medici, 1572, 2.

13. Medici, 1572, 9.

14. Medici, 1572, 13–16.

15. Medici, 1572, 10, 25, 28.

16. For a detailed discussion of these *tavolette* and their use by the Confraternity of S. Giovanni Decollato and the Compagnia dei Neri of Florence, *see* Edgerton, 1979.

17. The Oratory of S. Giovanni Decollato was not built until the 1530s, and the brothers frequently assembled in the Oratory of Sant'Orsola which belonged to the Confraternity della Pietà. They continued to assemble there even after their own oratory was completed, probably because Sant'Orsola, located on the Vicolo del Consolato, was nearer to the Tor di Nona. It was destroyed in 1889 when the Corso Vittorio Emanuele was created.

18. Serni, 1653, 23. Again it should be noted that the Compagnia dei Neri followed the same practice.

19. It is not clear just when construction of the church and cloister was far enough along for commencement of this practice, but the privilege was included in the original bull, and

mention of burying executed prisoners appears in the early records. For example, as early as 1511 there is an entry in the *Giornali del provveditore* noting that thirty *fratelli* were deputized to bury the *giustiziati*. *See* Bottari, 69.

20. Prisoners of higher social standing were usually decapitated; heretics were burned, sometimes alive, sometimes after having been hanged; there is occasional mention of a prisoner being drawn and quartered; but hanging was by far the most common means of execution.

21. Fanucci, 1601, 335. Fanucci also provides a brief account of the confraternity's practices of assisting the prisoners which corresponds with those cited above.

22. This privilege was granted by Pope Paul III in a bull of 1540 (see *Bullarum diplomatum* 5: 770), but it had been considered as early as 1513 when at a meeting the members discussed asking Pope Leo X for permission to free one condemned prisoner each year on the day of their *festa*. *See* Bottari, 70.

23. For discussion of the selection process and description of the procession and ceremony, *see* Riccardi, 1773, 20–26, and Matizia Maroni-Lumbroso and Antonio Martini, *Le confraternite romane nelle loro chiese* (Rome, 1963), 169–70.

24. *See* for example, *Giornali del Provveditore* 4: 3, for a notation stating that on 3 June 1556, five members paid ฿ 15 each for "rifiuta de trenta." It was the custom to keep a roster of thirty men variously called "trenta della sera," "trenta della giustizia," or "deputj per la notta," who were to participate in the processions carrying the corpses of the condemned from the gallows and then burying them.

25. Occasionally the professions or trades of the *confortatori* or officers were listed in the *Giornali del Provveditore* or *Libri di Testamenti*, after their names. *See* for example, *Giornali del Provveditore* 3: 25, and *Libri di Testamenti*, vol. 3, testament of 28 May 1526. *See also* Melissa M. Bullard, "Mercatores Florentini Romanam Curiam Sequentes in the early sixteenth century," *Journal of Medieval and Renaissance Studies* 6 (1976): 51–71. It is well known, of course, that Michelangelo was among the Florentine artists who belonged to S. Giovanni Decollato, but he does not seem to have been a very active member. *See* chapter 3, no. 51.

26. *Bullarum diplomatum* 5:345 and 7:768. The original bull of Innocent VIII granted the Confraternity the privilege of inheriting from the condemned "sine praeiudicio fisci." Clement VII, in 1534, conceded the legacy "anche in praeiudicio fisci" but with a limit of six gold ducats; Paul III, in 1537, raised the limit to ten ducats; and Julius III, in 1551, further raised it to twenty-five ducats.

27. Moschini (1926, 8) was the first to suggest this; *see also* Milton Lewine, "The Roman Church Interior, 1527–1580," Ph.D. diss. Columbia University, 1960, 270, and Iris Cheney, "Francesco Salviati (1510–1563)," Ph.D. diss. New York University, 1963, 237–38.

28. For example, in *Libri di Testamenti*, vol. 31, on 4 May 1553, was recorded the testament of Ortado di trogora Castigliano, who left two black satin jackets, one embroidered shirt, two scudi, one suitcase, one handkerchief, one desk, one cap with velvet trim, one pair of boots, and six giulii (in the desk).

29. The testament of Pietro di Motanuccio da Montefranco, of 24 January 1540, in *Libri di Testamenti*, vol. 31, includes instructions for the distribution of the money he left to various relatives and to pay his debts. In the same volume, the testament of Giulio di

nardo da Velletri, of 16 May 1550, has a long and detailed list of possessions to be given to his wife and relatives; the testament of Giovanni di Biagio da Rignano, of 12 February 1552, lists grain, wine, and various household goods with the request that the confraternity pay his debts; and the testament of Fabrizio Lecere da Napoli, also of 12 February 1552, left fifty scudi "per l'anima mia" with the request that his body be sent to Naples for burial.

30. This was very common. A few examples from *Libri di Testamenti,* vols. 30 and 31: on 28 May 1526, Cristofano. . .di Castello left four gold ducats to S. Giovanni Decollato to have masses said for his soul; on 14 December 1547, Girolamo di jacopo da Lucca requested that the confraternity write to his mother in Naples and ask her to send three or four scudi to S. Giovanni Decollato to "far tanto bene per l'anima sua"; and on 16 May 1550, Giulio di nardo da Velletri left ten giulii with instructions that the money be used for "atti bene per l'anima sua."

31. In June 1979 I found records of the commissions of the altarpieces in the Archive at S. Giovanni Decollato. *See* below, chapter 3, n. 47.

32. Giorgio Vasari, *Le Vite di' piu eccellenti pittori, scultori, ed architettori* [1568], G. Milanesi, ed., Florence, 1906, 7:16, 31.

33. The name of Giovanni da Cepperello appears forty times between 3 September 1532 and 15 June 1556 and that of Battista da San Gallo nine times between 3 September 1532 and 31 August 1543. (*Libri di Testamenti,* vols. 30, 31, and 32.) There is a gap in the extant *Libri* between 1533 and 1540. Most likely both men served frequently during those years also.

34. On 3 September, 6 September, and 11 December. *Libri di Testamenti,* vol. 30. The provveditore always attended the prisoner along with the *confortatori* and recorded the testaments and the other information included in the *Libri di Testamenti.*

35. *Libri di Testamenti,* vol. 31.

36. Bottari's compilation of entries from the *Giornali dei Provveditore* includes a *Catalogo de' Fratelli* with the dates when individuals became members. Again, I was able to check the accuracy of his entries by comparing them with the original entries in the existing volumes of the *Giornali del Provveditore* in the Archivio di Stato.

37. Delameau, Jean, *Vie économique et sociale de Rome dans la seconde moitié du XVI^e siècle, Bibliothèque des Ecoles Francaises d'Athenes et de Rome,* 184, 1: (Paris, 1957–59): 209.

38. He was the patron of Raphael, Cellini, and Vasari. Vasari painted several pictures for Altoviti during the 1540s prior to being commissioned in 1551 to paint the altarpiece for the Church of S. Giovanni Decollato. It is significant that Vasari became a member of the confraternity at exactly the same time Bindo Altoviti joined. Bottari's compilations cite the volumes and page numbers in the original *Giornali del Provveditore.* The reference for both Altoviti and Vasari is 1551, 9: 66.

39. In May 1559 a committee, consisting of Ruberto Ubaldini, Francesco Bandini, and Tommaso De Bardi, asked Michelangelo for designs. *See* Rufini, 1957, 15.

40. The name of Bartolommeo Cappelli (or Cappello) appears forty-one times between 20 September 1541 and 6 April 1560. (*Libri di Testamenti,* vols. 31 and 32.)

41. Emilio Rufini, *Michelangelo e la Colonia fiorentina a Roma,* 1965, 11; *see also* archives of S. Giovanni dei Fiorentini, *Catalogo,* Part 3, *Ospedale e Notarii,* 581.

42. Archives of S. Giovanni dei Fiorentini, Part 3, *Ospedale e Notarii,* 600.

43. Coriolano Belloni, *Un banchiere del Rinascimento, Bindo Altoviti* (Rome, 1935), 28.

44. On 12 May 1550. *Libri di Testamenti,* vol. 31.

45. He served five times between 4 May 1553 and 23 August 1553. *Libri di Testamenti,* vol. 31.

46. During the late 1550s and early 1560s the names of Bartolommeo Bussotti, Ruberto Ubaldini, and Giovanni Battista Altoviti appear among those marching in processions on feast days, carrying candles to the pope, to various cardinals, and to the senate. Also during the 1560s Ubaldini served as *governatore* of the confraternity. *See Giornale del Provveditore* 4 (1556–65): 99, 164, 204, 225.

47. *Bullarum diplomatum* 5: 343; *see also Privilegii et gratie concesse da diversi romani pontifici alla venerabile Compagnia de S. Giovanni Decollato, detta della Misericordia della natizone Fiorentina di Roma,* July, 1560.

48. As Florentine bankers in Rome, involved in papal finances, it was important to these men to remain in favor with the pope. This was particularly true in the case of Bindo Altoviti, who was out of favor with Cosimo de' Medici (*see* Delumeau, 1957, 210). Participation in the confraternity's activities, which were to be more and more involved with the actions of the inquisition against heretics, may have been a demonstration of support for papal policy.

Notes for Chapter 2

1. For the most precise and detailed description of the plan and interior of the church, *see* Lewine, 1960, 266–83. However, his description of the interior of the oratory is misleading in that he implies that the *aedicula* for the statue of St. John the Baptist and the frame of the altarpiece are actual architectural structures rather than painted. For descriptions of both structures, *see also* Moschini, 1926, and Walther Buchowiecki, *Handbuch der Kirchen Roms* 2 (Vienna, 1970): 76–85.

2. In the bull of Innocent VIII, the structure is spoken of as a "domum dirutam" belonging to the Confraternity of the Ferrari. This has been traditionally interpreted as referring to the Church of Sta. Maria della Fossa. The presence of fourteenth-century fragments, including a tombstone dated 1395, indicates that there was a church on the site. *See* Lewine, 1960, 276; Moschini, 1926, 6–7; and Mariano Armellini, *Le Chiese di Roma dal secolo IV al XIX* 2 (Rome, 1891 [1942]: 778–79.)

3. *Bullarum diplomatum* 5:343.

4. Moschini, 1926, 8.

5. *See* Vincenzo Forcella, *Iscrizioni delle chiese e d'altri edifici di Roma dal secolo XI fino ai giorni nostri* 7 (Rome, 1876): 49–66. Forcella cites inscriptions on tombstones of confraternity members dated 1490 and 1491, but they no longer exist, and the actual original locations of those tombstones is not known.

6. Archive of S. Giovanni Decollato, *Libri dei creditori e debitori 1531–1550,* 231, 241. In 1546 Benedetto da Fiesole, scalpellino, was paid 95 scudi "per due porte di tavertino e altri lavori...quali...servirono per la nostra chiesa" and on May 1546 Benvenuto Ulivieri was paid 50 scudi "per fare la soffita di chiesa nostra."

7. *See* Fioravante Martinelli, *Roma ricercata nel suo sito* (Rome, 1658), 58–59.

8. *Statuti dell'arciconfraternita di S. Giovanni Decollato* (Rome, 1883), 3.

9. *Privilegii et gratie concesse da diversi Romani pontifici alla venerabile Compagnia di S. Giovanni Decollato, detta della Misericordia della natione Fiorentina di Roma* (Rome, 1560), 3.

10. Bottari, 70, 71. *See also* Archivio di Stato di Roma, S. Giovanni Decollato, *Libro di Giustiziati,* 1536, "ferrante di Francesco, Siciliano, impiccato per aver rubato una tovaglia ed un Paliotto di velluto alla nostra Chiesa."

11. Lewine, 1960, 270. He assumes that the increased income resulting from the bull of Clement VII in 1534 made construction financially possible, but as stated above, I doubt that the amounts from the legacies of prisoners were significant.

12. For the relationship between S. Giovanni Decollato and Sto. Spirito in Sassia, *see* Milton Lewine, "Roman Architectural Practice during Michelangelo's Maturity," *Stil und Uberlieferung in der Kunst des Abendlandes,* Acts of the 21st International Congress for Art History, 2 (Berlin, 1967): 20–26.

13. Bottari, *Catalogo dei Fratelli.*

14. His will, dated 19 October 1548, is published in Gustave Clausse, *Les San Gallo* 3 (Paris, 1902): 286–87.

15. Battista assisted his brother Antonio da San Gallo the Younger with many of his projects. According to Vasari, he devoted all of his time to his brother's buildings (Vasari-Milanesi, 5: 471). It is beyond the scope of this study to attempt to prove that Battista was the architect of S. Giovanni Decollato. The matter may not be subject to proof. However, in a conversation during the early summer of 1979, the late Milton Lewine indicated that he had not been aware of Battista da San Gallo's deep involvement with the confraternity. He agreed that in light of this, the suggestion that Battista was the architect of S. Giovanni Decollato made good sense.

16. Bottari, *Catalogo dei Fratelli.*

17. Archive of S. Giovanni Decollato, *Libro di entrata e uscita dal 1550 al 1556,* 37.

18. Moschini, 1926, 10.

19. Archivio di Stato di Roma, *Giornale del Provveditore* 2: 98. Gustavo Giovannoni, *Antonio da San Gallo il Giovane* 1 (Rome, 1959): 88, 194, 475, claimed that Battista's name was Francesco originally, and therefore he would have been Francesco di Bartolommeo. However, the fact that Francesco di Bartolommeo and Battista are recorded as becoming members of the confraternity at different times indicates that they must have been two individuals—presumably brothers.

20. Keller (1976, 59) found in the Archive of S. Giovanni Decollato an account dated 1536 for masonry work in the oratory (*Libro dei creditori e debitori, 1531–49,* 151).

21. In 1551 the altarpieces for the church and oratory were commissioned, and payments were made to Salviati in 1550 and 1551 for the two Apostles and the *Nativity of St. John the Baptist* in the oratory. See citations of documents in chapter 3.

22. Lewine (1960, 50, n. 1) indicates that the walls of the oratory were decorated with frescoes at a time when the walls of churches being built in Rome were not so decorated and suggests that the iconography of the oratory was important.

23. For example, the Oratory of S. Bernardino in Siena is a structure of similar form, decorated with frescoes on the upper halves of the walls above a wooden dado and benches very like those in the Oratory of S. Giovanni Decollato; they are separated by pilasters decorated with *grotteschi* similar to some of the fictitious pilasters in S. Giovanni Decollato.

24. Lewine, 1960, 15–16, 49.

25. At this time, as stated in an inscription on the ceiling, the oratory was renovated, and the frescoes were restored.

26. Keller (1976, 17) suggests that the ceiling dates from the nineteenth century.

27. It is now in the confraternity's offices. Keller (1976, 17) refers to it as a *tumulo*.

28. S. Giovanni Decollato was the first of seven oratories built in Rome between 1530 and 1580. *See* Lewine, 1960, for descriptions of the others.

29. For the Oratory of the Crocefisso *see* Josephine von Henneberg, *L'Oratorio dell'Arciconfraternita del Santissimo Crocefisso de San Marcello* (Rome, 1974); for the Oratory of the Gonfalone, *see* Alessandra Molfino, *L'Oratorio del Gonfalone* (Rome, 1964). Barbara Wollesen-Wisch of the University of California, Berkeley, is writing a dissertation on the Gonfalone. Her approach to the material is similar to my treatment of the Oratory of S. Giovanni Decollato.

30. They probably assembled there occasionally for the processions to the prisons, but, as I stated above, they used the Oratory of Sant'Orsola more frequently.

Notes for Chapter 3

1. Vasari-Milanesi, 6:579–80; 7:16–17, 31, 576.

2. *See* note 44 below.

3. Two of the artists who worked in the oratory, Francesco Salviati and Jacopino del Conte, had been in Andrea del Sarto's shop. In the life of Salviati, Vasari says that he was in Andrea's shop during the siege of Florence (Vasari-Milanesi, 7: 10), and in the life of Andrea del Sarto, Salviati and Jacopino del Conte are both listed among the pupils of Andrea (Vasari-Milanesi, 5:58).

4. As was noted by Partridge (1978, 171).

5. Voss (1920, 1:142–44) was the first to suggest that the Bonasone print was a reflection of Jacopino's design for a fresco in the oratory.

6. Partridge (1978, 172) suggests that the frescoes were "organized according to a principle of responsive contrasts." As attractive as some of his suggestions are, such an interpretation assumes that a detailed, preplanned iconographical structure was adhered to throughout the long process of completions of the decorations.

7. Keller (1976, 124) was the first to identify the subject, and he drew the same conclusion about the originally planned inclusion of additional episodes.

8. Keller (1976, 126) identifies the subject of this simulated relief as the *Daughter of Time* (*veritas filia temporis*). I had at first believed that *Truth Revealed by Time* was indeed the subject, but my colleague Susan B. Downey pointed out that the wings on the male

figure suggest the subject of *Eros and the Sleeping Ariadne* as depicted on Roman Dionysiac sarcophagi.

9. *See* Edgar Wind, *Pagan Mysteries in the Renaissance,* 1968, 154, and Betty Radice, *Who's Who in the Ancient World,* 1975, 66.

10. *See* Freidrich Matz, *Die Dionysischen Sarkophage,* 4 vols., Berlin, 1968.

11. British Museum, Fawkener Collection, 5211–27, pen and sepia ink and sepia wash. This drawing was first published by Hirst (1961, 239) who noted the difference in format but concluded that Salviati had been unaware at first of the shape and size of the surface he was to paint.

12. Cheney (1963, 74 and 239, note 249) suggests that a drawing of the *Birth of the Baptist* in the Victoria and Albert Museum (Dyce Collection, #289) is by Giuseppe della Porta after Salviati's design for the birth scene in the oratory. She drew the same conclusion about the square format. The attribution of the drawing is by no means certain, but the inclusion of the unusual motif of the girl carrying doves as well as the similarity of the composition to Salviati's fresco lend support to this hypothesis.

13. An earlier Florentine precedent for the inclusion of Virtues in a St. John the Baptist cycle exists in the fourteenth-century doors by Andrea Pisano. However, the presence of the apostles Andrew and Bartholomew flanking the altarpiece suggests the possibility of an earlier plan to include other Apostles as well.

14. This emphasis on the dates of the frescoes is most unusual. One can only speculate about the reason for it. It could be an expression of the Maniera intensification of historical and stylistic consciousness. However, if this were the case, there should be other similar instances. It seems more likely that it is another example of the almost fanatical diligence with which every activity of the confraternity was recorded.

15. Specifically, this border resembles Raphael's Vatican tapestries, which, as will be discussed below, also inspired the composition.

16. Cheney (1963, 71) believes the decorative framework was not begun until after the *Annunciation to Zaccariah* was painted and that the border was added to make the picture large enough to fit the framework. This is possible but does not explain the absence of a cartouche and other differences in the framework around the *Annunciation to Zaccariah*.

17. The following dates have been published: 1535 by Voss, 1920, 1: 140, Venturi, 1925–34, 9: 6, 219, and von Henneberg, 1967, 140; ca. 1537 by Freedberg, 1971, 303, Cheney, 1963, 53, and Federico Zeri, "Salviati e Jacopino del Conte," *Proporzioni,* 2, 1948, 181, and "Intorno a Gerolamo Siciolante," *Bolletino d'Arte* 36, ser. 4 (1951): 140. Cheney later suggested (1970, 35) that the date of ca. 1537 could be pushed back a year. Keller (1976, 59), on the basis of the 1536 masonry payment he discovered said that the fresco could not have been begun prior to 1536 as the oratory was still under construction then.

18. Vasari-Milanesi, 7:16.

19. Zeri, 1948, 181.

20. Cheney, 1970, 34.

21. *See* B. Podestà, "Carlo V a Roma nel 1536," *Archivio della societa Romana di Storia Patria* 1 (Rome, 1878): 309.

22. Freedberg (1971, 501, n. 16) notes the origin in Sarto's Scalzo frescoes and suggests that Jacopino was responsible for the basic scheme.

23. The importance of these decorations for the development of Maniera in the 1530s is stressed by Craig Hugh Smythe in *Mannerism and Maniera* (New York, 1962), 75, n. 162. For descriptions and accounts, including expenses, of this event *see* Podestà, 1878, 303–44; Vincenzo Forcella, *Feste in Roma nel Pontificato di Paolo III 1534–1545* (Rome, 1885), 39–50; and Rodolfo Lanciani, *The Golden Days of the Renaissance in Rome* (Boston-New York, 1906), 110–11.

24. Vasari-Milanesi, 6:579.

25. Cheney, 1963, 73.

26. Cheney, 1963, 75, n. 96.

27. As suggested by Cheney (1970, 36, n. 23) Jacopino probably executed the painted architectural framework on the entrance wall, the altar wall, and most of the street wall. This was most likely done between 1538 and 1541 while he was painting the narratives on the entrance wall. These portions of the framework are consistent in style and use of antique motifs (pilasters with grotesque ornament supporting a frieze decorated with vases, sphinxes, and acanthus, and simple cartouches centered over each episode) and flatter than the elaborate illusionistic ornament surrounding Salviati's *Visitation* and *Nativity* as well as most of Franco's *Arrest* (the pilaster on the right of the *Arrest* is part of Jacopino's system), including the decoration of Salviati's false window and Franco's decoration of the real window to the left of the *Arrest*. The simulated reliefs below the narratives were painted by the artists of the respective frescoes.

28. Albertina, #23751, 21.7 cm. by 23 cm., pen. This drawing was published by Anny E. Popp, "Jacopino del Conte 1510–1598—St. John the Baptist Preaching—Vienna, Albertina," *Old Master Drawings* 2 (1927-28): 7–8, as by Jacopino. The attribution to Perino, which has been generally accepted, was made by Phillip Pouncey and first published by J. A. Gere, "Drawings in the Ashmolean Museum," *Burlington Magazine* 99 (1957): 161. *See also* J. A. Gere, "Two Late Fresco Cycles by Perino del Vaga: The Massimi Chapel and the Sala Paolina," *Burlington Magazine* 102 (1960): 13, n. 16.

29. *See* Michael Hirst, "Perino del Vaga and his Circle," *Burlington Magazine* 108 (1966): 402, n. 13.

30. This was first suggested by Cheney (1963, 70–71) and later by Bernice Davidson, in *Perino del Vaga e la sua cerchia,* Florence, 1966, 39–40. Hirst (1966, 402) on the other hand, connects the drawing to Perino's Pisa adding Duomo project, that "in the absence of any mention in the sources of a connection between Perino and the oratory such a hypothesis raises more problems than it solves."

31. Vasari-Milanesi, 5: 620.

32. Though a new contract was not drawn up until 25 April 1539, the fact that Perino's drawings for the evangelists are reflected in the fresco of the *Preaching* indicates that he must have taken up work on the project prior to that date.

33. The traditional date of ca. 1540/41 was maintained by Cheney (1970, 37) and Keller (1976, 74) but rejected in favor of a date in the late 1540s by von Henneberg (1967, 41) and Freedberg (1970, 304).

34. *See* note 47 below. *See also* Jean S. Weisz, "Daniele da Volterra and the Oratory of S. Giovanni Decollato in Rome," *Burlington Magazine* 123 (1981): 335–36.

35. Vasari-Milanesi, 6:579.

36. Giovanni della Casa, in addition to being a well-known author, was active in the papal service during the Counter-Reformation. In 1544 Pope Paul III sent him to Venice as Apostolic Nuncio. He was responsible for the intensification of the activities of the Inquisition in Venice; he directed the process against Pietro Paolo Vergerio, among others, and staged public book burnings. In 1549 he published the first Index of forbidden books. Later he was secretary and confidential assistant to Pope Paul IV. *See* Ludwig von Pastor, *History of the Popes* 12 (St. Louis, 1923): 513; L. Campana, "Monsignore Giovanni della Casa e i suoi tempi," *Studi Storici* 17 (Pisa, 1908): 145–282; and Girolamo Tiraboschi, ed., *Opere di Monsignor Giovanni della Casa,* vol. 1, *Classici Italiani* (Milan, 1806), 70. The exact nature of Monsignore della Casa's relationship with the Confraternity of S. Giovanni Decollato is not known. He does not seem to have been a member. However, it was customary for lay confraternities to have a "protector" among the church hierarchy, and that may have been the role of della Casa.

37. Vasari-Milanesi, 6:576–78.

38. However, Franco had been among the artists, along with Salviati, working on the decorations for the triumphal entry of Charles V into Rome in 1536 and would, therefore, have been in contact already with Battista da San Gallo. *See* Podestà, 1878, 309.

39. Campana, 1908, 52; Tiraboschi, 1806, 59.

40. Vasari-Milanesi, 7:31.

41. Giovanni Baglione, *Le Vite de'pittori, scultori, et architetti* (Rome, 1642), 9.

42. Keller, 1976, 105.

43. J.A. Gere, "Some Early Drawings by Pirro Ligorio," *Master Drawings* 9 (1971): 246–47. Recently Bernice Davidson ("The *Birth of John the Baptist* and Some Other Drawings by Daniele da Volterra," *Master Drawings,* 21, 1983, 152–59) suggested that Daniele da Volterra may have been commissioned to paint the *Birth* in this space.

44. Archives of the arciconfraternita di S. Giovanni Decollato, *Libri di entrata e uscita,* 1550–56:

 p. 74 verso: "E addi 26 detto (August 1550) *b*. 5 *p* diffarc el palcho del oratorio che aveva fatto fco salviati p dipingere li apostolj....b. 5"

 p. 31 verso: (5 September 1550) "A chonimi di nostra compagnia ▽ ventitre di mta paghatj alli bondini dell bancho p resto di ▽ 33 — si paghono a fco salviatj p resto della pittura del quadro della nativita di san giovanj batista.... ▽ 23"

 p. 34 (May 1551): "A ms. franco salviati pittore ▽ cinque"

 These documents were discovered and first published by Hirst (1967, 34).

45. By Venturi (1925–34, 9:5, 781) and Adriana Modigliani, "Due Affreschi di Pirro Ligorio nell'Oratorio dell'Arciconfraternita di S. Giovanni Decollato," *Revista del R. Istituto d'Archologia e Storia dell'Arte* 3: 1931–33, 184–85. Freedberg (1971, 503, n. 51) suggests that Ligorio may have designed the architecture.

46. Keller, 1976, 117–20.

47. Archives of the Arciconfraternita di S. Giovanni Decollato, Rubricella Generale...:

 p. 92 (1551): "Facoltà data a tre Fratelli di poter convenire in nome di tutta la compagnia per la tavola del Altar maggiore di Chiesa con Giorgio Vasari,

Aretino, e per la tavola dell'Oratorio con Daniele da Volterra, da quale la Compagnia pretendeva avanzare ▽ 25."

48. Archives of the Arciconfraternita di S. Giovanni Decollato, Rubricella Generale...:
 p. 92 (1551): "Adornamento della tavola dell'Altar maggiore fatto fare secondo il modello del Vasari, quale era stato approvato da Michelangelo Buon arroti."
 It is interesting that during this same year Vasari became a *fratello* of the confraternity; *see* Bottari, *Catalogo dei Fratelli.* According to the page numbers from the original *Giornale del Provveditore* cited by Bottari, Vasari joined a short time after receiving the commission for the altarpiece. He does not seem to have become an active member, however, as no record of his participation in the activities of the confraternity has been found.

49. Archives of the Arciconfraternita di S. Giovanni Decollato, Libro di entrata e Uscita dal 1550 al 1560, pp. 36 verso, 38 verso, 39 verso, 44, and 46.

50. Vasari-Milanesi, 7:57–59.

51. *See* above, chapter 1, note 39. It might be logical to infer from this that Michelangelo, who became a member in 1514 (*see Giornale del Provveditore* 2:94) was active in the affairs of the confraternity. This does not seem to have been the case. Except for the records of his becoming a member and approving Vasari's *modello,* the only mention of Michelangelo during his lifetime is a curious entry dated 1560. This states that Michelangelo's name had been found in the old books (1514) but not in the recent ones, and a meeting was held to discuss whether it was appropriate to embrace him and inform him that they considered him one of them. It was decided that Francesco Salvetti and Ruberto Ubaldini should speak to him and find out if he remembered and cared about it. (*See Giornale del Provveditore* 4:152) The fact that upon Michelangelo's death in 1564 the confraternity transported his body from his home to SS. Apostoli may indicate that his answer was yes.

52. Campana, 1908, 388.

53. Vasari-Milanesi, 7:31, 576.

54. Louvre, #1494, pen and brown ink with brown wash, gone over with grey wash, 302 mm. by 184 mm. For the provenance and bibliography of the drawing *see* Catherine Monbeig-Goguel, *Dessins Italiens du Musée du Louvre: Vasari e son Temps* (Paris, 1972), 46. The authorship of the drawing will be discussed in Appendix A.

55. The fact that Vasari submitted a *modello* for approval suggests that this may have been the practice.

56. The relationship between the drawing and the painting will be discussed in Appendix A.

57. *See* Bernice Davidson, "Daniele da Volterra and the Orsini Chapel, II," *Burlington Magazine* 109 (1967): 561, n. 19, and Norman W. Canaday, "The Decoration of the Stanza della Cleopatra," in *Essays in the History of Art Presented to Rudolf Wittkower* (1967), 110–18.

58. Vasari-Milanesi, 7:59.

59. *See also* Jean S. Weisz, "Salvation through Death: Jacopino del Conte's Altarpiece in the Oratory of S. Giovanni Decollato in Rome," *Art History* 6 (1983):

Notes for Chapter 4

1. *See* Giotto's frescoes in the Peruzzi Chapel, Sta. Croce, Florence.

2. Included are Marsilio Ficino, Poliziano, Cristoforo Landini, and many others, according to a list compiled in 1561 by Benedetto di Luca Landucci. *See* Gerald S. Davies, *Ghirlandaio* (New York, 1901), 120.

3. *See* Sydney J. Freedberg, *Andrea del Sarto* 1 (London, 1963): 65–66, and John Shearman, *Andrea del Sarto* 1 (Oxford, 1965): 71–72.

4. For a discussion of Jacopino's pre-Roman and earliest Roman works, *see* Cheney, 1970, 32–35; Zeri, 1948, 180–83; and Zeri, 1951, 139–49.

5. *See* John Shearman, *Raphael's Cartoons in the Royal Collection* (London, 1972), 128–30, for a discussion of Raphael's use of extra figures.

6. Freedberg, 1971, 304.

7. The Contini-Bonacassi *Madonna* was attributed to Jacopino by Zeri (1948, 181–82). It was most likely painted in Rome close in time to the *Annunciation to Zaccariah*. A drawing in the Uffizi for the head of the old woman is one of the very few drawings to have been attributed to Jacopino. *See* Valentino Pace, "Osservazione sull'attività giovanile di Jacopino del Conte," *Bolletino d'Arte* 55 (1972): 221, fig. 5.

8. It has been suggested that the figure on the far left is a portrait of Michelangelo. The difficult problem of this and other portraits in the oratory paintings will be discussed in Appendix B.

9. As suggested also by Partridge (1978, 172). Apollo is a standard reference to Christ.

10. Cheney, 1963, 62.

11. *See* Barbara Rutledge, "The Theatrical Art of the Italian Renaissance," Ph.D. dissertation, University of Michigan, 1973, 157.

12. Marilyn Aronberg Lavin, "Giovannino Battista: A supplement," *Art Bulletin,* 43 (1961): 325.

13. Salviati did not ignore Sebastiano's fresco. Several of the motifs—the woman with a basket on her head on the left, the kneeling woman with a child on the right, and the steps in the foreground—appear in both compositions.

14. As noted by Hirst (1961, 236).

15. Cheney (1963, 57) pointed out that the setting resembles the Vitruvian tragic setting later published (1545) by Serlio. However, the setting of the *Decollation of St. John the Baptist* of 1553 is much closer to and probably derived from the Serlian design.

16. As noted by Freedberg (1971, 501, n. 17). Freedberg also points out the reference to Perino's angel of the *Annunciation* in the Pucci Chapel and to Ghirlandaio (in the *Nativity of St. John the Baptist* in Sta. Maria Novella).

17. *See* Hirst, 1961, 239–40, fig. 61. Hirst is concerned with the importance of Michelangelo's Sistine ceiling for Salviati's use of color. His detailed and excellent stylistic analysis of the fresco includes a very precise and sensitive description of the color. However, I agree with Cheney (1963, 64) that considerable caution must be exercised in discussing the color in these frescoes because of their condition.

18. By Cheney (1963, 62), Keller (1976, 32), and Partridge (1978, 172). It is tempting to interpret the mother and child motif as a *Caritas* in some of the other frescoes as well; for example in the *Preaching of St. John the Baptist* or in the simulated relief next to the *Arrest of St. John the Baptist* (and the latter is referred to by Keller (1976, 129) as *Caritas*). This theme, the embodiment of Christian love, is appropriate in the context of a program which emphasizes the role of St. John the Baptist as precursor to Christ's sacrifice—the supreme example of Christian love. It is also relevant to the contemporary charitable mission of the Confraternity of S. Giovanni Decollato. However, the *Caritas* image in sixteenth-century Florentine painting usually includes three children (*see,* for example, Andrea del Sarto's Scalzo fresco or his paintings in the Louvre and the Washington National Gallery; and see Salviati's *Caritas* of ca. 1535-38, on loan to the Fogg Art Museum, and another *Caritas* of ca. 1543-45 in the Uffizi). Also the inclusion of a mother and one or more children among the crowd is very common in sixteenth-century frescoes in Florence and in Rome.

19. In this connection Salviati's drawing for the *Visitation* (fig. 16) should be compared to the Perino drawing rather than (as by Hirst, 1961, 336-37) to Parmigianino.

20. As pointed out by Cheney (1963, 59), Salviati may have been imitating contemporary stage practice.

21. Thus her function in the composition is similar to that of the sprawling youth in Jacopino's fresco. She and the youth reclining next to her may have significance similar to the youth and the old woman in the *Annunciation to Zaccariah.*

22. Vasari-Milanesi, 7:16–17.

23. Ibid, 31.

24. Cheney, 1963, 241, n. 250.

25. It is interesting that the seated woman on the far right, who is turned and reaching toward the baby, is a self-quotation. The identical figure appears in the right foreground of Salviati's *Descent from the Cross,* painted in 1547-48 for the Dini Chapel, Sta. Croce (fig. 35).

26. Bernice Davidson, "Some Early Works by Girolamo Siciolante da Sermoneta," *Art Bulletin* 48 (1966): 64, thinks the frescoes in the Fugger Chapel were painted during the second half of the 1550s.

27. Freedberg, 1970, 340.

28. Siciolante's *Visitation* also resembles Salviati's fresco in the Oratory of S. Giovanni Decollato, while the *Presentation of the Virgin* reflects Jacopino's *Annunciation to Zaccariah. See* Venturi, 9:5, figs. 320–22.

29. The actual hues of the draperies are the same as in the *Visitation,* but the values are lower in general. Also the interior setting is shadowy in contrast to the light-filled outdoor square of the *Visitation.*

Notes for Chapter 5

1. The statue is by an unknown sculptor, and, as far as I know, no attempt has been made to identify the artist. It is a conventional Florentine image of the Baptist, and it was probably done by a Florentine (perhaps a member of the Confraternity of S. Giovanni Decollato).

2. Freedberg, 1971, 304.

3. The structure in the right background, framed by the leafy tree, may be a reference to the still-incomplete Church of S. Giovanni dei Fiorentini. The placement, next to the river and bridge, and the design of the facade, vaguely San-Gallesque, support this suggestion.

4. Freedberg, 1971, 501, n. 21.

5. Hirst, 1966, 402.

6. *See* discussion of the altarpiece in chapter 4.

7. I am tempted to interpret this figure as a *Caritas* motif. However, it is likely that the figure was added by Jacopino as a further reminiscence of Andrea.

8. Cheney (1970, 35) was the first to notice this.

9. *See* Gere, 1960, 10, n. 8, for a discussion of the date of Perino's return to Rome.

10. *See* Davidson, 1966, 46–48.

11. Von Henneberg, 1967, 140.

12. *See* Pastor, 12:27–28, for discussion of the beginning of outdoor preaching by the Jesuits.

13. For a discussion of the relationship between the new emphasis on regular preaching and Roman church design, *see* Lewine, 1960, 79–83.

14. Lewine, 1967, 25. *See also* James S. Ackerman, "The Gesù and Contemporary Church Design," Rudolf Wittkower and Irma Jaffe, eds., *Baroque Art: The Jesuit Contribution* (New York, 1972), 8–19.

15. Davidson, 1967, 553, 561.

16. Cheney, 1970, 37.

17. A. E. Popham, "Sogliani and Perino del Vaga at Pisa," *Burlington Magazine* 86 (1945): 89.

18. This figure, located next to the cliff in the right middle ground, is difficult to see in the photograph. In the fresco, it is separated from the cliff, which frames it, by difference of color.

19. *See* Gertrud Schiller, *Iconography of Christian Art* 1 (Greenwich, Conn., 1971): 129.

20. *See* Michael Alpatoff, "The Parallelism of Giotto's Paduan Frescoes," *Art Bulletin* 29 (1947): 149–54; *see also,* as cited by Alpatoff, H. v. v. Gabelentz, *Die kirchliche Kunst im italienischen Mittelalter* (Strassburg, 1907), 105.

21. Though the motif occasionally appeared in northern European representations of the *Baptism,* I know of no Italian example of this pose of Christ in the *Baptism* prior to Jacopino's fresco. Typically, as for example, in Andrea's Scalzo fresco and Ghirlandaio's fresco in Sta. Maria Novella in Florence, and in Perugino's fresco in the Sistine Chapel and the *Baptism* in the Vatican Logge in Rome, Christ has his hands folded in front of his chest. The crossed arms pose does appear in later Italian representations, including Battista Franco's altarpiece in the Barbaro Chapel, S. Francesco della Vigna, Venice, painted in the 1550s.

22. As pointed out to me by James Ackerman.

23. Illustrated in Schiller, 1971, vol. 1, fig. 375.

24. There are no contemporary buildings discernible in this fresco, but the fact that the buildings are ruins suggests a view of modern rather than ancient Rome. Ackerman suggested to me that the structure on the right with the three superimposed loggias could be the Septizonium on the Palatine.

Notes for Chapter 6

1. For a recent discussion of St. John the Baptist's martyrdom as prototype of that of Christ, which includes extensive bibliographical references, *see* Barbara G. Lane, "Rogier's St. John and Miraflores Altarpieces Reconsidered," *Art Bulletin* 60 (1978): 55–72.

2. Vasari-Milanesi, 6:578–80.

3. W. R. Rearick, "Battista Franco and the Grimani Chapel," *Saggi e Memorie di storia dell'arte* 2 (1958–59): 107, 111.

4. Freedberg, 1971, 332–33.

5. *See* Freedberg, 1963, 1:41, and Shearman, 1965, 1:68.

6. As was noted by Keller (1976, 95).

7. It should be noted that in the left foreground is a container, presumably for wine.

8. Rearick, 1958–59, 111.

9. Keller, 1976, 98.

10. Partridge, 1978, 172.

11. Though Keller (1976, 98) compares her to the Cumean sibyl.

12. For example, by Voss, 1920, 1:119, and by Keller, 1976, 97.

13. Vasari-Milanesi, 6:575. The woman with outstretched arms standing in the center of the *Arrest* may be developed from the *Noli Me Tangere* cartoon. Rearick (1958–59, 111) suggested that this figure was taken from Bronzino's *Fall of the Manna* in the Chapel of Eleanor da Toledo. As noted also by Keller (1976, 98), this is less likely than that both painters referred to Michelangelo, since Bronzino's fresco certainly postdates Franco's.

14. A. E. Popp, *Die Medici-Kapelle Michelangelos* (Munich, 1922), 86, 146ff., as cited by Charles De Tolnay, *Michelangelo* 3 (Princeton, 1948): 195.

15. Rearick, 1958–59, 111. I agree and also find it interesting that there is a sketch of an antique river god on the verso of the drawing usually believed to be Franco's sketch for the seated sibyl on the left of the fresco. This drawing, which is in the British Museum (Payne-Knight, pp. 2–121, 24.2 × 20.5 cm., pen and bistre, fig. 44), is problematic, but the suggestion by Frederick Antal, "Observations on Girolamo da Carpi," *Art Bulletin* 30 (1948):95–97 that the female figure is by Franco and the river god by Girolamo da Carpi has been generally accepted.

16. Partridge, 1978, 172.

17. Ibid.

18. It is interesting to note that Keller (1976, 96) without attaching any significance to the form, refers to the building as the "Rustika-Torbogen des Gefangnisses."

19. In the engraving by Giorgio Vasi among the locations identified is the Cappella della Conforteria. This is difficult to read in the photograph, but it is very clear in the original print.

20. Rearick, 1958-59, 110.

21. Franco's preoccupation with Michelangelo's Sistine Ceiling while working on this fresco, is demonstrated by the drawings. In addition to the British Museum drawing discussed above in note 15, there is a sketch in the Louvre (Inv. No. 4971, 27 × 40.7 cm., pen and bistre; fig. 45) which contains a number of quick sketches based on the *ignudi* and the ancestors. The figure on the lower right of the drawing may be an idea for the reclining nude, but most of the figures show Franco working out the poses and gestures of the female figures.

22. As quoted by Edgar Wind, "The Ark of Noah," *Measure* 1 (1950): 418.

23. Wind, 1950, 411-21.

24. Ibid, 413.

25. Ibid, 415.

26. All of the other paintings of Ligorio's Roman period, which were described by Baglione (1642, 9) were facade decorations and no longer exist.

27. Partridge, 1978, 172.

28. Freedberg, 1971, 294, 328-33, 339-40.

29. Ibid, 504, n. 51.

30. For a discussion of the similar concerns and similarity of style in the drawings of Ligorio and Taddeo Zuccaro, *see* Gere, 1971, 242-43.

31. Keller (1976, 111) relates a tradition identifying the three figures as portraits of Bivio, Benvenuto Cellini, and Baccio Bandinelli. Neither he nor his source, Generale Puccetti, seems convinced. I feel certain that these are portraits of members of the confraternity who were active as *confortatori*. It is obvious here, as it was not so clear in Salviati's fresco, that the figures are wearing hooded black robes over their street clothing. Note particularly the bunched up fabric on the back of the left figure which can only be a hood. The center figure is holding something in his hand. The form is vague, damaged, and difficult to decipher, but I believe he is holding the handle of one of the *tavole* carried by the *confortatori* and held before the prisoners. The *tavola* is being held upside down, and the part with the image is not visible.

32. British Museum, 1964-3-31-1, 272 × 438 mm., pen and brown wash, heightened with white. This drawing appeared on the London art market in 1964 without any attribution and was attributed to Ligorio by Gere on the basis of its connection with the oratory fresco. *See* Gere, 1971, 239.

33. Keller (1976, 110) suggests that she should be identified by her gesture as a Muse, but in this context, it makes more sense to identify her as a sibyl.

34. David Coffin, *The Villa d'Este at Tivoli* (Princeton, 1960), 32.

35. Coffin, 1960, 32.

36. This figure is almost invisible in the drawing and is obscured by another figure carrying a plate with a wine vessel on it. This vessel may have been substituted for the traditional motif of the head of St. John the Baptist carried on a platter. This motif, as well as being the emblem of the Confraternity of S. Giovanni Decollato, was a Eucharistic symbol (*see* Lane, 1978, 663). The motif was frequently included in representations of the *Dance of Salome* or the *Feast of Herod*. However, when this is followed by the *Decollation,* as in the oratory, the inclusion of the already severed head of the Baptist makes no sense.

37. This description is of Salome's figure in the painting which differs from the drawing.

38. Though, as pointed out by Gere (1971, 240), similar figures appear in works by Giulio Romano, and, as pointed out by Keller (1976, 110), Ligorio's Salome slightly resembles the Sheba in the *Meeting of Solomon and Sheba,* attributed to Polidoro, in the Vatican Logge; the pose, drapery, and tambourine relate the figure most closely, and I think intentionally, to the Dionysiac Maenads. *See* Matz, 1968.

39. Including the reliefs around this fresco, presumably done by Ligorio. Beneath the window to the left of the fresco there is a sacrifice scene, and in the fresco, on the edge of the "stage" and partly obscured by the portrait figures, there is another scene which appears to be some kind of ritual offering.

40. For discussion of the significance of Dionysiac mysteries in Florentine Neoplatonic thought and reflections in art, *see* Edgar Wind, *Pagan Mysteries in the Renaissance* (1958), 60-62, 177-90. This includes a discussion of Michelangelo's *Bacchus. See also* Charles De Tolnay, *Michelangelo* I (Princeton, 1943), 89-90, 143-44, and Frederick Hartt, *Michelangelo, the Complete Sculpture* (New York, 1968), 70.

41. I would even suggest that Salome's dance, as the prelude to the sacrifice of St. John the Baptist, is being associated with the frenzied dance of a Maenad, the prelude to a Dionysiac ritual sacrifice—which is the essential prelude to the regeneration of life.

42. Voss (1920, 1:254-56) attributed it to Salviati with possibly the assistance of a pupil; Leo Steinberg, in "Salviati's Beheading of St. John the Baptist," *Art News* 70 (1971-72): 46-47, and David Summers, in "Contrapposto: Style and Meaning in Renaissance Art," *Art Bulletin* 59 (1977): 337, simply accept the attribution to Salviati; Venturi (1925-34) 9:5, 781, and Modigliani (1931-33, 184-85) attribute the work entirely to Ligorio; Cheney (1963, 244) and Freedberg (1971, 503, n. 51) suggest that the setting was designed by Ligorio and the figure composition was designed but not executed by Salviati; Keller (1976, 117-20) suggests that the work was executed by Roviale Spagnuolo.

43. Both Cheney (1963, 243) and Keller (1976, 114-16) point out that the kneeling figure in the left foreground came from the tapestry of *Joseph Explaining Pharoah's Dream,* the relief medallion of a horseman on the triumphal arch from the Sala dell'Udienza, and the pointing soldier on the right from the *Schoolmaster of Falerii* in the Sala dell'Udienza as well as the *Martyrdom of St. Lawrence* in the Cappella del Palio.

44. Keller, 1976, 117-20.

45. For examples of Roviale's work *see* Ferdinando Bologna, *Roviale Spagnuolo e la pittura napoletana del Cinquecento,* Naples, 1959.

46. Cheney, 1963, 244.

47. Leo Steinberg, "Michelangelo's *Last Judgment* as Merciful Heresy," *Art in America* (1975): 63.

48. Steinberg, 1971-72, 47.

49. Summers, 1977, 337.

50. Medici, 1572, 2.

Notes for Chapter 7

1. Keller (1976, 17, 48) suggests that perhaps the framework around the altarpiece was part of a nineteenth-century restoration. However, though portions of the Church of S. Giovanni Decollato were restored during the eighteenth and nineteenth centuries (*see* Lewine, 1960, 271), there is no record of any restoration of the oratory prior to 1953.

2. *See* chapter 3, n. 26.

3. *See* chapter 3, n. 32.

4. This tabernacle, presumably designed by Vasari, forecasts the type of altar tabernacle he later designed for Sta. Croce and Sta. Maria Novella in Florence. *See* Hall, 1979. It is possible that Vasari's *modello* for the "adornamento della tavola dell'Altar Maggiore" which was approved by Michelangelo was a *modello* for the tabernacle rather than for the painting.

5. F.S. Ellis, ed., *The Golden Legend* (London, 1922) 2:102-3.

6. Hans Aurenhammer, *Lexikon der christlichen Ikonographie* (Vienna, 1959-67), 300, as cited by Keller, (1976, 47).

7. Ellis, *Golden Legend* 5:37.

8. Hirst, 1967, 35. Hirst also mentions that Bartolommeo Bussotti later commissioned Vasari to paint his portrait as St. Bartholomew. Keller (1976, 47) repeats this.

9. Edgerton, unpublished MSS. *Pictures and Punishment: Art and Criminal Prosecution in the Florentine Renaissance,* Chapter 5, in a discussion of images of the *ecorché* in sixteenth-century anatomical treatises, refers to the fact that "the flayed skin symbolizes sin removed." He cites the legends of Marsyas and Cambyses, as well as Michelangelo's image of St. Bartholomew holding his flayed skin in the *Last Judgment*. It is possible that the symbolic connection between flayed skin and sin removed was considered in the selection of St. Bartholomew as one of the apostles to be represented. However, except for the attribute of the knife, there is no emphasis on the fact that St. Bartholomew was flayed in Salviati's painting.

10. Hirst (1967, 35-36) suggests Michelangelo's *Risen Christ,* Sta. Maria sopra Minerva, as the source. Cheney (1963, 246) cites a drawing of *Fortitude* by Parmigianino.

11. Hirst, 1967, 35.

12. *See* chapter 3, n. 45.

13. First by Voss, 1: (1920) 142.

14. *See* chapter 3.

15. *See* Appendix A.

16. Edgerton, unpublished MSS. *Pictures and Punishment: Art and Criminal Prosecution in the Florentine Renaissance,* Chapter 5, in discussing the subject matter of the *tavolette,* relates the depictions of the removal of Christ's body from the cross to the fact that the mission of the Compagnia dei Neri and of S. Giovanni Decollato included the removal and proper burial of the victim's body. He cites the instructions provided to the members of the Compagnia dei Neri which stresses the reverence with which the victim's body should be handled. It is possible that this aspect of the confraternity's mission is related to the selection of the *Descent from the Cross* as subject for the altarpiece.

17. In addition to the Orsini altarpiece by Daniele and to Salviati's altarpiece of ca. 1547–48 for the Dini Chapel in Sta. Croce, which are traditionally mentioned in connection with Jacopino's painting, Vasari painted the subject in the late 1530s and at least three more times in the 1540s.

18. Frederick Hartt, "Power and the Individual in Mannerist Art," *Studies in Western Art, Acts of the XX International Congress of the History of Art,* (Princeton, 1963), vol. 2, The *Renaissance and Mannerism,* 229–30.

19. The origins of the Oratory of Divine Love go back as far as 1494 in Vicenza, and by 1500 an Oratory of Divine Love existed in Genoa. The founder Ettore Vernazza, a layman, moved it to Rome, where by 1517 its membership included several high officials of the Roman Curia as well as laymen. *See* A. G. Dickens, *The Counter Reformation,* History of European Civilization Library, (Norwich, 1969), 69; Pastor, 10:338–92, John C. Olin, *The Catholic Reformation: Savonarola to Ignatius Loyola* (New York, 1969), 16–26; and Hartt, 1963, 226–27.

20. Olin, 1969, 24.

21. Hartt, 1963, 227–28. *See also* Pastor 10:401; Lady Herbert, *The Life of St. Cajetan* (London, 1887?); and D. Francesco Andreu, D. R., *Le Lettere di San Gaetano da Thiene* (Rome, 1954).

22. *See* John Shearman, *Pontormo's Altarpiece in S. Felicità* (London, 1971).

23. *See* G. K. Brown, *Italy and the Reformation to 1550* (New York, 1971), 175–81.

24. *See* Domenico Orano, *Liberi Pensatori Bruciati in Roma* (Rome, 1904), 22–23.

25. For example in a fresco by Albertinelli of 1505 in the Certosa di Val d'Ema, and an altarpiece by Vasari of 1560 in Sta. Maria del Carmine, Florence.

26. Freedberg, 1971, 304.

27. Vasari-Milanesi, VII, 576.

28. This tract is published, translated into English, in Harvey E. Hamburgh, "Aspects of the Descent from the Cross from Lippi to Cigoli," Ph.D. diss., University of Iowa, 1978, 751–54.

29. Leo Steinberg, "Pontormo's Capponi Chapel," *Art Bulletin* 54 (1974): 386–87.

30. First by Erwin Panofsky, "Ein Bildentwurf des Jacopino del Conte," *Belvedere* 11 (1927): 47. *See also* Partridge, 1978, 173. It is interesting that a connection between the themes of the *Visitation* and Christ's Passion appears in reverse in Pontormo's fresco of the *Visitation* in SS. Annunziata, where the *Sacrifice of Isaac,* as a prefiguration of the sacrifice of Christ, is depicted in the lunette.

31. For example, some small panels by Puligo (*Deposition,* ca. 1518–20, Venice, Seminario) and Bacchiacca (*Deposition,* ca. 1515, Bassano, Museo Civico; *Deposition,* ca. 1518 Florence, Uffizi), and a bronze relief by Baccio Bandinelli of about 1516 in the Louvre.

32. Vasari-Milanesi, 5:600. It may have been Perino's example that inspired Vasari to include the thieves in a *Pietà* that he painted in Ravenna in 1548.

33. *See* for example, Cheney, 1970, 37, and Keller, 1976, 77.

34. Partridge, 1978, 173.

35. Raffaello Borghini, *Il Riposo* (Florence, 1584), 110.

36. Hall, 1979, 45.

37. *See* chapter 1.

38. Ellis, *Golden Legend* 3:70. *See also* Hamburgh, 1978, 32–33, and 48, n. 86, for discussion of Longinus in the *Descent from the Cross.*

39. In 1546, Diego Spagnolo was hanged and burned in Piazza Giudea "come Luterano, ma morì ben disposto e pentito del suo errore." *See List of Giustiziati,* Inventario #285, Archivio di Stato, Rome. In 1549, "Pietro, prete franzeze e côffesso e côtrito fatto dal nîo proveditor/." *See Libri di Testamenti,* vol. 31, 36, Archivio di Stato, Rome. In 1553, Giovanni Buzio da Montalcino not only confessed but asked to become a member of the confraternity before he died. *See Libri di Testamenti,* vol. 31, 66, Archivio di Stato, Rome.

40. Taken from descriptions of executions of Frate Ambrogio de Cavoli di Milani, 1556, *Libri di Testamenti,* vol. 31, 96; Pomponio de Algerio di Nola, 1556, *Libri di Testamenti,* vol. 31, 98–99 (both in Archivio di Stato, Rome); and Macario Arcivescovo di Macedonia, 1562 (*see* Orano, 1904, 13).

41. Taken from description of execution of Pietro Carnessechi in 1567. *See* Orano, 1904, 23.

42. Vasari-Milanesi, 7:31.

43. Jacopino's contribution to the decoration of the Chapel of S. Remigio in S. Luigi dei Francesi, dates about 1547–48 and thus preceded the altarpiece, which is now known to date at earliest 1551 and probably closer to 1553.

44. Such as the *Pietà* in the Palazzo Massimi, Rome, or the *Magdalen* in S. Giovanni Laterano.

45. Freedberg, 1971, 305.

46. Federico Zeri, *Pittura e Controriforma, l'Arte senza Tempo di Scipione de Gaeta* (Turin, 1957), 35–36. *See also* Zeri, 1951, 139–49.

Notes for Appendix A

1. Panofsky, 1927, 43–51.

2. Monbeig-Goguel, 1972, 46.

3. Monbeig-Goguel, 1972, 46. Keller (1976, 75) follows Monbeig-Goguel in calling the drawing a copy after Jacopino.

4. *See* Davidson, 1966. Note for example some of the drawings for the Castel Sant'Angelo (figs. 46, 48, and 49).

5. Summarized by Paul Barolsky, "A Sheet of Figure Studies at Oberlin and other Drawings by Daniele da Volterra," *Bulletin* (Allen Memorial Art Museum, Oberlin College), 30 (1972): 23-36.

6. *See* Davidson, 1967, 557. She suggests that a drawing in the Kunsthalle, Hamburg, is a study by Daniele for the *True Cross Raises a Dead Man,* planned for the Orsini Chapel.

7. Published by Barolsky, 1972. Note particularly the sheet of figure studies at Oberlin and a drawing for the *Holy Family with Saints* in the Albertina.

8. Panofsky (1927, 48) observed that this configuration was derived from a print by Marcantonio Raimondi after Raphael (fig. 60).

9. Panofsky, 1927, 47.

10. *See* chapter 4.

11. Publishing by Marita Horster, "Eine Unbekannte Handzeichnung aus dem Michelangelokreis und die darstellung der kreuzabbahme im cinquecento," *Walfraf-Richartz Jahrbuch* 27 (1965): 191-234.

Notes for Appendix B

1. Ernst Steinmann, "Zur Ikonographie Michelangelos," *Monatshefte für Kunstwissenschaft* 1 (1908): 46-50; and *Die Portraitdarstellungen des Michelangelo* (Leipzig, 1913), 22-23.

2. This portrait is now in the Metropolitan Museum, New York, where it has been X-rayed (fig. 64). Though the portrait has been traditionally attributed to Jacopino del Conte, the *Holy Family* composition revealed by the X-ray is less like those attributed to Jacopino and datable to the 1530s than it is like a *Holy Family* in the d'Elci Collection, Siena, by Daniele da Volterra. This work is illustrated in Freedberg (1971, plate 208), where it is dated ca. 1552?. I am indebted to Keith Christiansen of the Metropolitan Museum for sending me photographs of the portrait and the X-ray. He also informed me that Freedberg had suggested a possible connection with Daniele.

3. Steinmann, 1913, 22.

4. Von Henneberg, 1967, 140, n. 9.

5. *See* chapter 3, n. 51.

6. Cheney, 1970, 39.

7. Ibid.

8. Von Henneberg, 1967, 140.

9. Ibid.

10. Ibid.

11. Cheney, 1963, 58.

12. Keller (1976, 111) repeated, with some skepticism, a traditional identification of these three as Bivio, Cellini, and Bandinelli.

13. For example, a portrait by Salviati in the Kunsthistorisches Museum, Vienna, illustrated in Cheney (1963, figure 51).

14. Cheney, 1970, 40.

15. *See* Chapter 3, n. 45.

16. *See* Chapter 1.

Bibliography

Ackerman, James S. "The Gesù and Contemporary Church Design," Rudolf Wittkower and Irma Jaffe, eds., *Baroque Art: The Jesuit Contribution*. New York, 1972.

Andreu, D. Francesco, D. R. *Le Lettere di San Gaetano da Thiene*. Rome, 1954.

Antal, Frederick. "Observations on Girolamo da Carpi." *Art Bulletin* 30 (1948): 81–103.

Armellini, Mariano. *Le Chiese di Roma dal Secolo IV al XIX*. Rome, 1891 (1942).

Baglione, Giovanni. *Le vite de'pittore, scultori, et architetti*. Rome, 1642.

Barocchi, Paola. *Vasari Pittore*. Milan, 1964.

Barolsky, Paul. "A Sheet of Figure Studies at Oberlin and other Drawings by Daniele da Volterra." Allen Memorial Art Museum Bulletin, vol. 30. Oberlin College, 1972.

——————. *Daniele da Volterra: A Catalogue Raisonné*. New York, 1979.

Belloni, Coriolano. *Un banchiere del Rinascimento, Bindo Altoviti*. Rome, 1935.

Bologna, Ferdinando. *Roviale Spagnuolo e la pittura napoletana del Cinquecento*. Naples, 1959.

Borghezio, Gino. "L'arciconfraternita di S. Giovanni Decollato o della Misericordia e l'assistenza di condannati a morte." In *Atti del V Congresso Nazionale di Studi Romani*, vol. 3. Rome, 1938.

Borghini, Raffaello. *Il Riposo*. Florence, 1584.

Brown, G. K. *Italy and the Reformation to 1550*. New York, 1971.

Buchowiecki, Walther. *Handbuch der Kirchen Roms*. 2 vols. Vienna, 1970.

Bullard, Melissa. "Mercatores Florentini Romanam Curiam Sequentes in the Early Sixteenth Century." *Journal of Medieval and Renaissance Studies* 6 (1976): 51–71.

Bullarum diplomatum et privilegiorum sanctorum romanorum pontificum taurinensis editio. Vol. 5, 7. Turin, 1860.

Busi, C. *Parere sulle disposizioni testamentarie per le doti da conferirsi dall'Arciconfraternita di S. Giovanni Decollato*. Rome, 1854.

Calvi, Emilio. *Bibliografia delle catacombe e delle chiese di Roma con indice topografico e per autori*. Rome, 1908.

Campana, L. "Monsignore Giovanni della Casa e i suoi tempi." *Studi Storici* 17 (1908): 381–606.

Canady, Norman. "The Decoration of the Stanza della Cleopatra." In *Essays in the History of Art Presented to Rudolf Wittkower* 2:110–18. London, 1967.

Cantimori, Delio. *Eretici Italiani del Cinquecento*. Florence, 1939.

Cappelli, Eugenio. *La Compagnia dei Neri*. Florence, 1927.

Celio, Gaspare. *Memoria delli nomi dell'artifici delle Pitture, che sono in alcune Chiese, Facciate, e Palazzi di Roma*. Naples, 1638.

Cheney, Iris. "Francesco Salviati (1510–1563)." 3 vols. Ph.D. diss., New York University, New York, 1963.

—————. "Notes on Jacopino del Conte." *Art Bulletin* 52 (1970): 32–40.

Cistellini, Antonio. *Figure della riforma pretridentina.* Brescia, 1948.

Clausse, Gustave. *Les San Gallo.* 3 vols. Paris, 1902.

Coffin, David. *The Villa d'Este at Tivoli.* Princeton, 1960.

Davidson, Bernice. "Daniele da Volterra and the Orsini Chapel, 2." *Burlington Magazine* 109 (1967): 553–61.

—————. *Mostra di disegni del Perino del Vaga e la sua cerchia.* Florence, 1966.

—————. "Some Early Works by Girolamo Siciolante da Sermoneta." *Art Bulletin* 158 (1966): 55–64.

Davies, Gerald S. *Ghirlandaio.* New York, 1901.

Delumeau, Jean. "Vie économique et sociale de Rome dans la seconde moitié du XVI^e siécle." *Bibliothèque des Ecoles Francaises d'Athènes et de Rom,* 184. 2 vols. Paris, 1957–59.

Dickens, A. G. *The Counter Reformation.* History of European Civilization Library. Norwich, 1969.

Edgerton, Samuel Y., Jr. "A Little Known 'Purpose of Art' in the Italian Renaissance." *Art History* 2 (1979): 45–61.

—————. "*Maniera* and the *Mannaia*; Decorum and Decapitation in the Sixteenth Century." In *The Meaning of Mannerism,* edited by F. W. Robinson and S. G. Nichols, 67–105. Hanover, N. H., 1972.

Ellis, F. S., ed. *The Golden Legend of Jacobus da Voragine.* 5 vols. London, 1922.

Fanucci, Camillo. *Trattato di tutte l'opere pie dell'alma città di Roma.* Rome, 1601.

Forcella, Vincenzo. *Iscrizioni delle chiese e d'altri edifici di Roma dal secolo XI fino ai giorni nostri,* vol. 7. Rome, 1876.

Förster, Kurt. "Metaphors of Rule." *Mitteilungen Kunsthistorisches Institut Florenz* 15 (1971): 65–104.

Freedberg, Sydney J. *Andrea del Sarto.* 2 vols. Cambridge, Mass., 1963.

—————. *Painting in Italy: 1500–1600.* Pelican History of Art. Harmondsworth, 1971.

Gambarucci, Marco. *Ricordi ed avvertimenti per i sacrestani della Compagnia della Misericordia della nazione Fiorentina in Roma in occasione di giustizie e liberazion de'prigionieri,* 1663. Codex Corsiniano 285, Biblioteca Corsiniana, Rome.

Gere, J. A. "Drawings in the Ashmolean Museum." *Burlington Magazine* 99 (1957): 161.

—————. "Some Early Drawings by Pirro Ligorio." *Master Drawings* 9 (1971): 239–50.

—————. "Two Late Fresco Cycles by Perino del Vaga: The Massimi Chapel and the Sala Paolina." *Burlington Magazine* 102 (1960): 8–19.

Giovannoni, Gustavo, *Antonio da Sangallo il Giovane.* 2 vols. Rome, 1959.

de Gregori, Luigi. "Memorie delle guistizie romane presso la chiesa di S. Giovanni Decollato." *Ecclesia* 5 (1946): 379–82.

Hall, Marcia B. *Renovation and Counter-Reformation: Vasari and Duke Cosimo in Sta. Maria Novella and Sta. Croce 1565–1577.* Oxford, 1979.

Hamberg, Gustav Per. "G. B. da Sangallo detto il Gobbo e Vitruvio." *Palladio* 8 (1958): 15–21.

Hamburgh, Harvey E. "Aspects of the 'Descent from the Cross' from Lippi to Cigoli." 2 vols. Ph.D. diss., University of Iowa, 1978.

Hartt, Frederick. "Power and the Individual in Mannerist Art." In *Acts of the XX International Congress of the History of Art.* Vol. 2, *The Renaissance and Mannerism.* Princeton, 1963.

Henneberg, Josephine von. "An Unknown Portrait of St. Ignatius Loyola." *Art Bulletin* 159 (1967): 140–42.

—————. *L'Oratorio dell'Arciconfraternita del Santissimo Crocifisso di San Marcello.* Rome, 1974.

Herbert, Mary Elizabeth A'Court, Lady (Baroness Herbert). *The Life of St. Cajetan.* Dublin, 1873.

Hirst, Michael. "Daniele da Volterra and the Orsini Chapel 1: The Chronology and the Altarpiece." *Burlington Magazine* 109 (1967): 498–509.

—————. "Francesco Salviati's *Visitation.*" *Burlington Magazine* 103 (1961): 236–40.

—————. "Perino del Vaga and His Circle." *Burlington Magazine* 108 (1966): 398–405.

—————. "Salviati's Two Apostles in the Oratorio of S. Giovanni Decollato." In *Studies in Renaissance and Baroque Art Presented to Anthony Blunt on His 60th Birthday.* London/New York, 1967.

Horster, Marita. "Eine unbekannte Handzeichnung aus dem Michelangelo-Kreis und die Darstellung der Kreuzabnahme in Cinquecento." *Wallraf-Richartz Jahrbuch* 27 (1965): 191–234.

Janelle, Pierre. *The Catholic Reformation.* Milwaukee, 1963.

Keller, Rolf. *Das Oratorium von San Giovanni Decollato in Rom: Eine Studie seiner Fresken.* Neuchâtel, 1976.

Kirwin, Chandler. "Vasari's Tondo of 'Cosimo I with His Architects, Engineers and Sculptors' in the Palazzo Vecchio," *Mitteilungen Kunsthistorishches Institut Florenz* 15 (1971): 104–22.

Lanciani, Rodolfo. *The Golden Days of the Renaissance in Rome.* New York, 1906.

Lane, Barbara G. "Rogier's St. John and Miraflores Altarpieces Reconsidered." *Art Bulletin* 60 (1978): 55–72.

Lavin, Marilyn Aronberg. "Giovannino Battista: A Supplement." *Art Bulletin* 153 (1961): 319–26.

Lewine, Milton. "Roman Architectural Practice During Michelangelo's Maturity." In part 2 of *Stil und Uberlieferung in der Kunst des Abendlandes, Acts of the XXI International Congress for Art History.* Berlin, 1967.

—————. "The Roman Church Exterior, 1527–1580." Ph.D. diss., Columbia University, 1960.

Lumbroso, Matizia Maroni, and Martini, Antonio. *Le Confraternite Romane nelle loro chiese.* Rome, 1963.

Marignani, Eugenio. "Nel chiostro di S. Giovanni Decollato." *Capitolium* 15 (1940): 829–37.

Martinelli, Fioravante. *Roma ricercata nel suo sito.* Rome, 1658.

Masseron, Alexandre. *Saint Jean Baptiste dans l'art.* Paris, 1957.

Matz, Friedrich. *Die Dionysischen Sarkophage.* 4 vols. Berlin, 1968.

de Medici, Zanobi. *Trattato utilissimo in conforto de condennati a morte in via di giustizia.* Ancona, 1572.

Modigliani, Adriana. "Due affreschi di Pirro Ligorio nell'Oratorio dell'Arciconfraternita di San Giovanni Decollato." *Rivista del R. Istituto d'archeologia e storia dell'arte* 3 (1931–32): 184–88.

Molfino, Alessandra. *L'Oratorio del Gonfalone.* Rome, 1964.

Monachino, Vincenzo. *La Carità Cristiana in Roma* Vol. 10. Bologna, 1968.

Monbeig-Goguel, Catherine. *Dessins Italiens du Musée du Louvre: Vasari et son Temps.* Paris, 1972.

Morichini, Carlo-Luigi. *Degli Istituti di Carità per la sussistenza e l'educazione dei poveri e dei prigionieri.* Rome, 1870.

Moschini, Vittorio. *San Giovanni Decollato, Le chiese di Roma illustrate.* No. 26. Rome, 1926.

Olin, John C. *The Catholic Reformation: Savonarola to Ignatius Loyola. Reform in the Church 1495–1540.* New York/Evanston/London, 1969.

Orano, Domenico. *Liberi pensatori bruciati in Roma.* Rome, 1904.

Ozzola, Leandro. "Nota dei quadri che stattera in mostra nel cortile di S. Giovanni Decollato a Roma nel 1736." *Archivio della R. Societa Romana di Storia Patria* 37 (1914): 637–58.

Pace, Valentino. "Osservazioni sull'attività giovanile di Jacopino del Conte." *Bolletino d'Arte* 57 (1972): 220–22.

Panofsky, Erwin. "Ein Bildentwurf des Jacopino del Conte." *Belvedere* 11 (1927): 43–51.

Partner, Peter. *Renaissance Rome: 1500–1559.* Berkeley, 1976.

Partridge, Loren. Review of Rolf Keller. In "Das Oratorium von San Giovanni Decollato in Rom: Einte Studie seiner Fresken." *Art Bulletin* 60 (1978): 171–73.

Paschini, Pio. "Roma nel Rinascimento." *Storia di Roma.* Vol. 12. Bologna, 1948.

Pastor, Ludwig von. *History of the Popes.* Vols. 10–14. St. Louis, 1923.

Pecchiai, Pio. *Roma nel Cinquecento.* Bologna, 1948.

Piazza, Carlo Bartolomeo. *Eusevologio Romano overo delle Opere Pie di Roma.* Rome, 1698.

Pinna, Anelia. "L'Oratorio del Crocefisso di S. Marcello." *Bolletino della Unione Storia ed Arte* 8 (1968): 96–98.

———. "L'Oratorio di S. Giovanni Decollato." *Bolletino della Unione Storia ed Arte* 8 (1965): 89–92.

Podestà, B. "Carlo V a Roma nell'anno 1536." *Archivio della Società Roma di Storia Patria* 1 (1878): 303–44

Pognisi, Achille. *Giordano Bruno e l'archivio di S. Giovanni Decollato.* Turin, 1891.

Popham, A. E. "On Some Works by Perino del Vaga." *Burlington Magazine* 86 (1945): 56–66.

———. "Sogliani and Perino del Vaga at Pisa." *Burlington Magazine* 86 (1945): 85–90.

Popp, Anny E. "Jacopino del Conte: St. John the Baptist Preaching." *Old Master Drawings* 2 (1927): 7–8.

Pozzolini, Arnaldo. *Arciconfraternite Fiorentini in Roma.* Florence, 1904.

Privilegii et gratie concesse da diversi Romani Pontefici alla Venerabile Compagnia di S. Giovanni Decollato, detta della Misericordia della Natione Fiorentina di Roma. Rome, 1560.

Radice, Betty. *Who's Who in the Ancient World.* Harmondsworth, 1975.

Rearick, W. R. "Battista Franco and the Grimani Chapel." *Saggi e memorie di storia dell-arte* 2 (1958/59): 107–39.

Reau, Louis. *Iconographie de l'art chrètien.* Paris, 1957.

Riccardi, Francesco. *Direttorio per il Maestro di Cerimonie della Ven. Arciconfraternita di S. Giovanni Decollato in Roma.* Rome, 1803.

Rufini, Emilio. *Michelangelo e la colonia fiorentina a Roma.* Naples, 1965.

———. *S. Giovanni de'Fiorentini. Le chiese di Roma illustrate.* No. 39. Rome, 1957.

Ruggeri, Luigi. *L'Archiconfraternita del Gonfalone.* Rome, 1866.

Rutledge, Barbara. "The Theatrical Art of the Italian Renaissance: Interchangeable Conventions in Painting and Theatre in the Late 15th and Early 16th Centuries." Ph.D. diss., University of Michigan, 1973.

Saalman, Howard. *The Bigallo: The Oratory and Residence of the Compagnia del Bigallo e della misericordia in Florence.* New York, 1969.

Scanarolo, Giovanni Battista. *De Visitatione carceratorum.* Rome, 1655.

Schiller, Gertrud. *Iconography of Christian Art.* 2 vols. Greenwich, Conn., 1971.

Serni, Pompeo. *Memorie a fratelli della Ven. Archiconfraternita di S. Giovanni Decollato detta della Misericordia della Nazione Fiorentina in Roma. Per la solita praticca di aiutare a benimorire i Condennati a Morte,* 1653. Vat. Reginense latino 2084. Vatican Library.

Shearman, John. *Andrea del Sarto.* 2 vols. Oxford, 1965.

———. *Pontormo's Altarpiece in S. Felicità.* Newcastle upon Tyne, 1971.

———. *Raphael's Cartoons in the Royal Collection.* London, 1972.

Smythe, Craig Hugh. *Mannerism and Maniera.* New York, 1962.

Statuti dell'arciconfraternita di S. Giovanni Decollato. Ordini coi quali deve esser governata la venerabile arciconfraternita di S. Giovanni Decollato detta della Misericordia in Roma. Rome, 1833.

Steinberg, Leo. "Michelangelo's *Last Judgment* as Merciful Heresy." *Art in America* 63 (No. 6, 1975). 49–63.

—————. "Pontormo's Capponi Chapel." *Art Bulletin* 54 (1974): 385–99.

Steinmann, Ernst. *Die Portrait darstellungen des Michelangelo.* Leipzig, 1913.

—————. "Zur Ikonographie Michelangelos." *Monatshefte für Kunstwissenschaft* 1 (1908): 46–50.

Summers, David. "Contrapposto: Style and Meaning in Renaissance Art." *Art Bulletin* 59 (1977): 336–61.

Tiraboschi, Girolamo, ed. *Opere di Monsignor Giovanni della Casa.* Vol. 1, *Classici Italiani.* Milan, 1806.

Titi, Filippo. *Studio de pittura, scultura, ed architettura nelle chiese di Roma.* Rome, 1674.

De Tolnay, Charles. *Michelangelo.* Vol. 3. Princeton, 1948.

Toni, Diomede, ed. *Il Diario Romano di Gaspare Pontani. Già riferito al "Notaio del nanti porto" (30 gennaio 1481-25 luglio 1492).* In *Rerum Italicarum Scriptores,* vol. 3, part 2, Città di Castello. 1907.

Uccelli, Gio. Battista. *Della Compagnia de S. Maria della Croce al Tempio.* Florence, 1861.

Vasari, Giorgio. *Le Vite de'piu eccellenti pittori, scultori, ed archittettori* [1568]. G. Milanesi, ed. 9 vols. Florence, 1906.

Venturi, Adolfo. *Storia dell'arte italiana.* Vol. 9, *La Pittura del Cinquecento,* parts 5, 6, 7. Milan, 1933.

Voss, Herman. *Die Malerei der Spätrenaissance in Rom und Florenz.* 2 vols. Berlin, 1920.

Weisz, Jean S. "Daniele da Volterra and the Oratory of S. Giovanni Decollato in Rome," *Burlington Magazine* 123 (1981): 355–56.

—————. "Salvation through Death: Jacopino del Conte's Altarpiece in the Oratory of S. Giovanni Decollato in Rome," *Art History,* VI, 1983.

Wind, Edgar. "The Ark of Noah: A Study in the Symbolism of Michelangelo," *Measure* 1 (1950): 411–21.

—————. *Pagan Mysteries in the Renaissance,* New York, 1968.

Zeri, Federico. "Intorno a Girolamo Siciolanti." *Bolletino d'Arte* 36 (ser. 4, 1951): 139–49.

—————. *Pittura e Controriforma, l'Arte senza Tempo di Scipione de Gaeta.* Turin, 1957.

—————. "Salviati e Jacopino del Conte." *Proporzione* 2 (1948): 180–83.

Index

DATE DUE